Against Ambience and Other Essays

Animal Ambience and Other Essays

Against Ambience and Other Essays

Seth Kim-Cohen

Bloomsbury Academic
An imprint of Bloomsbury Publishing Inc

BLOOMSBURY
NEW YORK · LONDON · OXFORD · NEW DELHI · SYDNEY

Bloomsbury Academic
An imprint of Bloomsbury Publishing Inc

1385 Broadway	50 Bedford Square
New York	London
NY 10018	WC1B 3DP
USA	UK

www.bloomsbury.com

BLOOMSBURY and the Diana logo are trademarks of Bloomsbury Publishing Plc

First published 2016

© Seth Kim-Cohen, 2016

All rights reserved. No part of this publication may be reproduced or transmitted in any form or by any means, electronic or mechanical, including photocopying, recording, or any information storage or retrieval system, without prior permission in writing from the publishers.

No responsibility for loss caused to any individual or organization acting on or refraining from action as a result of the material in this publication can be accepted by Bloomsbury or the author.

Library of Congress Cataloging-in-Publication Data
Kim-Cohen, Seth, author.
[Essays. Selections.]
Against ambience and other essays / Seth Kim-Cohen.
pages cm
Includes bibliographical references and index.
Summary: "An argument against the "ambient turn" in contemporary art"–
Provided by publisher.
ISBN 978-1-5013-1031-7 (hardback) – ISBN 978-1-5013-1032-4 (paperback)
1. Art, Modern–21st century–Themes, motives. 2. Sound in art. I. Title.
N6497.K56 2016
700.9'051–dc23
2015031572

ISBN: HB: 978-1-5013-1031-7
PB: 978-1-5013-1032-4
ePUB: 978-1-5013-1034-8
ePDF: 978-1-5013-1033-1

Typeset by Deanta Global Publishing Services, Chennai, India

For my mom

Contents

Preface	viii
Part 1 Against Ambience	1
Part 2 Shallow Listenings: Sounds, Silences, Scenes, and Sites	83
1 Nothing That Is Not There And The Nothing That Is: Doug Aitken's *Sonic Pavilion*	85
2 I Have Something To Say, But I'm Not Saying It	94
3 That Jabbering Which Thinks It Sees: Robert Morris Sites His Sources	117
4 Sound Today (Is No Longer A Function Of The Ear) *or*, Why Do I So Dislike *Glee*?	121
Part 3 The Conceptual Garage: Rock and Roll, Expanded	129
5 No Depth: A Call for Shallow Listening	131
6 Burden Bangs Joy	144
7 Rock and Roll Lecture No. 1	167
Part 4 Anxious, Dismal, Giddy, Aggressive: Seth Kim-Cohen Interviewed by Mark Peter Wright for *Ear Room*	175
Index	189

Preface

This book is comprised of texts written between 2009 and 2015. Some were written to be read in books and journals, others to be read aloud at conferences and such. The piece referenced in the book's title, "Against Ambience," was originally published by Bloomsbury as a stand-alone e-book in late 2013. This long essay responds to a spate of exhibitions in New York in the summer of 2013. The thought, at the time, was to engage the conversation the exhibitions had initiated by reaching readers as quickly as possible. Thus the e-book, with its quicker turnaround.

Now, the thought is to supplement this essay with seven others, plus an interview, in order to contextualize and expand the ideas presented in "Against Ambience." The additional seven essays have been divided into two sections. The first, "Shallow Listenings," engages a set of artistic examples—John Cage's *Lecture on Nothing*, Robert Morris's *Hearing*, Doug Aitken's *Sonic Pavilion*, and the television show, *Glee*, among them—to test various theses about contextual and conceptual sound. The second part, "The Conceptual Garage," includes three nascent attempts at a theory of rock and roll, connecting rock practices to the "conceptual turn" of the visual arts since the late 1960s. This project will be further developed in my next book.

I am indebted to those who invited or commissioned these contributions to journals, compendiums, and conferences: Matthieu Saladin, Julie Beth Napolin, Michael Schumacher, Giorgiana Zachia, Lou Mallozzi, Chris Forsyth, and Mark Peter Wright. I am grateful to the friends and colleagues who have challenged my thinking, thereby improving these pieces in the process: Seth Brodsky, Brian Kane, Christoph Cox, Mattin, Lytle Shaw, and Delinda Collier. I am inordinately lucky to share both life and listening with my formidably brilliant wife and my voraciously imaginative daughter.

To conclude, as is the fashion, an epigraph:

The world is a harmonious institution too, whether we know it or not. Franz Schubert slept with his glasses on, even that's all right, and when they get bent

the optician fixes them. For the worst cases, I've found a medicine, a kind of whiskey with yoga, little green pills which help for and against everything, above all for everything they help against. Everyone knows how important that is. My discovery, my contribution to the State. I rest on these laurels.

<div style="text-align: right">Gunter Eich</div>

Part One

Against Ambience

One need never leave the confines of New York to get all the greenery one wishes—I can't even enjoy a blade of grass unless I know there's a subway handy, or a record store or some other sign that people do not totally regret *life. It is more important to affirm the least sincere; the clouds get enough attention as it is and even they continue to pass. Do they know what they're missing? Uh huh.*

—Frank O'Hara

1 Meditations in an Emergency

Consider the summer of 2013 in New York:

June 15, Seth Siegelaub dies;

June 20, The exhibition, *ambient*, opens at Tanya Bonakdar Gallery in Chelsea (the press release cites Brian Eno's conception of ambient music as a precedent);

June 21, James Turrell's monumental show opens at the Guggenheim, one of three Turrell retrospectives nationwide;

June 27, Robert Irwin's *Scrim veil—Black rectangle—Natural light*, initially installed at the Whitney in 1977, is reinstalled;

August 1, The conceptual sound show, *The String and The Mirror*, opens at Lisa Cooley Gallery;

August 9, Turner Prize winner, Susan Philipsz, begins work on her public sound installation, *Day Is Done*, on Governor's Island;

August 10, *Soundings: A Contemporary Score*, the first major sound show at Museum of Modern Art (MoMA) opens;

September 10, The Metropolitan Museum of Art presents Janet Cardiff's *The Forty Part Motet* at the Cloisters.

Three short months: inaugurated by what we might think of as the symbolic death of conceptual art; characterized by an unprecedented torrent of sound and light.

Siegelaub's passing shouldn't have been so easily allegorized. But the fact of his demise found itself drowned in rooms full of sound and light. By the end of each tribute to his legacy, the beginning was already dissolving in the flood of the ambient. Back in the late 1960s, as artists launched radical experiments with ideas and language, Siegelaub rushed to their side, acting as champion, explicator, and most importantly, as organizer of many of their important early exhibitions. It is hard to imagine the history of Conceptual Art unfolding without his participation. That unfolding is now in danger of folding back on itself. After forty years of conceptual expansions of art practice, we may now be witnessing the elastic snapping back. As the dust of Relational Aesthetics and social practice settles, as the rowdy Rancièrism of the 2000s finds its place in the long view of aesthetic discourse, we are seeing an unexpected retreat to ambience.

I worry that the arguments I made in my 2009 book, *In The Blink Of An Ear: Toward A Non-Cochlear Sonic Art*, have fallen on deaf ears. Rather than attesting to an expansion of sound practice in the directions of conceptualism, the New York summer of 2013, organizes exhibitions and discourse along the simple lines of materials and medium. This commonality implicitly accepts that the appeal of ambient phenomena, like sound and light, is attributable to their evanescence, ineffability, and immersiveness. The flow I'd hoped to see (and to help generate) may, in fact, be flowing in the opposite direction, away from conceptual concerns and back to mute perception. Much of the visual art on offer in this very specific (and admittedly limited) time and place, invokes ambience. In the cases of the Turrell and *ambient* exhibitions, specific appeals are made to sound as a precedent and a metaphor. Implicitly, this work, these shows, and their critical-institutional framing, capitalize on (or capitulate to) the reductionist reading of sound as the most ambient of modalities.

Thanks to the redefinitions initiated by conceptualism, we've seen the so-called, "visual" art world move beyond strictly formal, Kantian-Greenbergian questions; beyond purely visual, perceptual, or phenomenological issues. The art world embraces a widely dispersed set of engagements not only with the

senses and the media, but also with philosophy, economics, gender, identity, and interpersonal relations at the level of individuals, organizations, corporations, and nation-states. Along the way, art is as likely as not to deal with technology, materiality, language, duration, performativity, and cultural critique. These lists are necessarily partial, because art now gives itself permission to address any subject by any strategy that might be productive. In the 1960s, philosophy experienced the apex of what is known as the "linguistic turn," and around the same time the visual arts experienced the so-called "conceptual turn," licensing visual art concerned with the complex relations of form, materiality, and image, to language and thought.

The sonic arts, however, have been less expansive. More often than not, works of sound art concern themselves with the material and perceptual properties of sound. There is much talk of "vibrations," "resonance," "immersion," and "affect." Two rough equivalents in the visual arts are op-art and what we might refer to as "immersive installation." Op-art, which makes use of abstract, optical illusions, had a brief moment of notoriety, peaking in 1965 with the exhibition, *The Responsive Eye*, at MoMA. But op-art has never been an approach that demands (or deserves) serious critical response. One might see it as the last gasp of the "purely" visual, coinciding with minimalism's sly subversions of the paradigmatic acceptances of form and vision. If we no longer consider op-art an important contemporary movement, why present sound works that explore similar territory within the sonic realm?

But more to the point of this summer in New York (and more troublingly), immersive installations, like those of Turrell and Irwin, leverage the features of sound's conventional jurisdiction. A broader survey of this approach might include Olafur Eliasson's *The Weather Project*, at Tate Modern's Turbine Hall in 2003; Ryoji Ikeda's *The Transfinite*, at the Park Avenue Armory in 2011; LaMonte Young and Marian Zazeela's *Dream House*, which has been installed in Tribeca since 1982; or Random International's *Rain Room*, at MoMA, which closed on July 28, 2013, smack dab in the middle of the three months under discussion here. This type of work, which I will deal with as one plank in the platform of the ambient, is more troubling than op-art because, knowingly or not, it avails itself of the traits of sound, as sound is typically construed. This construal is multifarious. Some of its assumptions are more stubbornly

attached to sound than others. In *The Audible Past: Cultural Origins of Sound Reproduction*, Jonathan Sterne describes these assumptions as "the audiovisual litany,"

- hearing is spherical; vision is directional
- hearing immerses its subject; vision offers a perspective
- sounds come to us, but vision travels to its object
- hearing is concerned with interiors; vision is concerned with surfaces
- hearing involves physical contact with the outside world; vision requires distance from it
- hearing places you inside an event; seeing gives you a perspective on the event
- hearing tends toward subjectivity; vision tends toward objectivity
- hearing brings us into the living world; sight moves us toward atrophy and death
- hearing is about affect; vision is about intellect
- hearing is a primarily temporal sense; vision is a primarily spatial sense
- hearing is a sense that immerses us in the world, while vision removes us from it.[1]

Ambience runs down the left-hand column and checks every box of this litany (Sterne also calls it a "balance sheet"): from "spherical," to "places you inside an event," to "brings us into the living world," to affective, temporal, and immersive. Of course, Sterne's intention in presenting this litany is to dismantle it, or, at the very least, to complicate it. Some have joined him in this project of debinarization. Others have retained the dualism, while hoping to reverse the hierarchical positions of sound and sight. Marshall McLuhan and Walter Ong have argued that the left side of Sterne's balance sheet is the preferable column. Veit Erlmann proposes sound as an alternative to the "mirror" model of human knowledge based on a subject's ability to reflect on, and see her reflection in, the natural world. His 2010 book, *Reason and Resonance: A History Of Modern Aurality*, suggests the vibrating string as a substitute metaphor for the mirror. This pairing, of course, provides the title for the exhibition, *The String and The Mirror*, organized by Lawrence Kumpf and Justin Luke. Later, we'll return to the metaphors and the exhibition.

The problem with the embrace of the sonic column of the balance sheet, is that it happens without complication or critique. When I say I worry that the flow I'd hoped to see is moving in the opposite direction, I mean that instead of sound adopting some of the criticality and self-reflection of the past forty-five years of thinking and making in the gallery arts, visual artists and/or visual arts institutions are assuming some of sound's litanous self-beliefs. Surely, if the gallery arts are now willing to welcome sound, they should do so according to the same criteria of quality and engagement that they demand of other media. The kind of optico-centrality of op-art doesn't cut it anymore. One could argue that this disallowance is precisely what licenses immersive installation, which does indeed move away from pure visuality. But, as Sterne and others would suggest, simply trading in optico-centrality for audio-centrality—even in a metaphorical sense—is not necessarily an improvement.

I engage these examples and the issues they raise from the perspective of an artist. Every work of art is a response to the conditions within which it is produced and received. My own work necessarily engages the assumptions and problems inherent to its time and place. What I'm trying to do here is to understand the moment, to match tendencies with their corresponding pretexts, and to question the sequence of events and inclinations that allow these correspondences to emerge. My hope is that seeming inevitabilities will reveal themselves as highly contingent. We must start by questioning sound's traditional entitlements. We must be willing to release some of the claims that license many of sound's most cherished methods, self-beliefs, and meanings. We must be willing to complicate the role and rationale of sound while at the same time complicating sound's relations to, and interactions with, other sensory stimuli. Ultimately, I will argue, artists and audiences need to drop allegiance to any sense, to any material, to any medium and its history. Media, material, and the senses that perceive them, are means to an end. That's not to suggest they are neutral, transparent, or, in any way, natural. As Sterne, again, has shown, these things are also products and producers of distinct histories, saddled with expectations, limitations, and, as we have seen, misapprehensions. We must interrogate what we've previously taken for granted. We deserve an art that is the equal of our information age. Not one that necessarily parrots the age's self-assertions

or modes of dissemination, but an art that is hyper-aware, vigilant, active, engaged, and informed. And it's not as if there is no such art. As an artist, I'm inspired by a host of practitioners who make sound do difficult, real-world work, people like: Johannes Kreidler, Christof Migone, Sharon Hayes, Pussy Riot, Ultra Red, Carey Young, Christopher DeLaurenti, Michelle Rosenberg, Mutlu Çerkez, Nina Katchadourian, James Hoff, Anne Walsh and Chris Kubick, Phil Niblock, G. Douglas Barrett, Marina Rosenfeld. . . . None of these artists have work in the MoMA show (but a few are included in *The String and The Mirror*).

2 Percept—Concept—Precept

I want to place on our table—like a fork, spoon, and knife—a set of three terms/methodologies/values.

1. **Percepts** are objects of perception. I use the term bluntly, but not in an attempt to suggest a lack of sophistication regarding the status of such objects or of perception. For our purposes, this points to artworks concerned primarily with sensory phenomena and their apprehension via the organs of perception.
2. **Concepts** are abstract ideas that create connections between objects or other concepts. I use the term as an allusion to capital C conceptualism in visual art, without mapping, 1:1, to that category. I will insist on small c conceptualisms, plural.
3. **Precepts** are general rules that regulate behavior or thought. I take it for granted that all behaviors ascribe to precepts.

Percept

Douglas Kahn's essay, "Artistic Interoception: Let Me Hear My Body Talk, My Body Talk,"[2] reminds us that James Turrell's pivotal works, the ones that led him down the path he's still on, occurred under the sway of John Cage's example. In fact, Kahn points out, Turrell and Robert Irwin worked in an anechoic chamber as part of the *Art and Technology* project at Los Angeles County Museum of Art (LACMA) in the late 1960s. In the early 1950s, after visiting an anechoic chamber at Harvard, Cage reached the now-famous conclusion that "there is no such thing as silence."[3] Turrell arrived at a parallel conclusion:

> There never is no light—the same way you can go into an anechoic chamber that takes away all sound and you find that there never really is silence because you hear yourself. With light it is much the same—we have that contact to the light within, a contact that we often forget about until we have a lucid dream.[4]

Kahn's essay focuses on the body in the works of Cage, Turrell, Irwin, and William Burroughs: what the body means; the body's role as a producer and/or receiver of signals; the body's status as a component of the subject, as a discrete object, or as an entity that complicates this divide. Following from this, I want to think about how Cage, Turrell, and so many contemporary artists working with sound direct attention toward percepts, toward the sensory conditions of a given time and space. I want to think about how this turn toward a situation's ambience downplays other situational relations: issues of interiority and exteriority, real versus mediated experience, and how these relations instantiate power in one location, one actor, or another.

Perhaps the embrace of sound as a viable medium in the art world is not simply patronizing. Perhaps the problem is not a dearth of curators well-versed in the practitioners and problematics of the field. Perhaps what's happening is that the art world is turning away from what I will call, "linguistic conceptualism," engaged with language and terminological sites, and turning toward an "ambient conceptualism," that discards "hard" materiality, in favor of the "soft" materiality of a-signifying phenomena such as, light, space, and time. If this is the case (and I think it is too early to tell, but I'm vigilant), then the embrace of sound may be evidence of a broader turn toward the ineffability to which sound has always claimed privileged access. To my mind, this would signal the "immaterialization," of the art object, rather than its "dematerialization" (Lippard's term). The former indicates a passive, immersive, ambient experience, while the latter has always meant, for me, a critical response to commodity objects and their attendant fetishisms; a resistance to the prevalent (and often unquestioned) social and political uses of things. I have held out hope that the positive movements of the last forty-five years of art history: linguistic conceptualism, institutional critique, feminism, postcolonialism, relational aesthetics, social practice, etc., would infect sound practice and bring it into phase with the important art of our times. It would pain me (but not surprise me) if, instead, sound is coaxing the art world into a state of nebulous, naive, navel-gazing.

Perhaps, confronted with avalanching evidence of state and corporate corruption, of the theft and cooptation of private communications and online behavior, of base manipulation of societal values for the gain of a select few, the art world would prefer to escape to soothing environments of diffuse light

and sound. Turrell's inchoate spaces of wombessence seem safe from such encroachments. But it's impossible to play possum. While you're in the soft space of light, the NSA and Facebook are still collecting your data. The money in your bank account is still being used to fund who-knows-what without your knowledge or consent. The government you elected is still imprisoning and targeting people with whom you have no beef.

Turrell's spaces and the experiences they are designed to engender implicitly claim privileged access to a condition of being that is purported to live beyond the reach of language. And when I use the blanket term "language" here, I'm indicating an extended matrix of practices that are both the products and producers of signification, including systemizations, structuralisms, images, traditions, processes, narratives, analyses, diagrams, thinking, and so on. I can only think of two reasons why such a condition of being might be valorized. The first is mystical, appealing (or offloading responsibility) to an authority beyond the influence of flesh and blood. There is some comfort to be found in the notion that somewhere, somehow, there is an agency to the universe; that there are reasons for seemingly unreasonable events, that all the trivia and travail of life is not random. The second reason is political: constructing, and then protecting, a position of authority. Those who avow an understanding of the machinations of the cosmos simultaneously grant themselves authority. And so, these two reasons often collapse into one. There are those who possess the key, the ladder, the code, the hotline, the exegetic cipher. And there are those who don't. Negotiating access is the basis of politics. But the mystical force to which the anointed, alone, have access, invariably turns out to "move in mysterious ways." The essence and function of the mystical always exceeds signification. If such a force were transparent in its methods and motivations, then we would have the same access as the gatekeeper, and his power would be lost. We are well-advised to be skeptical of claims of privileged access or of forces that exceed signification. I believe there's plenty that I don't get. Perhaps there are even things that aren't getable. But I don't trust anyone who tells me that they get it, that I can't, and that they would like to favor me with their gotness. These folks are commonly known as "con-artists."

Returning to plain-old artists, it seems to me that sound, as an artistic medium, is particularly prone to implying its own gotness. Or perhaps it's that listeners are prone to infer it. Likely, it's a codependent combination of the two.

Examples of this cited in my previous book, *In The Blink Of An Ear: Toward A Non-Cochlear Sonic Art*, include, Christina Kubisch's electrical walks, in which the wearer of Kubisch's custom headphones is granted access to the "hidden" sounds of the city; and Francisco López's clandestine live set-up, in which the blindfolded audience sits with their backs to López as he manipulates a panoply of audio technology. More recently, I've raised similar concerns regarding Doug Aitken's "Sonic Pavilion."[5] Contemporary sound's presumed privileges are often granted by technology. The artist maintains a knowledge (of gear, of code, of patches) that is not shared with (and sometimes actively withheld from) the audience. More traditionally, sound's privileges have been the product of technical virtuosity and of sound's (or music's) own brand of mysticism: it's ineffability. "Ineffable," in its Latin etymology, means "in-utterable." So, again, we're confronted with conditions of being (technological, mechanical, skill-based, immaterial) that are beyond the reach of language.

My worries about directions of influence, then, are about whether sound will relinquish its claims of ineffability and engage with the truly important and meaningful relations that the gallery arts have engaged in over the past forty-five years (roughly commensurate with Turrell's and Irwin's careers as artists). Just to be clear, what I'm pointing to here are practices that engage issues such as institutional critique, gender politics, economics, the AIDS crisis, foreign policy/cultural imperialism, globalism, philosophy, interpersonal and societal power relations, and the distribution of knowledge. And just to be clearer, I'm not suggesting that these engagements need to be explicit or at the level of content. Much of the work I favor merely displays a kind of self-awareness about its own relation to these issues and does its best to be transparent with regard to its own status and mechanics in the various structures within which it operates.

As I've noted, Turrell and Irwin, to name just two examples, have been at this for forty-five years. So I'm not claiming that their embrace is bandwagon-jumping. Instead, it appears as if, for some reason, critical response may be gravitating toward the ambient side of conceptualism. The upcoming Turrell exhibitions in Los Angeles, Houston, and New York are so well orchestrated—three of the four largest cities in the United States; West Coast, middle America, and East Coast; North and South; blue states and red state—as

to resemble a successful national electoral strategy. Recent *New York Times* articles: a Magazine cover story on Turrell[6] and an Arts Section front-page story on Irwin,[7] speak to the PR machine blowing smoke (eerily lit, no doubt, and indigo) up the trouser legs of art critics, museum board members, and private collectors from sea to shining sea.

I'm not inclined to let the ambient off the hook by calling it something as easily slipped as "escapist." I think the dangers are far stickier than that. What troubles me about López's performances, about Aitken's pavilion, about Turrell's installations, are their implications—that is to say, their knock-on effects—on the audiences and the discourse they attract and simultaneously produce.

I am fond of suggesting to my art school students that the only irreducible component of works of art, the only thing that all works of art produce, are relations: between the artist and the audience, between the artist and the materials, between one audience member and another, between each audience member and the collective audience, between each of these actors and institutions, between the present and history, between one artwork and another. So I believe that a work's effects are real. Art works change things in the world. I'm not talking about toppling governments—not directly anyway. But I do mean that works of art impact the thinking and sensibilities of people and groups of people, and that every human-initiated change in the world begins with a swerve in the thinking and sensibility of a person or a group of people. Art is hardly the only source of such cultural clinamina. But it is a cultural force, like any other.

Concept

Seth Siegelaub did as much as any other individual to import concepts into the art world, although I realize, almost immediately, that this formula is backward. What Siegelaub helped to do was to position art under concepts. This is true in three senses:

1. Rather than being a branch of inquiry focused on materials and their physical and/or perceptual status, art has been, for the past forty years, an inquiry into concepts, as embedded and enunciated in materials. Philosophically, the art

world now appears as a subcategory of conceptualism in the larger human intellectual project.

2. Since 1790, and the publication of Kant's third critique, artists, philosophers, and critics, have struggled to comprehend and to use Kant's notion of "reflective judgment." This is a kind of judgment (i.e., regarding the beautiful) made without preexistent concepts to regulate the faculty of judgment. In other words, unlike, say, logic, aesthetics has no preexisting rules. No one can know in advance, what an artwork must do in order to be judged to be beautiful. Each judgment of the beautiful is taken on a case-by-case basis. The criteria for such judgments are discovered after the judgment. As Kant writes,

> In order to find something good, I must always know what sort of a thing the object ought to be, i.e. I must have a concept of it. But there is no need of this to find a thing beautiful. Flowers, free delineations, outlines intertwined with one another without design and called foliage, have no meaning, depend on no definite concept, and yet they please. The satisfaction of the beautiful must depend on reflection upon an object, leading to any concept (however indefinite).[8]

What Kant calls concepts, I am calling precepts, mostly because I believe them to be socially constructed rules and not transhistorical universals. Still, I am disinclined to allow Kant his sleight of hand, producing after-the-fact criteria for aesthetic judgment. Instead, I would argue that all precepts are, in fact, pre-. That is, they exist prior to judgment. They may not be consciously known, suspended, as they are, in the muddled solutions of psychology, history, cultural conditioning, social identity, economic and political demands. Concepts, in my usage, are free of this Kantian paradox. In the art of the past forty-five years, the term *concept* is used to indicate something not formally in the work, something to which the work ascribes or aspires; an organizing principle, a process of composition, an attitude toward precedents and premises. Siegelaub's great contribution was to shepherd to pasture the fledgling notion that supplemental materials of an art exhibition, things like catalogues and textual descriptions, are not outside the work, but in fact, integral to the work as a construct. Sometimes a Siegelaub exhibition would consist of nothing but supplements—just the catalogue, merely a plan, simply a project description.[9]

The lack of a recognizable art object confirmed that concepts and percepts are mutually dependent.

3. Pragmatically, the art world has bought so completely into conceptualism that there is hardly an important artist or artwork of the past forty years that does not rely significantly on conceptual scaffolding. (Of course, to say that the art world has "bought into" conceptualism is to acknowledge the commodification of practices that, in some cases, were meant to escape the market. So, to declare conceptualism victorious is not to suggest that it has not been injured on its way up.)

To effectively define what I mean by "conceptualism," would be a different (longer) book. But let me begin to refine my use of the term, identifying some of what I mean (and don't mean) when I use it. First, and most importantly, as should already be clear, I think that there are multiple "conceptualisms." Failing to acknowledge this and conflating the various practices that can wear the hat, confuses any argument that employs the term. In addition to the pluralization, I'll insist on a lowercase "c," to distinguish what I'm talking about from the historical movement of capital "C" Conceptual Art. Yet, some of the artists I'll claim as conceptualists would undoubtedly also appear in any history of Conceptual Art. What I'll try to do briefly here is to disentangle capital "C" Conceptual Art from lowercase "c" conceptualism. At the same time, I'll work to distinguish various strands of the lowercase from each other in order to make what I hope will be some useful distinctions.

Even Lucy Lippard's all-too-famous conception of "dematerialization," does too little to really tell us what conceptual art is. It now appears that dematerialized works took at least two distinct forms, followed two distinct strategies. Much writing about conceptual art prioritizes practices that emphasize language as both a producer and product of artistic objects and experiences. This linguistic conceptualism eschews materiality in its entirety, embracing ideas as the fundamental and productive necessities of a work of art. (I would further argue that this linguistic conceptualism forks again, with artists like LeWitt, Bochner, and Kosuth, practising a kind of logical, linguistic conceptualism; and on the other side, folks like Graham, Nauman, and Piper engaged with a more narrative type of linguistic conceptualism.) But, as I've already suggested, there is also a strong strain of ambient conceptualism, which

rejects objects as a form of materiality, pursuing less concrete aspects of bodily and perceptual experience. This would certainly include the work of Irwin and Turrell, for whom light, space, and time are constituent concerns. It's not that these distinctions have never been noted before. But the differences between the linguistic and the ambient have never before seemed so obvious, nor so important.

Conceptual Art—capital C—is often said to refer to art practices, beginning in the late 1960s and early 1970s, that concerned themselves principally with ideas, rather than images or objects. The story goes that artists turned away from material concerns, including, paradigmatically, the mediality of Greenbergian abstract painting, and concerned themselves with the language that motivated, engaged, described, and resulted from works of art. To some, the "Conceptual Turn," in the visual arts, echoed the "Linguistic Turn," in philosophy. As Rosalind Krauss writes in "Sculpture In The Expanded Field,"

> It is obvious that the logic of the space of postmodernist practice is no longer organized around the definition of a given medium on the grounds of material, or, for that matter, the perception of material. It is organized instead though the universe of terms that are felt to be in opposition within a cultural situation. (289)[10]

In the past, I've relied heavily on this quote and on the understandings it represents. But I've now come to think that the transition in question was more complicated. It's not that I disagree with the assertion that the organization of the logic of art in the late 1960s began to rely explicitly on terms in opposition. But Krauss's statement contains a gaping chasm precisely the size and shape of the word "terms." What, exactly, constitutes a term? Is it only a dictionary-accredited word? Or might the terms in opposition also include other units? For instance, might we see the steps of a conventional process as terms capable of productive opposition? Might the moves and countermoves of a given practice's history also be ordered and disordered like terms? Other terminological nominees might include the expectations of a given audience in a given space; or the historical, economic, and ideological components of a presentation situation; or the generally overlooked material substrate(s) of

a medium. The specific differences in how particular practices engage these terminological oppositions are crucially important.

But similarities are also important. One could argue that it is this kind of play with term-units that binds some of the most fruitful art practices of the past forty-five years. To think this through we need to be inclusive with our definition of the word "term." Not only must it designate a lexical unit, but also a temporal unit (a prison term, an academic term, the duration of a contract). It must also indicate the conditions under which action and agreement may occur (the terms of a treaty, a bargain, or a settlement). After all, we speak of things "in terms of" other things, we plan for the "long term," we "come to terms" with our realities and restrictions, we are on "good terms" or "bad terms" with each other. Conceptual art, site-specific practices, institutional critique, performance, body art, relational aesthetics, and social practice—just to name one path through the past five decades—all engage in the displacement of terms. These displacements may be syntagmatic—the reordering of units in their linear, syntactical arrangement—or it may be paradigmatic—the substitution of one term by another that can occupy the same position, yet can also change the semantic, situational, valence of the context. I'm adopting this model from semiotics, of course, but imagining much broader applications: physical, spatial, temporal, methodical, historical, psychological.

For example, the German composer, Johannes Kreidler works from an expanded palette of musical terms. (Perhaps it is time for music to have its "expanded" moment, like sculpture and cinema before it.) As Kreidler says in the video documentation of his piece *Product Placements*,

> For me, music never exists alone; a composer must always deal with interrelationships. Music deals with technology and the politics of technology, with consumption behavior, and the cultural and economic value of art. These things play a role in my creative work; I use them as artistic material.[11]

Kreidler's approach is never more evident than in his 2009 piece, *Fremdarbeit* (Outsourcing), commissioned by the Klangwerkstatt Berlin contemporary music festival. Kreidler, who was paid €1,500 for the composition, outsourced

the compositional labor. He hired X. Xiang, a Beijing-based composer-for-hire who writes music for weddings, parties, and other occasions. Xiang was provided with a number of Kreidler's recent compositions and asked to compose something in the same style for the specific instrumentation of the Ensemble Mosaik, who would perform the piece at the festival. Xiang was paid the equivalent of $30. Kreidler then hired, R. Murraybay, an Indian computer programmer, supplying him with the same compositions he'd given to Xiang. Murraybay analyzed Kreidler's compositions and concluded that they consisted of 25 percent samples, 70 percent of which were pop music, 20 percent speech, and 10 percent classical. Of the remaining 75 percent, 53 percent were "pointilisitic" and 23 percent "linear," the remainder being "indefinable." In Murraybay's analysis, moderate volumes accounted for "ca. 46%" of the compositions, loud volumes accounted for 39 percent, and quiet volumes 15 percent. Murraybay's analysis yielded an algorithm that generated *Fremdarbeit*'s second movement. Murraybay was paid the equivalent of $15.[12] When *Fremdarbeit* is performed, Kreidler is present to moderate, introducing each movement and giving the details I've outlined above. At one point Murraybay's score moves beyond the piano's range. The ensemble stops, to allow Kreidler to explain what happened, and then picks up again where the score returns to the piano's playable range.

The terms that are felt to be in opposition within this cultural situation are numerous and diverse. The title and the compositional method indicate a friction between nation-states and cultures occupying different positions in the circuits of global commerce and influence. The divide that separates a German festival of *neue musik* from the realities of a Chinese composer is vast. The task for Xiang was daunting. His conservatory-training has prepared him to write utilitarian music for social functions. The idea of "autonomous art" or "absolute music" is an alien concept. As Kreidler explains, "The Western avant-garde was [a] new genre for him."[13] But before we insert "the Western avant-garde" and "the Chinese composer-for-hire" into readymade slots on the global culture game board, let's test how much play is built into these terms. Kreidler, the avant-garde composer, was just as hired as Xiang. Sure, we say "commissioned," rather than "hired." Still, one might argue, Xiang was saddled with a host of restrictions on the style, duration, and instrumentation of the music he was to compose. But so was Kreidler. The instrumentation was set by

the commission: that of the Ensemble Mosaik. The duration was determined by the festival program. And the style was undoubtedly hemmed in on all sides: by the pre-1960 music that Kreidler's style must assiduously avoid, by the strands of post-1960 music that Kreidler may use in carefully determined proportions so as to signify expertise without betraying servility, and by the precedents of his own style: arguably a heavier burden for him to bear than for Xiang.

All these terms are severely elasticized by their activation in *Fremdarbeit*. The tensions between these terms are torqued to uncomfortable extremes. On Kreidler's website, the video documentation of the premiere performance shows a member of the audience interrupting Kreidler during one of his spoken moderations. The man yells, "I'm sorry, but what you're doing is nothing but exploitation."[14] It's a fair enough criticism. As with the work of a visual artist like Santiago Sierra, Kreidler's bald-faced presentation of global capitalism's abuses doesn't absolve him of complicity. But *Fremdarbeit* slips between the clenching grasp of easy indictment by making its complicity so conspicuous. The euro and dollar figures are all revealed to the audience, who are left to consider the price they paid for their concert tickets or festival passes. Who have they paid? And for what? Kreidler's presumed cultural superiority is flaunted, only to force the audience—there in the hall—but also anyone else made aware of the piece's details (me and, now, you) to question where this presumption is generated. In retrospect, when the method of *Fremdarbeit*'s composition was revealed to us, were we a little bit smug about this "Chinese composer" and this "Indian programmer," we, the enlightened, progressive, Western audience of the avant-garde, of *neue musik*?

What's more, the mode of presentation of the critical information about the compositional method becomes part of the performance, part of the composition. The piece is not "absolute music" in any sense, it is utterly dependent on its frame, on the explanatory notes delivered live by Kreidler, and on the conventions and expectations of the compositional tradition and of *neue musik*. Our presumptions regarding the values of art and music in our cultural tradition versus those of China or India, are undermined by this composition that relies so heavily on these very same presumptions. The piece depends upon the tension between Western, autonomous music and Eastern, functional music; between spirit and labor—as if this dichotomy could withstand scrutiny.

Yet, here, in working through the latter to produce the former, the autonomy of the composition is sacrificed to its dependence on its frame and the functional disclosure of its collusion with the globalized exploitation of labor. At the same time, the humor of Murraybay's analysis of Kreidler's music is predicated on our certainty that serious music can't be so ham-fistedly quantified. Fifty-three percent of the compositions were "pointilisitic!" The foundation of this certainty is that serious music is not beholden to such earthbound exigencies as politics or economics, nor is it the product of a cultural machine grinding gears across historical epochs to churn out the excreta/disjecta of human civilizations. Yet, *Fremdarbeit* is clearly a machine, its device bared. The products of the "machine-like" training of the Chinese composer, and the machine-made process of the Indian programmer each substitute adequately for an authentic "Kreidler composition." At the same time, the musical material is clearly devalued as but one unit in this demolition derby of terms. *Fremdarbeit* may be a commissioned composition, but just as surely, it decommissions the act of composition, like removing a sub from a fleet.

When I call for an engaged art, this is what I mean. Engagement does not need to be explicit or at the level of content. I'm not suggesting that every work of art needs to be "about" global capitalism or the AIDS epidemic or economic inequality or war or global warming or gun violence. What I'm asking for is an art that doesn't pretend that these realities don't exist; an art that acknowledges that the same societal systems and the same institutional reasons that license "stand your ground" laws and climate change denial, also authorize the norms of artistic encounter and the frameworks that sanction most varieties and strata of artistic experience. As I've written above, such work displays a kind of self-awareness about its own relation to these issues and does its best to be transparent with regard to its own status and mechanics in the various structures within which it operates.

Precept

On a Guggenheim wall, vinyl lettering presents a quote from Turrell: "My art deals with light itself. It's not the bearer of the revelation—it is the revelation." It's impossible to avoid the biblical implications of this statement. Turrell

with his equally unavoidably biblical beard, casts himself in the role of Maker: dispensing light and seeing that it is good. I don't really care about his (or anyone else's) delusions of divinity. What strikes me as more problematic, artistically and philosophically, are the word "itself" and the phrase "it is the revelation." The implication of the *itself* and of that *it* being, not bearing, revelation, is that this *it* is something essential, something without precedent, without cause. The quote suggests that Turrell's light is self-evident. It depends on no physical or conceptual substrate because it emerges *ex nihilo*. It requires no preconditions. It neither requires nor offers explanations. It simply is. This "simply is" supplies the most common and most problematic precept for thinking about and working with sound. Elsewhere, leaning on Derrida's critique of what he calls "the metaphysics of presence," I've argued that this "simply is," this self-evidence, is a fantasy.[15]

And this fantasy marks the precise point of breach in the self-understandings of sound, on the one hand, and practices like Turrell's, on the other. The "simply is" that sound has long claimed as its own is siphoned by Turrell and his light. It flows through and around the title of the exhibition, *ambient*. Again, without playing chicken and egg, it's hard to avoid feeling that all this seeping and emanating and oozing of light and sound have something to do with each other. In his 2011 essay, "The Theology of Sound: A Critique of Orality,"[16] Jonathan Sterne subjects sound's "simply is" precepts to a much-deserved interrogation. Sterne exhumes the Christian origins of sound's presumed self-presence, questioning the accepted opposition of orality and literacy. Traditionally, the former is bodily, interior, affective, closer to the spirit, and temporal, while the latter is intellectual, exterior, rational, distanced from the spirit, and spatial. Orality and, by association, sound, are natural, primary, and god-given, while literacy is artificial, once removed, and man-made. Sterne examines the announcement of a privileged, resurgent orality in the work of two influential Canadian academics: media theorist, Marshall McLuhan and, the Jesuit priest and cultural historian, Walter Ong, whose pronouncements on orality have been widely adopted. Sterne concludes that the aim of Ong's work on orality was specifically intended "to better understand the conditions under which it was possible for people to hear the word of God in his age."[17] In the second half of the twentieth century, Ong believed that—via technology—Western,

Christian societies were entering into a second, and superior (for being Christian), era of orality. Much of Ong's work emanates from and hinges on a theological distinction between *spirit*, associated with Hebrew thought, and *letter*, associated with the ancient Greeks. As a result of this distinction,

> Ong's "oral man" . . . lived in a dynamic, ephemeral, and engaged world shaped by sound as an event, where the power of words is carried in their sound. Ong's "literate man" . . . lived in a world defined by sight and oriented toward distance, objectivity, rationalism, disembodiment, and form, where words derive their power from being seen.[18]

Sterne draws attention to Ong's and McLuhan's hierarchical evolutionary model of societal progress. From the "pre-Christian" civilizations of the Hebrews and the Greeks, we move to the pinnacle of spiritual advancement in Catholicism. In addition to the temporal prejudice built into the championing of orality, there is a strange geographic prejudice that allows present-day, non-white societies to slip through a trapdoor into a pre-Christian past. Sterne notes that McLuhan explicitly equates modern, non-Western, non-white peoples with ancient preliterate societies. Contemporary white societies and contemporary non-white societies are presented as living in differently evolved epochs. So, not only is orality closer to god, but Christian orality is separated from primitive oralities and preserved as evidence of the superiority of white, Western people. As Sterne notes,

> The denial of coevalness is an inherently political gesture: it perpetuates an unexamined acceptance of Whiteness and White experience as the default categories of experience.[19]

There are two problematic precepts built into McLuhan's and Ong's privileging of orality (the word as sound) over literacy (the word as graphical unit). These are the same two problems I pointed out above. The first is that this ranking is based on a mystical appeal to an authority beyond the influence of flesh and blood. The second problem is political: once the mystical source is asserted, the gatekeepers construct for themselves, and then protect, a position of authority. These two problems often collapse into one: we are people of God (not your god), we know things you don't know, and we are better for it. There are those who possess the key and those who don't. It bears repeating: negotiating access

is the basis of politics. Much of the often-unspoken, sometimes unconscious, dispensation afforded to sound, is motivated by the same mystical and political impulses evident in Ong and McLuhan. This is not to say that those who think about sound in these ways are making conscious grabs for mystical power; just that the precepts of sound are too often accepted without the requisite skepticism.

Sterne is right to demand that we set ourselves the task of thinking about the precepts of media and culture without recourse to mysticism and with full cognizance of human impulses to acquire and maintain power over access to information.

> For those of us who do not believe the work of communication studies is identical to the project of the church, we must ask how appropriate the orality-literacy model really is for more secular cultural theory and cultural history. Ong's understanding of culture brackets questions of power, agency, and ultimately the human role in human history, instead searching for pathways to the divine.[20]

In the late-capitalist, post-Enlightenment, technocentric environment of Western culture, we're persuaded to cloak our mysticism in nonstandard vestments. Rather than the gilded robes of prelates, we're more likely to dress our transcendent inclinations in the idiolect of scientism and methodical diagrams. We call our religiosity "auratic" or "ethereal" or "ambient," allowing ourselves to sidestep questions of dogma and divinity. Or we call it "natural," disavowing mystical implications altogether. In either case, transhistorical and transcultural essences cling parasitically to the hindquarters of our rationality. Sound simply is.

The "simply is" of sound is joined in this contemporary moment by a resurgence of realist and materialist philosophies. Speculative Realism, a movement that coalesced and gained a name at a conference in 2007, is concerned largely with two significant objections to the Continental philosophy that precedes it. The first of these has to do with what Quentin Meillassoux has dubbed "correlationism," and/or what Graham Harman calls "philosophies of access," including hardcore idealism and skepticism about our ability to know things in the world outside of human apparatus and anthropocentric

modes of thinking. The second objection is directed at relational models of ontology or epistemology claiming that entities and our knowledge of them require contextualization; that their being and their meaning are dependent upon how they relate to other entities. Among the thinkers who are attached to Speculative Realism, there is a spectrum of opinion on both these issues and a fair amount of disagreement and debate. But in some respect, all these thinkers are, at the very least, concerned with these problems. The realism in Speculative Realism contends that entities in the world have discrete ontologies and are not wholly dependent on their relations to other entities, least of all on perceiving human minds.

This thinking, and the related but not synonymous movement, Object-Oriented Ontology, takes inspiration from a number of against-the-grain thinkers of the last half-century. Notably, a zigzag line can be drawn through Gilles Deleuze, Manuel De Landa, Alain Badiou, Bruno Latour, and François Laruelle—accepting certain tenets of each thinker's project, modifying some, and rejecting others—to establish an inheritance of terms and concepts. Later, when I cast a scrutinizing ear toward ambience, I will discuss, in some detail, the object-oriented philosophy of Timothy Morton. Here, I will acknowledge the important contributions that the philosopher Christoph Cox has made to materialist thinking about sound. No one has more clearly annunciated the realist demands of the sonic. Cox is not strictly aligned with either Speculative Realism or object-oriented thought. But his ideas do resonate in significant ways with those of philosophers connected to these movements. Although Cox is more inclined than Ray Brassier and Meillassoux to accept a DeLandian reading of Deleuze as a committed realist, he shares their rejection of the object-oriented claim that real objects "withdraw" from the access of other entities. So, he rails against the compulsion to place sound under the exegetic rubric of textuality and discourse, arguing that the ascendant literary- and art-theoretical models of the past four decades are at odds to account for the divergent behavior and ontology of sound. In a number of eloquent and influential essays, Cox has been at the forefront of a newly recuperated materialist sonic philosophy. As Cox has written,

> A rigorous critique of representation would altogether eliminate the dual planes of culture/nature, human/non-human, sign/world, text/matter,

not in the manner of Hegel, toward an idealism that would construe all of being as mental, but in the manner of Nietzsche and Deleuze, toward a thoroughgoing materialism that would construe human symbolic life as a specific instance of the transformative process to be found throughout the natural world.[21]

Cox suggests that the near absence of rigorous theorization of sound in contemporary aesthetic discourse is due to the fact that the tools available to literary theory and art history are insufficient to account for the materiality of sound. I would argue, however, that the dearth of good thinking and writing on this subject is not the tools' fault, but a by-product of the field's nascency. Sure, the tools need to be adapted, the methods retrofitted, but if we apply discursivity in the expanded sense I've offered above, then the tools at hand are capable of deep, expository examinations of the sonic arts.

Still, I want to respond to two assertions Cox has made in a recent essay. My quibbles here reside at the level of method, but as is nearly always true, methodology both reflects the precepts in place and restricts the possible outcomes of their application. Cox's philosophy is presented, largely, as an attempt to rethink the phenomena of the world, and human beings' place in the world, without reflexively falling back on anthropocentricism. One of the principal moves, then, is to avoid claims of objectivity, separateness, or godlike perspectives from which to judge phenomena. He takes issue with his own discipline, philosophy, for conceiving of itself as "the 'queen of the sciences,' claiming the ability to reveal what its object cannot reveal about itself."[22] On this point, Cox and I agree. The terms I utilize to activate an engagement with works of art are not master keys. Discourse is not a master discourse. I acknowledge, as both an artist and a critic, that I cannot remove myself from the objects of my work. I am incontrovertibly entangled with them. Both they and I are compromised. So, I acknowledge this predicament and take it on board as one of the responsibilities of my practice. Cox, though, in his discussion of sound, slips back in to hierarchizing habits. Following Schopenhauer and Nietzsche, he asserts that

> the sonic flux is not just one flow among many; it deserves special status insofar as it so elegantly and forcefully models and manifests the myriad fluxes that constitute the natural world.[23]

It's unclear, here, whether Cox is speaking figuratively or literally. Is sound the master metaphor that *models* a thinking of flux? Or is it, somehow, the activating flux that *manifests* fluxness? Why not water, which comprises most of us and the planet's surface; which sustains nearly all life on earth? In any case, this ordering puts Cox, as author, as philosopher, back in the driver's seat that he wants to abdicate. And, once again, it grants sound special status.

Additionally, if one holds that objects in the world (or flux or energy or flow) are independent of, and indifferent to, signifying systems, then doesn't it follow that the thinker of these thoughts should refrain from expressing them by means of signifying systems? If one believes, as Deleuze does, that signification is a symptom of modernity's anthropocentric epidemic, and that it is responsible for many of the species' and the planet's ills, it seems to me that the only appropriate response is to engage the flux of the universe via other nonsignifying fluxes. Cox might reply that, as humans, we are beings that process the universe by thinking it (and writing it). As plants photosynthesize, as DNA relays genetic material, as the atmosphere extracts water from the sea and deposits it on the land, we reflect, deliberate, and contemplate; we discuss, debate, and disagree. Naturally, then, we think and write flux. Fair enough. But doesn't this allow for an anthropomorphism, minus the anthropocentricism? Merely bringing the world across our perceptual transom anthropomorphizes it. Vibrations bound through the universe across a vast spectrum of frequencies. What we call "sound" is just a sliver of that spectrum, carved out by human capacities and named as if it is ought to be recognized by all of nature. Yet, while human "sound" resides between 20 and 20,000 Hz, feline "sound" ranges from 55 to 79,000 Hz, and bat "sound" extends from 1,000 to 200,000 Hz. It seems futile to deny that, intentionally and not, we form the phenomena of the universe simply by perceiving it. Sound is literally compressed and contorted through the ear canal. High frequencies register at one location in the ear, while lower frequencies must travel farther, through differently shaped and sized anatomy to reach their receptors. Why deny this inevitable anthropomorphizing, this human shaping of phenomena, in order to avoid the whiff of anthropocentricism? Couldn't we acknowledge it, reckon with its effects and the prejudices it might engender, and then work assiduously to resist the temptations of the anthropocentric? Might we not allow that human processes

can interact with other natural processes in productive, nondestructive ways? Regardless of its acknowledgment in doing so, materialism is forced to start from this position, permitting itself the presumptuousness of judgments and declarations, of representation and signification, while diligently locating its analyses in materials bigger than both an individual human's perspective and the apparatus of humanity's cultural and classificatory discrimination.

Behind these questions lurks a more fundamental question: Do phenomena, including artistic phenomena, demand human reception? Can the artwork get along without us? The *New York Times*' critic, Roberta Smith, closes a review of Turrell's Guggenheim exhibition with this observation about its main feature, a new installation, called *Aten Reign*, which fills the museum's spiraling, central rotunda from bottom to top:

> These visual reveries give the Guggenheim exhibition a surprise ending. As your eyes become alive to both the work's mysteries and its self-evident simplicity, it is possible to sense a quiet renunciation of *Aten Reign*, with its gorgeous effects and hidden mechanisms. You may not care, but it is there.[24]

Does your caring—not only of both "you," the individual subject and "you," the human mind, but also of your caring (a Heideggerean term, and a camouflaged Kantian notion)—mean diddly-squat to the universe? Can your caring change anything? Is caring a form of anthropomorphism, fitting the world to human capacities? I insist, for reasons that have nothing to do with me or my individual caring, that works of art court our caring. This is why I've spent the last few years thrashing at sound's "it-is-what-it-is-ness" like a man clawing at the lid of the coffin from the inside. The "gorgeous effects and hidden mechanisms" of Turrell's installation are precisely the ambient features of too much sound art these days. We see and hear our fair share of it at MoMA's *Soundings* exhibition. It is not enough for the work to "be there." One must be attentive to, and responsible for, the conduct of one's relationships. And this goes for "ones" who are humans, and "ones" that are artworks, books, institutions, actions, attitudes, behaviors, stones, storms, and dreams.

3 Against Ambience

Let the record show that, as I write this, I am listening to Brian Eno's *Ambient 1: Music For Airports* (Editions EG, 1978). What follows is an attempt to disenvelop the term "ambient," as a modifier of art practices. Three occurrences, in particular, suggest themselves as significantly unique—yet interrelated—employments of the term: Eno's coinage in the mid-1970s; the phrase "ambient poetics," which Timothy Morton has been using since the early 2000s; and the 2013 exhibition, *ambient* (lower case a), at Tanya Bonakdar Gallery.

The press release for *ambient*, the exhibition, opens with the old saw: Brian Eno is stuck in his sickbed. The volume of the music playing in his room is too low. Eno struggles to make out the music amidst competing sounds. And Eno discovers a new way to listen:

> This presented what was for me a new way of hearing music—as part of the ambience of the environment just as the colour of the light and the sound of the rain were parts of that ambience.[25]

This story has always struck me as the complement of Cage's anechoic episode. Like Cage, Eno discovers a new aesthetic experience in disavowing the distinction between foreground/music and background/noise.

Eno's story (and Cage's) is a creation myth, positioned chronologically prior to the work it licenses, but provided to its audience retroactively as *ex post facto* exegesis. The *ambient* press release proposes the term "speculatively," wondering if Eno's model of an artistic experience that bobs above and below the threshold of the listener's attention, might supply a useful interpretation of "contemporary ways of looking" at art in a "postindustrial paradigm."[26] Again, it seems to me that the confluence of this show, Turrell at the Guggenheim, Irwin at the Whitney, *The String and The Mirror* at Lisa Cooley, *Soundings* at MoMA, and Cardiff at the Met, points to a moment in the New York art world. I'm willing to adopt Tim Griffin's title and call it an "ambient" moment.

In the press release, Griffin further leverages Eno's liner notes for *Discreet Music* (the source of the sick bed listening story), likening the included signal path diagram to Olafur Eliasson's claim that his work initiates an act of "seeing

yourself seeing."[27] Turrell uses the identical formulation to describe one of the effects of his work. (In a conversation I had with James Hoff about the Turrell exhibition and the arrival of this "ambient moment," Hoff astutely noted that Eliasson is likely the artist most responsible for preparing the ground for a revival of interest in Turrell's and Irwin's original light and space investigations.)

But it's worth testing this analogy between Eno's diagram for *Discreet Music* and Eliasson's/Turrell's notion of "seeing yourself seeing." Eno's signal path feeds a signal from a "synthesizer with digital recall system" through a graphic equalizer and echo unit before reaching two tape recorders. The first records and the second plays back, through a delay return, to a combined monitor output. (An image search for "Eno Discreet Music" will yield the diagram.)[28] Seeing implies a seer in a passive or, at least, a receiving role. The phrase suggests that one is seeing as one normally would, with the additional, perceptual or, perhaps, intellectual, awareness of the activity of seeing. Rather than invoking the tired trope that, contra seeing, listening is active and constructive, I want to investigate what kinds of perception and awareness are present in the *Discreet Music* signal path. Eno's system begins not in passivity or receptivity, but with an active transmission, "in this case, two simple and mutually compatible melodic lines of different duration stored on a digital recall system."[29] Nor is the listener's experience of the sonic product of Eno's system made uniquely aware of itself. *Discreet Music* is an album of music, not so different as a species of experience from the Pachelbel it samples, nor, for that matter, from Pink Floyd or Public Enemy. The system alters the listening experience of precisely one listener: Eno. Only he hears the input *and* the output. Only Eno can listen to himself listening. The rest of us just listen. "Seeing yourself seeing" invokes a kind of inward turn characteristic of meditative practices while also responding to perception, not with critical questions about what is being seen but with a compounded perception that amounts to a feedback loop that does not resemble that of Eno. The feedback of the Spectacle reflects itself reflecting. The ambient, in both its sonic and visual incarnations, describes a closed system. The sites of transmission and reception are identical. Nothing changes, nothing moves. It is ascetic and abstinent. Its apparent (desired) purity is but an abnegation of participation in the social, communicative, and critical realms.

Perhaps Griffin was thinking of the tape loops at the end of Eno's signal path. To be frank, the diagram is not entirely clear. It seems to depict a signal being recorded on the first of two tape machines. The tape then travels to a second machine that plays back the recorded signal. This recording is then delayed (either electronically, or simply by dint of the additional distance it must travel before being amplified) before joining the initial signal. The result is a phased (and continuously phasing) canon of original and copy, of x and $x + t$ (where t is time). But if this is where the perception of perception supposedly occurs, in this looping of material back upon itself, we have a different sort of problem. This would conflate human perception with technological reproduction. The only entity, other than Eno, in a position to perceive itself perceiving would be the tape recorders. Yet, as Friedrich Kittler has argued, the radical innovation of recording technology is precisely its lack of awareness, its agnosticism regarding input. Data are neutral, Kittler would say. Being aware of its content is beyond technology's remit. Presumably, being aware of its own processes would be an inconceivable outcome.

Contemporary materialism and realism might take issue with Kittler. Some might contend that the tape machines, too, have a kind of awareness. Their states of being both affect and are affected by, the input and output. An object-oriented philosopher might argue that this affect is synonymous with awareness. Human consciousness is nothing more than a surface of registration. It is not a special case. Human consciousness, magnetic tape, the rings of a tree, DNA, sand dunes, paintings, and kisses are all surfaces of registration, none privileged relative to the others. It is here that Timothy Morton locates the ambience of his "ambient poetics." For Morton, we are living in the anthropocene, the first epoch of the Earth's history in which human beings are altering the material reality of the planet. As a result, we have a duty to engage the planet as a discrete entity whose being is owed the same ethical considerations as human beings are. Likewise, all entities command equal status. For Morton, ambience is a state of awareness and conduct, a kind of immersion in, and with, other entities, and with the entity of all these entities together. Unlike some of his colleagues in object-oriented philosophy, his thinking retains a degree of influence from prior Continental philosophy—particularly some tenets of Derridean deconstruction.

While he allies himself with Derrida's critique of the metaphysics of presence, Morton approaches the problem in unique ways. He asserts that philosophy has traditionally been preoccupied with discovering the line that separates being from appearing, and with inventing the necessary scissors to cut along that line. But Morton insists that being and appearing are insuperably entwined. There is no line. Scissors are of no use. Instead, Morton suggests that entities are essentially contradictory: they are *both* and *neither* beings and/nor appearances. This *and/nor-ness* manifests itself as an intrinsic, ontological gap. Unlike many less careful than he is, when Morton uses the term "ambient," he is not suggesting an undifferentiated wholeness. Rather, ambience is an experience of nowness that does not imply singularity or consistency. On the contrary, it is multiply multiple: every entity is already double—being and appearance—and ambience contains a proliferation of entities.

At times, Morton's description of ambience sounds like a form of site specificity: "The *atmosphere* in which the message exists—its ambience—is a significant element of its meaning. In fact, its context *is* its meaning."[30] Morton alludes to Roman Jakobson's notion of "contact" in language. Contact is the activating context of performative statements like, "a spell, a mantra or the 'so be it' of 'Amen.'"[31] The phrase, "I do," can mean many things, but it only enters its speaker into marriage when spoken in a specific and recognized context. Morton describes one feature of ambient poetry as "contact as content." The atmosphere of the poem is its message. That message is often about, and designated by, minimal signification. And, just as the *ambient* press release evokes Eno when it references stimuli that occur "at or just beneath the threshold of perception,"[32] Morton, too, locates the origin of the environment/content of the ambient poem in Eno's sickbed:

> Eno's gramophone was just barely audible. So in the same way ambient poetry makes certain features of reality just perceptible (but nevertheless, they are perceptible). . . . This is a minimized degree of speech, not a metaphysical zero-degree (a structuralist concept) but an *infinitesimal* degree.[33]

This *infinitesimal* degree has other effects. Eno claims that the ambient allows him, the composer, to "become an audience to the results."[34] Later, he defines

ambient as music that aims "to reward attention, but not (be) so strict as to demand it."[35] In all these claims, from "seeing oneself seeing" to minimal perceptual stimuli, to artist-as-audience, to low demands on attention, there is a common thread. Ambience is an artistic mode of passivity. Its politics, that is, the kind of relation it fosters with the world in which it exists, is content to let other events and entities wash over it, unperturbed. Ambience offers no resistance.

However, it is not viable to claim that context (or contact) is the whole of content; that the work is identical with the world in which it exists. This would collapse discrete entities back into a primordial wholeness that doesn't allow differentiation. And, while differentiation is always a dangerous operation, it is a necessary risk. Critical judgment, ethical choices, and everyday decisions are its offspring. Morton recognizes this and distances himself from Deleuzean-derived theories of material monism:[36]

> If everything really is just atoms, or just some kind of fudge, or just rhizomes, or just . . . you know the philosophical anxiety: I've got to get it down to nothing but atoms or rhizomes or fudge or some kind of thing, that's underneath what's appearing, then I have no criteria. If, on the other hand I think that there is an intrinsic gap . . . if there's that gap, then there is such a thing as worthiness.[37]

What's striking about this is that Morton's version of ambience is not all-encompassing. It is not "some kind of fudge." In Morton's ambience, entities have a strangely convoluted double-existence. They are both beings and appearances. This *and/nor-ness* is responsible for what Morton calls a gap. Elsewhere, he describes entities as strange loops, simultaneously constituted and corrupted by the codependence of being and appearance. Morton's ambience, then, is hopelessly interstitial. Rather than suggesting expanse, it suggests expenditure, the exhaustion of its own ontological status. One wonders if Morton's ambience even qualifies as an ontological description. Or is it, more effectively, and more accurately, an ethics, a pragmatics?

The *ambient* press release suggests that there is also a pragmatic ethics at work in Eno's conception of the ambient, suggesting that ambience "may usefully be expanded today," to supply a model of "contemporary ways of looking" at art in a "postindustrial paradigm."[38] "Usefully expanded" here,

presumably refers to a new ethics of interaction with images and objects. But there are two distinct impulses embedded in Eno's liner notes for *Discreet Music*. To test the pragmatic ethics of ambience, we'll need to separate these impulses to see if they support, ignore, or cancel each other. On the one hand, the sickbed episode imagines a new mode of aesthetic perception. The artistic material surfs the threshold of perception, mingling with other environmental stimuli. The listener, rather than fighting to discern the former from the latter, accepts their symbiosis. Of course, this is always more or less true. Art never takes place in a vacuum. Listeners and spectators always have to negotiate the work and its environment. All art is inevitably, often unintentionally, site specific. The ambient, however, foregrounds a devaluation of foregrounding.

Let's hold that contradiction in abeyance for a moment and think about the second ambient impulse. Eno's diagram depicts a system that takes individual compositional decisions out of the hands of the composer. Instead, the composer merely designs the system, selects some basic input, and lets the system run. Eno describes it as a system "that, once set into operation, could create music with little or no intervention on my part."[39] Sounds familiar?

> The completed work is fundamentally parsimonious and systematically self-exhausting.[40]
> —Mel Bochner, "The Serial Attitude," 1967

> Though I may have the pleasure of discovering musical processes and composing the musical material to run through them, once the process is set up an loaded it runs by itself.[41]
> —Steve Reich, "Music As A Gradual Process," 1968

> The process is mechanical and should not be tampered with. It should run its course.[42]
> —Sol LeWitt, "Sentences On Conceptual Art," 1969

Eno's ambient system is nothing if not a technically enabled conceptual process. As such, it is not a matter of turning down the volume of author-supplied stimuli. Neither is it a matter of diminishing the disparity between foreground and background. Nor is it a matter of celebrating the already-present stimuli of the environment. The listener's experience is still focused

on the present (and presented) audible material of the composition. So, while the first impulse is about a modification of the values and focus of an artistic listening experience, the second is about a modification of the methods of composition. The first impulse changes the expectations and behaviors of the audience. The second impulse changes the expectations and behaviors of the composer. But Eno's ambient recordings do not succeed at instituting impulse one. I can listen to *Ambient 1: Music For Airports* at high volume. I can hum Robert Wyatt's piano parts from the first track, "1:1." Regardless of inspiration or process, the ambient recordings are capable of being the foreground. Only the listener can adjust the listening volume to recreate Eno's sickbed experience. But this can be accomplished just as successfully with *Black Sabbath*, Merzbow's *Venereology*, or Nixon's White House tapes.

Returning to the contradiction of ambient's foregrounding of the devaluing of foregrounding, Eno's compositional withdrawal runs into a similar problem. He claims that the system relegates him to the role of "an audience to the results."[43] But, of course, it doesn't. Eno's name (not yours or mine) is on the cover. The system's design is his. He has chosen the materials to feed into the system. He has decided whether the results are satisfactory for release. And in his lecture-cum-essay "The Studio As Compositional Tool," he describes making postproduction changes to the recordings prior to release. Perhaps most importantly, Eno is the composer of the creative decision to make music in this manner. One of the most often misidentified innovations of Eno's method is the reorientation of the composer's attention. Rather than concerning himself predominantly with the conventionally musical material of his ambient compositions, or to the Cagean sounds of the listening environment, Eno's attention is devoted to a process and to the principles of chance, repetition, and phasing. Ultimately, what Eno composes in his ambient works (and with the narrative that authorizes them) is new compositional values and methods. This isn't exactly listening to yourself listening. It's more like *reading* yourself listening.

Eno elaborates on these values and methods in "The Studio As Compositional Tool."[44] Delivered in 1979 as part of *New Music, New York*, at the Kitchen (where Tim Griffin is now executive director), this talk details some of Eno's compositional and recording methods. It describes a way of working

with sound that does not start from an effort to capture a performance with a recording medium. Rather, Eno proposes building musical compositions in the studio from the ground up. As Eno puts it,

> You're working directly with sound, and there's no transmission loss between you and the sound—you handle it. It puts the composer in the identical position of the painter—he's [sic] working directly with a material, working directly onto a substance, and he always retains the options to chop and change, to paint a bit out, add a piece, etc.[45]

By "transmission loss," Eno means not only the gaps between a composer's intentions and the available notational and instrumental tools, but also the gap between composer and conductor, between conductor and players. But surely, some of these gaps exist in a studio-composed process too. And Eno is smart enough to acknowledge that fewer gaps don't necessarily mean better music. He zeroes in on how the possibilities afforded by the studio can reorganize a set of musical values. He contrasts "the 50s concept of music" in which "the melodic information is mixed very loud . . . and the rhythmic information is mixed rather quietly," with 1970s music, "where the rhythm instruments, particularly the bass drum and bass, suddenly become the important instruments in the mix."[46] Eno pinpoints the moment of this transition in the mix of Sly and The Family Stone's 1973 album, *Fresh*.

4 Sight—Site—*Zeit*

How do you form it? It doesn't form like clay where you form it with the hand. It doesn't form like hot wax. You don't carve it away like wood or with stone. So, getting to work with it is almost like making the instrument that helps you form it. So it's almost like sound, like music.

—James Turrell, on working with light,
on *Charlie Rose*, July 1, 2013[47]

For the Fourth of July, 2013, my wife and daughter and I stayed at the apartment of our friends Sarah, Joe, and Aaron. We stood on their balcony and watched what is reputed to be the largest fireworks display in the United States: over 40,000 individual explosions over the Hudson river. The following day, we visited the Turrell exhibition at the Guggenheim. On July 7, 2013, from the same balcony, we watched heat lightning caroming across the sky over the northern suburbs. The following day, we visited the exhibition, *ambient*, at Tanya Bonakdar Gallery in Chelsea. Neatly, these events create four adjacent instances for thinking about recent tendencies in the art world. It is from their similarities, their common conditions, that I'll begin.

Two of these four events, as you'll notice, are art exhibitions. Two are not. Of the two exhibitions, one focuses on the work of a single artist whose work presents "quiet, almost reverential atmospheres, [that] celebrate the optical and emotional effects of luminosity."[48] The other, a group show, invokes Brian Eno's category of ambient music as a precedent for a show of "dislocations and relaxations of authorship and quasi-reversals of figure and landscape."[49] Of the two that are not exhibitions, one is a natural phenomenon, one is not. All four events involve a shift in focus from objects, per se, to perception itself and/or the conditions of perception, as in "seeing yourself seeing." Eliasson looms over *ambient* in the form of six included pieces. Similarly, fireworks and lightning allow us to see light not as an illuminator of other things, but as a discrete and visible phenomenon unto itself. In the cases of Turrell, fireworks, and lightning, what we experience is not something we could hold or handle. The same is true, to a greater or lesser extent, of much of the work in *ambient*,

from Eliasson's "mirror strip" works to Sherrie Levine's "Black Mirrors" to Liz Deschenes's photograms.

Above, I suggested that there might be a link between the recent embrace of sound in the art world, and the resurgence of ambient conceptualism. I further suggested that these tendencies might be related to new work in philosophy, known collectively as "Speculative Realism," or in a related, but not identical formulation, "Object-Oriented Ontology." On July 1, 2013, on the talk show, *Charlie Rose*, Turrell compared working with light to working with sound (see the epigraph at the start of this section). I started using the adjective *ambient* to modify *conceptualism* before I was aware of the show at Tanya Bonakdar. Discovering that such a show ran concurrent with the Turrell victory lap, closing only two weeks before the opening of *Soundings*, at MoMA, only further tingled my spidey sense. How much evidence (and what kind of evidence) does one need before concluding that what might have been a coincidence is more than that? From October 10, 2013, a class at MoMA called "Ambient Poetics: an Introduction" was led by Tan Lin. The deeply ambient *Rain Room* closed at the same museum in July, Janet Cardiff at the Met, and Susan Philipsz on Governor's Island. And, finally, the exhibition, *ambient*, was curated by Tim Griffin, executive director and chief curator at the Kitchen, and former editor-in-chief of *Artforum*. This is someone whose finger is professionally required to be taking the pulse of the art world. All in all, I'm persuaded that there is reason enough to continue connecting the dots. This confluence of interest in, and employment of, ambience (to use the noun)—of light, sound, immersion, and atmosphere indicates that something is afoot.

What I'm attempting to diagnose is a moment, if not a turn, in some recent museological and curatorial practices, toward an art concerned foremost with percept, with sensory experience, detached, to whatever extent possible, from social meanings and discursive justifications and analyses. This is noteworthy because for the past forty-five years, art has pursued an agenda pointed decidedly in the direction of concepts and precepts (the latter most often in the form of a critique of institutional, political, and ideological precepts). This moment's emblem is Turrell's coordinated, three-institution retrospective in Los Angeles, Houston, and New York. The consensus represented by this west-middle-east span, in three of the four most populous cities in America,

with press coverage up and out the proverbial wazoo, should not go unnoticed or uninterrogated. As I've alluded to above, I suspect a good deal of this has to do with the winds of fashion that pass through the museum world with the same breezy nonchalance that they pass through everything else, from burgers to bands to beards. I know the market cannot be bracketed. Eventually, I need to account for it and hold myself accountable for my complicity in its machinations. I know. But, for the moment, I want to think about different motivations; other causes, other effects.

Sight

In what ways is the experience of the Turrell exhibition—specifically, the central installation, *Aten Reign* (2013), in the main, spiral, atrium space of the Guggenheim—different from the experience of the Fourth of July fireworks on the Hudson? I don't think they are very different at all. Does that mean that the tawdry exhibition of nationalistic explosions rises to the level of esteemed art? Or does it mean that Turrell's effects sink to the status of populist pageantry? These are not the questions that interest me. To equate Turrell and lightning and fireworks is not to make a high-to-low comparison (or vice versa). Instead, I do so to initiate an inquiry into the nature of this type of experience and, simultaneously, into the capacities of present-day art: What do we want art to do? What is it prepared to do?

In her review of Turrell's show in the *New York Times*, critic Roberta Smith writes, "The latest site-specific effort from Mr. Turrell, 'Aten Reign' is close to oxymoronic: a meditative spectacle."[50] I take this up because I think there are two assertions here that are widely held and that both demand further consideration. I'll take the second assertion first: the "oxymoronic" idea of a "meditative spectacle." This is only oxymoronic at first glance. Thinking about it and about both meditative experiences and contemporary spectacle, it reverses valence so as to actually seem tautological. It is precisely the function and, dare I say it, the *desire*, of spectacle to achieve a sort of meditative equilibrium. I mean "spectacle" here in both the everyday and the Situationist senses (realizing that, ultimately, the former is merely a retroactively normalized version of the latter). Spectacle can't remain spectacular. That would attract

too much attention. If there is a flash of the spectacular it must immediately subdue. It must level off and settle into a coy suggestiveness that feels to the spectator (already etymologically and ideologically complicit) as if it couldn't be otherwise. Spectacle embeds itself parasitically, such that the host doesn't recognize itself as host, doesn't recognize the parasite as other. It embeds in the naturalism of objects, in the inevitability of images, and in the therefore-I-am-ness of the self. We can describe the spectator's relationship to this embeddedness variously: *opiative* (thinking of Marx), *epistemic* (thinking of Foucault); but it is also in some sense *meditative*. It faces both inward and outward. It recommends itself as being for the good of the spectator. It appears self-motivated, even self-generated. Likewise, and by a similar logic, I think the formula could be reversed. Much meditational practice presents a spectacle front, staking claims to both magnificence and inevitability.

I have tactically forestalled applying this description to the Fourth of July fireworks. But I don't think there's a lot more work to do. Fireworks, too, are meditative spectacles. They may, in fact, be the paradigmatic example of the category. A fireworks show, not only as a whole, but also in its individual blasts, offers an initial burst of spectacularity. But, almost instantly, the experience lulls into a complacency of expectation that easily accepts the adjective "meditative." Craned upward to the sky, heads bob like buoys, eyes glaze while mantric "ooohs" emit from the self as a "column of air" (in Allen Ginsberg's meditational parlance). The meditative-spectacular experience, equally optic and cultural, ignores that these are thousands of violent explosions (the redirected force of guns and bombs) and accepts a gradual diminishment of expectation—a kind of meditative boredom—as the repetition dulls each climax on its way to the never-quite-as-grand-as-hoped-for finale. After the show, we are left a little bit ho-hummed.

So, when I say that *Aten Reign* is not very different from fireworks, I mean that these experiences are both spectacular and meditative. Like kaleidoscopes, they offer a visual treat—eye candy as it is known—that is momentarily sweet, easily swallowed, but which offers little of substance. Most of us like these sorts of things. Heck, there's nothing in the experience, *qua* experience, that's not to like. A couple of harmless hours oohing and aahing is anyone's prerogative. But devotion to these sorts of encounters puts its faith in the "simply is" of

perceptual experience. Such devotees tend to be either toddlers or tripping. (As a father of a young child, I can confirm that the mindsets of these two groups have more than a little in common.)

The "is" of Turrell's light is anything but "simple." As it lands in museums, in the press, in interviews, it relies on a finely crafted and well-practiced set of creation myths. If one reads a few articles about Turrell, if one reads or listens to or watches a few interviews, if one ingests the catalogue copy and the wall text and the web blurbs, one hears the same just-so stories again and again. My favorite is the one about how he studied perceptual psychology as an undergraduate, as if this is supposed to establish his credentials as an expert. I've eaten coq au vin, but that doesn't make me a French chef. Then there are the stories about the young Turrell piloting about the United States in his own plane, looking for he knew not what; that same Turrell discovering the Roden Crater in Arizona and negotiating to purchase it and the land around it despite his wife's threats that if he bought it, she would leave him and take the children. (He did. She did.) There's Turrell cutting gaps into the walls and ceiling of a Santa Monica hotel to experiment with letting light into the darkened spaces, and his year in jail for remaining steadfast to his pacifism and coaching men to avoid the Vietnam-era draft. This all amounts to a story about Turrell's light that is far from "simply is." His light is not *the* revelation. It's not even *a* revelation. It is the documentation of one man's quest for revelations; for something to be revealed to him. Some might find it disappointing that this quest isn't more inventive, more original. Like so many previous quests, Turrell's looks to light as its source and its destination. If light isn't illuminating other things, if it insists on being the thing itself, then it requires that we look it straight in the eye. But, as we're warned during solar eclipses—yet another Turrellian meditative spectacle—such encounters run the risk of damaging our vision. Turrell's light is a kind of illustration: of his single-mindedness, of the purity of his vision (in both senses of the term), of the trajectories of his pilgrimage, of his status as both a seeker and a seer. Ultimately, his installations are the illustrations for a long personal interest story, or a short *Bildungsroman*.

I don't point any of this out to disparage Turrell or his relation to light. That's all his. I don't pretend to know more about him or light than he himself knows. What I'm zeroing in on is that this work—that claims to be so singularly about

a given object of perception and the perception of that object—relies heavily on scaffolding narratives to generate interest and meaning. There is more to Turrell's light than meets the eye.

As I've done with the three terms *percept*, *concept*, and *precept*, I'm investigating what can be wrung out of a braiding of three near-homonyms: sight, site, and *zeit* (German for time). Right off the bat, one could argue that these three terms go a long way toward tracing the trajectory and fundamental concerns of contemporary art since the 1960s (when Turrell's career began). We start from a Greenbergian formalism devoted to the demands and cultivation of the sense of sight. Next, site specificity undermines such formalism. Artists like Robert Smithson and Michael Asher interact with spatial sites. In different ways, Mary Kelly, Chris Burden, Vito Acconci, and Carolee Schneemann, identify the body as a site. And artists as varied as Bruce Nauman, Marcel Broodthaers, Martha Rosler, and Cildo Meireles, respond to the conventions (the precepts) of art as a site. More recently, we've witnessed the move toward time-based media: video, performance, dance, sound, durational work, and social practice. It's too simple. But, crudely, we could say art has traveled from sight to site to *zeit*.

More importantly, I want to think about what it means to shift the emphasis of a work of art (or works of art in general) from sight to site to *zeit*. Again, using Turrell as a kind of limit-case is instructive. Clearly, all three terms are in play in his work. But the framing of his work, via the creation myths I've itemized above and via both curators' and Turrell's characterization of the work, directs attention toward sight, at the expense of site and *zeit*. Here (as promised above) I'll return to the first of two assertions included in Roberta Smith's *New York Times* review of the Turrell exhibition. Smith writes, "The latest site-specific effort from Mr. Turrell, 'Aten Reign' is close to oxymoronic: a meditative spectacle." I've already discussed the problem of "meditative spectacle." Now, I'd like to consider the claim that *Aten Reign* is site specific.

Site

This immense installation is site specific only in the most literal sense of the term. Yes, it was made for this space. But it makes no attempt to negotiate its

site in the Guggenheim rotunda. It accepts its site as given and accommodates it, almost literally swallowing it. This is not site specific in the meaningful sense of the phrase. *Aten Reign* doesn't perform any kind of archaeology (literal or figurative) on the site, its history or its ideological support. Nor does it enter into any kind of debate or create any productive friction with the site. In her book, *One Place After Another: Site-Specific Art and Locational Identity*, Miwon Kwon establishes three "paradigms" of site specificity, which emerge in roughly chronological order. The first, what she calls the "phenomenological or experiential," responds to the physical realities of the space in which it will be seen. Unlike previous sculpture, this kind of work denies the absolute autonomy of a sculptural work, accepting that the work is in a dialogue with the dimensions and materials of its viewing space. *Aten Reign* is site specific only in this limited and outdated sense of the term. But I want to explore Kwon's other two paradigms, as a way of beginning to characterize what is lacking in the ambient. The second paradigm, the "social/institutional," goes beyond the parameters of the space itself, acknowledging that the space is just one component of a more general, conditioned, set of expectations and responses, which are themselves manipulated by forces with their own desires and demands. The third, and most recent, the "discursive," goes beyond the parameters of the institution, taking "site" as a product of various intersecting narratives and practices. These intersections frame the work in a series of overlapping discursive matrices, generated intentionally and coincidentally, by the artist, curators, critics, historians, patrons, spectators, commerce, current events, and so on.

It's easy to see how Kwon's category of discursive site specificity is related to, and in fact, relies upon, Rosalind Krauss's notion of "terms that are felt to be in opposition within a cultural situation." Both Krauss's essay—in 1979—and Kwon's original essay-length version of "One Place After Another"—in 1997—were published in *October*, the seminal journal, cofounded by Krauss. With the benefit of eighteen years of hindsight, Kwon is able to braid the discursive fabric of Krauss's expanded field with the strands of emerging social-based art practices. In doing so, Kwon asserts that this discursivity is the bridge that allows art practice to escape from its own island of subjectivity, insularity, and neutered autonomy. For Kwon, discursive site specificity

moves beyond the restrictive concerns of art history, leaving behind merely aesthetic precedents for judgment. She argues that discursive site specificity is a practice that allows artists to cross boundaries into social, economic, and political issues without worrying about whether their projects register as "good" or "successful" art works. Kwon's argument implicitly proposes that turn-of-the-century movements, like "relational aesthetics" and social practice, are the inheritors of discursive site specificity, while it retroactively credits previous site-specific work with a social conscience it may not have claimed.

In his recent book, *Fieldworks: From Place to Site in Postwar Poetics*, Lytle Shaw extracts important implications of Kwon's genealogy. Shaw's aim is to challenge Kwon on one specific point about discursive site specificity. He acknowledges that Kwon's chronology moves in a positive direction, allowing site-specific works to engage their context in productive ways. But Shaw is careful to qualify context as a product of the art historical maneuvers of a work. Whatever social, economic, institutional, or political issues the work tangles with, it does so as a gesture within an artistic lineage, always simultaneously borrowing from and rejecting parts of that lineage.

> For in passing beyond any literal or spatial concept of site, *discursive* site-specificity argues for site not just as a network of social practices, conventions and consequent power relations but also a genealogy of artistic precedents that can allow for contextualization and even evaluation.[51]

Shaw's contention is that the context of even discursively site-specific works always includes the intersection of the work and its thematic concerns with the arc of art history that allows a specific gesture to be legible *as art*. If this aspect of context is absent, then the work fails to register and slips between the cracks of history's rage for disciplinary identification. Thus, the second and third of Kwon's categories fold into each other in complicated, and complicating, ways while also folding back into Krauss's earlier declaration of discursivity. We are no longer dealing, simply, with a linguistic text; with discursivity, but always with the (con)text, or the *with-text*. As with my expansion of Krauss's notion of terminological opposition, we must see discursivity as a more expansive matrix of codes and processes. Following Shaw's adjustments to Kwon's model,

and in light of Claire Bishop's recent writings on social practice, we have to conclude that the artwork cannot simply will itself to become something other than art: community organizing or political activism. An artwork, if it is to register as such, cannot help but rejoin the narrative contentions of the art that precedes it. The most constructive artworks cut both ways, into the world *and* back against the tradition that licenses them. Later I will introduce the idea of the *mit*-sine, the *with-wave*. And, similarly, I will insist that the *mit-sine*, cantilevers both into the space of nonart concerns and into the endowment of its progenitive practices.

One of the sites to which any work must be specific is the site of art history: of the traditions, works, artists, and ideas, to which it responds. It doesn't matter if an artwork wants to be engaged thus. It happens anyway. Part of the onus of site specificity is the kind of self-awareness I've discussed above. It is incumbent upon the work that it acknowledge its own relation to all the sites with which it engages: art history, yes, but also, politics, economics, institutionality, race, gender, climate, violence, and so on. Site specificity begs a transparency with regard to the work's relation to the various structures within which it operates.

Zeit

The final sentence, the closing three words, of Michael Fried's "Art and Objecthood" create an equation: "Presentness is grace." This essay, published in 1967, is one of the most astute pieces of art criticism ever published. Looking at the minimalist sculpture of Donald Judd, Tony Smith, and most crucially, Robert Morris, Fried forecasts the art of the next two decades. Confronted with a set of four mirrored cubes on a gallery floor, Fried predicts the advent of modes of practice that will come to be called, conceptual art, performance, body art, video, even social practice. Fried's prescience is unparalleled. But of course, he bet on the wrong horse. In opposition to Minimalism, and the prospect of all these practices-to-come, Fried backed Modernist painting and sculpture: artists such as Kenneth Noland, Jules Olitski, David Smith, and Anthony Caro. Notably, what Fried denounced in Minimalism was what he called "theatricality." Theatricality, in Fried's view, is too reliant on the spectator.

While the invaluable qualities of the Modernist work inhere in its materials and forms (it retains its greatness even when it is not seen—in the museum at night or locked in storage), the Minimalist work requires the activation of the spectator. Without the spectator the work does not happen, in a sense, it does not exist.

Fried insists that an encounter with a Minimalist work requires and persists in time. The Modernist work, on the other hand, is timeless. Everything the work has to offer is there at first glance. This doesn't mean we perceive it in a glance. But that, in Fried's view, is our fault, not the work's. According to Fried, an encounter with a great Modernist work is experienced

> as a kind of *instantaneousness*: as though if only one were infinitely more acute, a single infinitely brief instant would be long enough to see everything, to experience the work in all its depth and fullness, to be forever convinced by it.[52]

The grace of presentness is a variety of ambience. It simply is, hovering, ever-in-attendance. Ambience is, by definition, that which cannot be absent. Nor is ambience beholden to time. Paradoxically, Turrell's *Aten Reign* claims to be both time-based and to bask us in the grace of ambient presentness.

I'm inclined to think you can't have all these cakes and eat them too. Sound, too, exists inexorably in time and is associated with the presentness that Fried describes. This is why Turrell likens his light to sound. However, sound's presentness is more accurately understood as a form of liveness. Because sound cannot be stilled, it suggests activity, occurrence, motion—like a living thing. If we want to call this "presentness," we are forced to describe a kind of self-presence. But, with Sterne's critique still in mind, self-presence must be rejected as an explicitly theological claim. Only the divine could be wholly present to itself without remainder. The identity of sound—like everything else here at Earth-level—is constantly contested, always this *and* that, either *and* or. Sound's presentness, then, cannot be self-presence; it is not self-evident like Fried's conception of a Modernist canvas. Rather, its apparent presentness results from sound's liveness, its vitality in time and space. The mistake, then, is to claim for sound the grace that Fried equates with presentness. Liveness evokes the opposite of grace. Sound, consummately temporal, is allergic to

grace. Sound's liveness is just like our liveness: it carries its inevitable demise in the bustle of its viscera. There is no salvation, no promise of grace. The best we can hope for—for ourselves and for sound—are a few productive negotiations with self and other, with the obdurate surfaces of things and ideas, with the porous membranes of categories and habits.

5 Errata is Data

As with most categories, ambience gets a little slippery when one tries to locate its precise boundaries and the qualities that dictate its ontology. Attempts at definition or description can punch leaks in ambience, causing it to overflow and mix with neighboring genres. Hard pressure on its meaning and identity can almost flip it upside down, such that it sometimes looks like types of music we might have assumed were its antithesis.

In addition to citing Sly and the Family Stone's *Fresh* as a transitional moment, Brian Eno also mentions the recording-enabled shift in compositional values in the work of Lee "Scratch" Perry. When confronted with a buildup of hiss from bouncing and overlaying tracks on his mixes, Perry finds a way to use that hiss as a creative element in the composition. Eno writes,

> A Western engineer might get frightened by this, and use all sorts of noise reduction and filtration. Perry says, "Okay, that's part of the sound, so we'll just add something else to it and use it." This adds an ambience of weirdness behind what was straightforward reggae.[53]

Starting in the late 1960s, Perry's work (along with that of Osbourne "King Tubby" Ruddock, Errol Thompson, Herman Chin Loy, Keith Hudson, and others) evolved into a form of studio-produced, reggae-based composition known as "dub." Eno's acknowledgment of the similarities between his studio-based composition and that of Perry allows us to think about ambient and dub as flipside metaphors. Once we move past their similarities, we find a number of distinct differences in the musics' origins, how they function, and how they might operate as metaphors for other modes of artistic practice.

Ambient, as a genre of music, was developed by Eno, an art-college-educated, middle-class Englishman, who makes music in a high-tech studio in the English countryside. Dub was developed by working-class Jamaican men in makeshift studios stocked with jerry-rigged equipment. (King Tubby, an electrician by trade, hand-wired his amplification systems.) Eno's ambient music is recording-based music, manufactured in large editions, and released by well-known and widely distributed record labels. Dub began as music

for social gatherings. Dub "plates" were quickly made into acetate discs, sometimes produced specifically for that night's sound system. After only a few plays, these plates would become degraded and unusable. They were, in a sense, site specific and one-of-a-kind objects. Ambient music is marked by a lack of recognizable pulse. It encourages private listening, and as Eno has suggested, it does not demand the listener's primary attention. Dub is a highly rhythmic music. Dub mixes typically strip away melodic instruments and center on the rhythmic interactions of the drums and bass. Beyond that, the signature sound of dub production is the echo, which converts melodic content such as a guitar chord or a vocal phrase into a repeating rhythmic component as it beats against the song's primary rhythm, often highlighting three beats against the rhythm section's two. In its early incarnations, dub was a type of public music that organized the attention of hundreds of people at once. Later, separated from its sound system origins, dub became an idiosyncratic music. It rescues the reggae rhythm section from the background and pushes it to the foreground. But then, perversely, it takes these foregrounded rhythmic materials and repeats them until they melt into a kind of malfunctioning, machinic background pattern. This isn't the simple reversal of foreground and background, as Griffin claimed of Eno's ambience. It is something far more complicated and profound.

Timothy Morton acknowledges the kinds of differences that separate ambient and dub when he detects an implied site in the domestic presumptions of ambient experience.

> One cannot help thinking of the paucity of the "lounge" or "living room" as a model for a contemplative space—one of the central inadequacies of Brian Eno's view of the role of ambience. Surely common land, or a street corner, in our time a locus of racist arrests (and of Miles Davis's *On the Corner*, a strongly ambient work)—or Westminster Bridge—are more potent spaces?[54]

What is mind-blowing here is Morton's inclusion of Miles Davis's 1972 album, *On The Corner*, in the ambient canon. One might just as comfortably nominate *On The Corner* for the list of albums that could, under no circumstances, be recuperated as ambient. One begins to suspect that Morton's ambience and that of Griffin-via-Eno might not be identical. *On The Corner* is hardly an

easy listen. Few, if any, of the album's fifty-five minutes and nineteen seconds could be described as passive. The music is built on a foundation of off-kilter rhythms, like a man on crutches galloping through a tire fire. Dissonant burps and yowls irregularly punctuate the air, more poison than perfume. Nothing sits comfortably, on its own, or in conjunction with the rest. There are no solos to speak of. It sounds as if all the players were asked to disassemble their virtuosity and to pick parts at random to drop into, or throw onto, the mix. In fact, the mixes were cut and pasted from long studio jams by Davis and producer, Teo Macero, who had studied computer music with Otto Luening at Columbia University. On top of passages of the rhythm section, snippets of other instruments were edited and remapped within the rhythmic and ensemble context. *On The Corner* is often cited as a merger of jazz with rock and funk. Methodologically and structurally, it has at least as much in common with dub.

On The Corner is a music of fragmentation. Wholeness is held perennially at bay. This response is confirmed and deepened by the six-disc collection, *The Complete On The Corner Sessions*. Both the techniques of its production and the resulting listening experience are ruptured and ripped. Its edges are tattered, its seams split and badly resewn. The listener is never allowed to get comfortable as the instruments constantly interrupt and undo what might pass for a groove, a melody, a mood. Perhaps this is why Morton mentions *On The Corner*. For him, sound is an operative site (being) or metaphor (appearance) for the interstitial nature of the ambient. This constitutes its own strange loop, the ambient occupying the positions of both progenitor and product. Sound's ontology is equally *and/nor*. Sound has a material existence; it is a wave, a dynamic fluctuation in air pressure. Yet, it is also a sign: of lurking danger, of communication, of artistic gesture, but also of socioeconomic conditions and of geo-historical exigencies. Countless unresolved investigations of musical "language" and the status of acousmatic sound, point to the ambiguity of sonic ontology. On a conference panel entitled "Operative Ambience," Morton notes the uncomfortable contortions of sound's *and/nor-ness*:

> A sound is a physical thing. On the other hand, it is a semiotic thing. But we can't locate where the physical stops and the semiotic starts, anywhere on the surface of the sound. A sound is a Möbius strip, a strange, twisted loop, whose twist is everywhere.[55]

If, in fact, sound nominates itself as an analogy or a symptom, or possibly, as the composer, of this ambient moment in the New York art world, then we are behooved to ask if Eno's sickbed revelation is the true creation myth of ambience. And, if we are honest with ourselves, with Eno, with ambience, we are forced to concede that it is not. John Cage's aforementioned anechoic chamber epiphany is where ambience is born in all but name. Truth be told, we can also find precursors to Cage's inspiration, even if none of these precedents rise to the level of the ambient: in Satie's *Furniture* Music, in Rauschenberg's white canvases, in Zen. So, once again, origin stories are but stories. With 4′ 33″, Cage jettisons (if only momentarily) all intentional sound in favor of happenstantial, environmental phenomena. And, while Tim Griffin's press release claims that Eno's ambient initiates "dislocations and relaxations of authorship—and quasi-reversals of figure and landscape, foreground and background,"[56] we all know this is Cage's move. Not only does Cage reverse these valences, he completely eradicates figure and foreground while abolishing authorial agency regarding the formal content of the work. What's more, 4′ 33″ is not just the birth of these erasures and of the "*infinitesimal degree*," but their apotheosis. One could say that, all at once, with 4′ 33″, ambience is born, graduates high school, takes a job, has kids, retires to Phoenix, and dies in its sleep.

Yet, the ambience of 4′ 33″ is not as simple as it sounds. In *Noise Water Meat*, Douglas Kahn points out that Cage's experience of hearing himself hear was predicated on a "third internal sound." This is the sound of Cage's critical consciousness asking, "what are those sounds?" Kahn argues that discursivity sits at the base of Cagean experience.[57] I would similarly argue that ambient aesthetics relies on the myriad terminological oppositions we've been ticking off: foreground/background, signal/noise, intention/chance, producer/receiver, agency/awareness, natural/unnatural. Without these oppositions hanging in the air, the ambient gestures of Cage and Eno fall on deaf ears. Ambience is constituted by this terminological complex. Like all environments, it is only *apparently* neutral, nonexistent, nil. Without acknowledging the environment's rich particulate matter, its particularities, that its particulars matter, our ears are more (and less) than deaf. They are blind. They are blind to the differences that allow you to see yourself seeing. This blindness is called "just seeing."

In some ways, *ambient*, the exhibition, makes a better case for what I've been calling (before I was aware of this show) "ambient conceptualism" than the work of Turrell and his light and space compatriot, Robert Irwin. At the very least, and counterintuitively, *ambient* makes a better case for the conceptualism of my phrase, while Turrell and Irwin rely more strictly on what I am calling ambience. *ambient* features works by twelve artists, including well-known visual artists such as Eliasson, Sherrie Levine, and Haim Steinbach, and a few, like Tristan Perich, Seth Price, and Alex Waterman, better known for work that involves sound and other time-based media. That the exhibition was curated by Griffin strikes me as germane. Staying on top of what the art world is thinking has been Griffin's professional remit for some time now.

It's easy to see how some of the works hew to Griffin's account of Enoesque ambience. Three of Eliasson's untitled mirror strips pieces get a darkened room to themselves. Each features a spotlight on a stand, trained on a thin strip of mirror leaning against a wall. The light reflects off the mirror while casting a strip of shadow on the wall. Liz Deschenes's two photograms—both *Untitled (Charlotte Posenesnke)*—hang in different corners. One hugs its corner's two joined walls. One spans across the angle, creating a triangular space between the photogram's plane and those of the walls. These dimly reflective surfaces emit a visual hum, neither signal nor noise. They could carry the adjective "auratic" as comfortably as "ambient." Sherrie Levine's six *Black Mirrors*, though, resist both the auratic and the ambient. They do allow a kind of dark reflection in their black surfaces. But, in the context of Levine's oeuvre, they point away from the kind of self-reflection that Griffin suggests in his press release, and toward an art-historicity that can't be confused with the here-and-now of ambient reflexivity. Instead, they turn the gallery space, the viewing subject, and all the other works in the room, into an art historical *tableau vivant*, albeit one with a somewhat subdued vivacity. Because the reflection is weak, one stands still before the mirrors' surfaces, trying to detect some recognizable form. On the surface of Levine's mirrors, this *tableau* devolves into a kind of real-time *mise en abyme*, whose emphasis is most decidedly on the *abyme*, the abyss of reduced visibility, of curtailed vitality, of constantly deferred self-presence.

But some of the works in *ambient* resist the Eno/Griffin account of ambience and lean toward the contorted surfaces and interstitial gaps so evident in dub and *On The Corner*. Susan Goldman's paint-by-numbers pieces, four of them, hang in a modest cluster at the top of the stairs in the second-floor gallery. They are small. Three are 10 ½" × 14 ½". One is 16 ½" × 20 ½". These works start with a track that's already been laid down: a store-bought paint-by-numbers kit. This homey-est, hobby-est, of artistic practices is remixed by Goldman. In much the same way that Davis and Macero ignored the original intentions of *On The Corner*'s musicians, Goldman disavows the inherent meaning and method of the paint-by-numbers kit. Instead, she runs it through a kind of machine, subjecting it to the grid that orders and grounds so much Modernist art.[58] The grid is only suggested, but is nevertheless unavoidable. In *Country Scene*, from 2000, eight squares run horizontally just below the middle of the canvas.[59] A ninth square that ought to finish the sequence is instead dropped half a square below the sequence of eight, and nudged slightly beneath the rightmost square, upsetting the implied regularity of the grid-rhythm. Each of these squares is painted in accordance with the paint-by-numbers outlines but in decidedly uncalled-for colors: bright greens, fuchsias, garish yellows. The title of Goldman's piece is simply a retransmission of the name of this particular paint-by-numbers kit. This name, which, in standard usage, would have been painted over, is still visible in the unpainted upper left of the canvas. Rather than the bucolic "country scene" promised by the title, Goldman's squares imply a rigid psychedelia.

Pursuing a series of procedures and effects that I will refer to as "dub"—as a pointed antithesis to "ambience"—Goldman inverts the initial emphases of the painting. Much of what should have been supplied is omitted. In its absence, however, the guidelines for the amateur painter remain visible. The effect is a version of "baring the device," of allowing the audience to glimpse the mechanism and technique of the artist. This demythifying gesture, first suggested by the Russian Formalist, Viktor Shklovsky in the early 1920s, is meant to disrupt the reader's inclination to suspend her disbelief. Rather than sinking into the lifeworld of the fiction, baring the device keeps the audience perennially on alert to the manipulations inherent to the artist's stratagem. But, of course, the device of paint-by-numbers is never truly concealed. Any eye can reconstruct the undercarriage that supports the artist's work. And to

simply carry out the paint-by-numbers according to the instructions, doesn't qualify the painter as the author/artist of the work. Like Lee "Scratch" Perry (also known as "The Upsetter") or King Tubby, Goldman turns the canvas inside out, twisting and looping it back on itself and on the process it is meant to initiate and guide. Its surface transmits a visual code of too-vivid grid squares, creating a periodic rhythm. This periodicity does the work of supplying the grid that organizes the rectangular canvas in agreement with the geometrical model of perspective that, arguably, has ordered the European sense of vision since the fifteenth century. As it nears the end of the canvas, moving, like Latinate writing, from left to right, the regularity of the painted squares hiccups, upsetting the rhythmic, perceptual, and syntagmatic logic of Goldman's intervention.

It is hard to see what might be ambient about this work. Its mechanisms are all dub: subtractive composition and rhythmic counterpunching. As in dub, misuse and abuse are central to its effects. Rather than integrating seamlessly with a listening or viewing environment, dub unsettles its environment. Disruptions become intentions. Obstructions provide inspirations. Errata is data. As Michael Veal puts it, dub responds to the socio-historical horrors of modernity, specifically the African slave trade,

> through an aesthetic of broken, discontinuous pleasures that may represent a synaptic adaptation to long-term historical trauma, but that also fit into a broader global pattern in which collage forms join the search for new realities to define the twentieth century.[60]

Disjuncture is not strictly a formal gesture, but a formal response to societal events and drives. It is adaptive. The identity of the music, like the identity of its creators and audiences, is made of its faults and infidelities. To borrow a title chapter from Veal's book, "every spoil is a style."[61]

Goldman's paint-by-numbers pieces respond similarly to the terms in play in their cultural situation. They perform a neat maneuver of scalpeling through the bodies of two distinct artistic practices and, by doing so, integrating them. The sophistication of grid-based minimalism (think Agnes Martin or Sol LeWitt) begins to echo the rote techniques of paint-by-numbers. The amateur and the avant-garde display resemblances we might never have expected. Each constructs itself from a guiding schematic. In the case of paint-by-numbers,

the mass-produced factory schematic is concealed in the final painting. In the case of the minimalist grid, the repressed schematic of Western opticality is revealed by the work. Goldman's canvases acquire a sociocultural poignancy by setting their operative traditions against the terms of their own practices and by complicating the binarism that, by all accounts, should separate them.

To subsume Goldman's paint-by-numbers pieces under the rubric of the ambient represents an attempt to restore sound as a kind of metaphor for what is being sought, found, and championed in Turrell, Irwin, and the *ambient* exhibition as a whole. Ambience is smuggled into the visual arts within sound's corpus. Ambience, as imagined and proposed by Griffin and Turrell, as attached to the sonic, is elemental, like atmosphere. It is that which simply is, around us, inevitable, immutable. But, of course, we no longer take the atmosphere to be simply natural, beyond the influence of cultural activities such as burning coal, driving cars, or spraying hairspray. By being in it, we alter it. The atmosphere is anthropomorphized. Likewise, sonic ambience is subject to the motivations, interventions, and imaginations of producers and listeners. Composers, musicians, and sound artists can no longer take for granted, or as given, the socio-ethical atmosphere of their work. At the same time, listeners cannot continue to deny the social content that produces and is produced by sound and music.[62]

Some have criticized me for neglecting the Adornian claim that all music (and all cultural products) are inevitably social; that they arise from specific sets of social conditions, and, in a feedback loop that is continual and constitutive, they contribute, in turn, to their social milieu.[63] If I have failed to acknowledge this fact, it is not because I discount or disbelieve it. I take it as an article of aesthetic faith that the social and the artistic experience are inextricably entwined. My disquiet ensues from sound's routine dismissal of sociality at both the sites of production and reception. Too many works and too many practitioners insist on bracketing out everything but the formal qualities of the sonic. The extramusical, the parerga, the frame, are all excluded in paranoid fashion. Like Kant fleeing from the duty of accounting for clothing on a Greek statue, the sonic arts decide to judge only what lies beneath the distractions of *ecouterment*.

6 Sine—Sign—*Sein*

If, as I'm suggesting, the exhibitions I've singled out—all on view in New York City in the summer of 2013—evince the romance of the sonic, then we might identify an alternate set of homonyms to chart a set of concerns. As a sonic supplement to *sight, site,* and zeit, we might think about *sine, sign,* and sein. In this trio, the analogous term for the sanctity of sight is the sine wave, a pure wave without the complications of overtones, blissfully free of contextual and social problematics. The complement of site is the sign, the location of meaning, contextual and differential. And, in place of *zeit* (time) we have *sein* (being). These two German terms are, of course, the critical pairing in the title of Martin Heidegger's monumental work of twentieth-century philosophy, *Sein und Zeit* (Being and Time).

Sine

Sound art loves sine waves. There seems to be a belief that, by using electronically produced sine waves (sometimes called "pure tones") one avoids the annoying complications of other kinds of signals. The sine wave, so the thinking apparently goes, is unencumbered by historical reference, timbre, instrumental voice, expression, connotation, or previous use. Leaving aside the question of whether this unencumberance is even desirable, let's acknowledge that this thinking is just plain wrong. The sine wave has its own history, its own timbre, its own instruments. It expresses something very clearly (most often, the desire for purity I've inventoried above). The sine wave has become a very clear expression of a particular aesthetic mode with a whole host of artistic, technological, and ideological connotations. As for previous use, the sine wave in sound art is, by now, the genre's most egregiously overused trope. The bottom line is that the desire for purity, for transcendence, ends up plunging back into the miasma of history and the social. I mean it when I say I don't know if there are experiences that exist prior to or outside of signification. But if such experiences exist, they are trapped in a form that allows no conveyance.

We cannot speak them. We cannot even think them, because thinking is a transposition that relies on signification: a this-for-that transaction that would encumber "pure" experience with all the burdens of signification. Thus, "I don't know" is the only real answer to this question of unsignifiable experience. Pure tones can't escape the process of signification. In use they acquire meanings. Differences, contexts, and conventions load the wave, corrupt its purity. Even the sine is a sign.

Sign

Music and sound have long debated the status of sounds as signs. I don't have the space (or the inclination) to rehearse that history here. Let me, instead just point to a signal moment in this debate: the disagreements between Pierre Schaeffer and Luc Ferrari about the relation of concrete sounds to their sources. Schaeffer, the inventor of *musique concrete*, insisted that sounds be employed in such a way as to sunder them from their sources. He called the resulting mode of audition, "reduced listening" (*écouter réduite*), an allusion to the phenomenological reduction of Husserl. Put simply, according to Schaeffer, when listening to a piece of *musique concrete*, the listener isn't supposed to know (or care about) what caused the sounds used in the composition. Ferrari, who teamed up with Schaeffer in the late 1950s as a kind of pupil/assistant, eventually pulled away from reduced listening. As Brian Kane puts it in his book, *Sound Unseen: Acousmatic Sound in Theory and Practice*, Ferrari "became interested in 'anecdotal' sounds, a use of recorded sound that revealed its origins, even the banality of its origins. Anecdotal sounds broke the taboo on the recognition of the sound source, instituted by Schaeffer's demand for *écouter réduite*."[64] In a nutshell, Schaeffer treated sounds as basic units in a formal practice of composition, like Lego blocks rearranged to create forms based on morphological complements and contrasts; Ferrari, on the contrary, treated sounds as signs of their sources and contexts, replete with a set of recognized usages and meanings acquired through such usage. Tellingly, Michel Chion has characterized Ferrari's revision of concrete tenets as a "return of the repressed."[65]

Sein

Being is always a complicated topic. Ontology may be first philosophy, the ground of all else, the problem that must first be dealt with before dealing with other problems. Or, ontology may be a fiction necessitated by epistemology. As Lyotard puts it,

> There is no 'in accordance with,' because there is nothing that is a primary or originary principle, a Grund. . . . Every discourse, including that of science or philosophy, is only a perspective.[66]

Nevertheless, we can find notions of sonic being (and sonic beings) in the theory and practice of the sonic arts. Schaeffer's *écouter réduite* focuses on what he calls the "*objet sonore*," the "sonic object." This would be a unit of sonic being—possibly a fundamental unit, a kind of elementary particle. La Monte Young takes frequencies to be beings of a sort, not unlike biological entities, with their own needs for nurturing conditions. And many in the sine-wave set like to think about waves as material realities, ontological entities whose realness is indisputable and whose capture by sign systems is both impossible and beside the point. But it strikes me that much of this thinking of sonic beings (and sonic being) ignores Heidegger's important contributions to, and revisions of, ontology. Specifically, the piece of Heidegger I want to cherry-pick for the purposes of thinking about sound is his notion of "*mitsein*." Usually translated as "being-with," this is one of Heidegger's major emendations of the age-old view of what being is all about. Rather than ascribing an internal, immanent, identity to a thing, *mitsein* proposes that all things arrive at their identity in relation to other things in the world. Although Heidegger was overwhelmingly focused on the specific instance of human being, which he referred to as "*dasein*," or "being-there," one of his most famous examples of the being of a thing-in-the-world is his discussion of a hammer. Heidegger suggests that the identity of a hammer is not ascertained by examining its inherent qualities: its form, its materiality, its color. Instead, a hammer is best understood via its use as equipment, that is, in its relation to other things: nails, wood, and, most importantly, for Heidegger, the intentions of human beings who use

the hammer for a particular purpose. Christoph Cox criticizes this view as overtly anthropocentric,

> Contemporary cultural theory often falls prey to a provincial and chauvinistic anthropocentrism as well, for it treats human symbolic interaction as a unique and privileged endowment from which the rest of nature is excluded. (Cox, 147)

And, of course, it is preposterous to maintain the position that all things achieve their being, wholly or in part, due to human interests. But, if we accept humans as other things-in-the-world, and not necessarily as special cases of being, then it is easy to accept that the hammer's being is not inherent but the result of its relations to other beings. As I've suggested above, such an understanding is possible if we accept an anthropomorphism separate from anthropocentricism. At the same time, it is important to recognize that the things of the world also shape us. The hammer not only asks me to hold it in a particular fashion, it also suggests a kinship to some materials, like nails and lumber, and alienation from other materials, like screwdrivers, screws, water, and skulls. This acknowledgment of being-with (*mitsein*) is a crucial insight about being and one too often left out of conceptions of sonic ontology.

7 No Tone Stands Alone

When applied to art, this thinking demands more of works than that they simply grant access to the immanent being of phenomena. The luminiosity-of-light, or the sonicity-of-sound, are not meaningful enough accounts in a post-Heideggerean ontology. Worse than that, they are misrepresentations of things and our relations to them. In attempting to bypass the complications of worldliness, the ambient presents a lie as truth; a synecdochic part-for-whole substitution is tendered as an encounter with unabridged experience. And thus we arrive at the crux of the matter: a declaration of what it is we want from art. For me, this comes down to a basic precept (circling back to my original set of terms) of how I want to engage with the world. Focusing on where value is generated, on what is meaningful and why, I accept that there is no *sein* without *mit*; that all being is being-with. I believe that to understand anything—any thing—including myself, I must consider that thing integrally as part of a matrix of other things, meanings, valences, narratives, beliefs, histories, intentions, desires, and nested and overlapping matrices. There is no thing-in-itself. I don't declare this to persuade you, dear reader, whoever you are, whatever you believe. I declare it as a statement of my own conviction. In a worldview such as mine, convinced of *mitsein*, there is no point in making ambient works of perceptual experience, as if that light, that sound, were a being, complete in itself, and that we, in a rare moment of access, are gazing into the very materiality of presence.

The sign, as we well know by now, is also *mit*-sign. Each and every sign comes by its meaning, its signification(s), by way of its relation to other signs. These relations are sometimes characterized with the Saussurean/Derridean term "differance." The meaning of any sign arrives not via some internal set of criteria carried by the sign itself, but, instead, by comparing and contrasting that sign with a host of other signs with which the sign-in-question shares certain features. The word "house," for instance acquires its specific meaning by contrast with related words such as "abode," "mansion," "shack," "domicile," "crib," "pad," and so on. It also contrasts with homonyms and near-homonyms

such as "how's" or "hose," and capital H, "House," the TV show about the megalomaniacal doctor, or Ron House, the singer of the great Ohio band, Thomas Jefferson Slave Apartments. Some take issue with what they see as our overdependence on the sign as a mechanism for shepherding experience, but there is little disagreement about the fact that the sign, for better or worse, is always *mit*-sign.

So, if *sein* is understood as *mit-sein*, and the sign as *mit*-sign, then I will also insist on the "*mit*-sine," the "with-wave." No tone stands alone. We experience and understand the things we hear relative to other sounds. This is the basis of musical form. But we also understand what we hear relative to a whole host of other factors, such as the attributes I ascribed earlier to being: things, meanings, valences, narratives, beliefs, histories, intentions, desires, and other nested and overlapping matrices. The sine wave, the tone, and the sound object, are all subject to the same interlocking set of relations and influences. Every wave is a "with-wave," a "*mit*-sine."

The recent explosion of the academic discipline of sound studies testifies to a cross-disciplinary urge to reinsert sound into the purview of the humanities and the social sciences. The rapid rise of sound studies echoes, or is echoed by, the recognition of sound art as a category of creative practice. It hardly seems a stretch, then, to suggest that the sonic has alighted on the tendrils of the artistic and academic imagination. The more difficult questions are those of history, methodology, and meaning. Why now? How to handle sound as an artistic medium, as a scholarly object? How does sound construct its own meaning, and contribute to the meaning of multisensory assemblages? Keeping in mind Jonathan Sterne's deconstruction of the audiovisual litany, especially of the audio column's imbrication with Christian values, we are well-advised to tread delicately into the thickets of both ontological essentialism and epistemological positivism. The challenge is to construct a flexible meshwork of qualities and capabilities, limitations and expectations, that help us to think about sound not as a thing-in-itself, flush with is-ness, confident of its quiddity, but as a dynamic substance, inescapably *and/nor*, constantly redefined by context and use. In doing so, we must be careful not to replace one ontological description with another. *And/nor-ness*, for example, cannot merely substitute for evanescence. *And/nor-ness* is not an identity, not a characteristic, that one can point to in

or on a sound. We must resist the urge to attribute to sound a set of essential features. Whenever this is attempted, every essence births an exception.

Perhaps the first thing we must clarify is the jurisdictional context within which a given discussion of sound happens. The lack of such clarifications often creates confusion. As ought to be clear, I am interested in sound as artistic material, content, form, methodology, and history. A careful thinking of sound in this context will, of course, take other contexts into consideration. While I am not primarily committed to the question of the ontological status of sound, nor in the physical properties of sound, and while my direction of inquiry does not track the newly blazed anthropological or historical trails, all these approaches inform my thinking. Ultimately, I am focused on the pragmatic ethics of the use of sound in artistic contexts. This means that I am interested in how we can, and should, use sound in works of art. But also, and just as importantly, it means being cognizant of the ethical radix of sound and its organizing methodologies while remaining attentive to the nature of relations initiated by the work.

It's easier to work with objects. The solid and the stationary offer themselves up far more willingly to manipulation and analysis. Both makers and scholars encounter less resistance with materials that are unchanging and currently present. But not to possess these qualities doesn't make something nothing. To lack solidity doesn't transform something into solidity's mystical inverse. If sound is constantly changing and evading an easy, stable presence in time and space, that doesn't mean it is constitutively a kind of absence. Sound is not a cipher. It is not the key to a code for breaking, nor a ghost that evades the historicity of material engagement with culture. Sound, like all other substances, is continuously conflicted. As Morton would have it, it is forever negotiating its twin existences as being and appearance. As Derrida would insist, it is inexorably a product of a caterwauling cacophony of inscriptions traversing its surfaces, its viscera, and its substrates. I'll further contend, as a supplement to Morton and Derrida (rather than as a rebuttal), that sound's and/nor-ness is not a property of sound itself, but emerges through sound's contextualization. Like other substances, sound's being and its appearance are not simple facts. Instead, its twin existences are emergent qualities, forced into existence by the friction generated by the interactions of substances. These

substances may, or may not, be solid, stationary, currently present. They interact just the same. They chafe against each other, creating heat, dislodging residue from each other's surfaces, leaving traces of new and mingled substance on the surfaces upon which they rest.

Web copy for MoMA's *Soundings* asserts that the artists in the exhibition "share an interest in working with, rather than against or independent of, material realities and environments."[67] It's important to acknowledge that this is web page text and not a critical, curatorial statement. Still, this assertion appears to acknowledge the fantasy of sound's "simply is." The text suggests that the works in the exhibition will avoid the trap of the "simply is." But a number of works in the exhibition seem to double back on this text's description. Or, worse yet, certain works start from a severely reduced definition of material and environment, often stopping at what they imagine to be sound's own, self-evident materiality, or at environments comprised solely of sound. Take, for example, Tristan Perich's *Microtonal Wall* (2011). On a wall to your right, as you enter the exhibition, a rectangular grid of 1,500 small speakers is mounted, flush, in an aluminum sheet. The precisely uniform grid consists of 100 columns of fifteen speakers. Each speaker is mounted with two screws positioned at 10:30 and 4:30. Each speaker is oriented so that the adhesive that attaches the cone to the voice coil's suspension emanates up from the cone's center like little, black-on-black, bunny ears. From a distance, the wall as a whole gives off a static hum, something like white noise, or the sheathing grizzle of a thousand-and-a-half robot mosquitoes. But, in fact, each speaker emits a single, differently pitched, one-bit, tone. As you walk along the wall, the pitch ascends, emulating Doppler effects.

On the MoMA website, Perich suggests that the operative aesthetic gesture of *Microtonal Wall* is the audience member's spatial interactions with the span of pitches. "Each listener's exploration of that aural space shapes what they hear."[68] By moving closer and farther away, from one end of the wall to the other, the visitor composes(?), mixes(?), remixes(?) the piece. This is a minor allowance to begin with. Just walking down the street enacts this privilege, and with a richer (albeit less curated) soundscape. At the same time, so many musicians, so much software, so many apps, already grant us the liberty of making or remaking music. By reducing the parameters-in-play to pitch

alone, Perich's work diminishes its potential dynamism, settling for a merely spatialized spectrum of pitch.

From title to encounter, *Microtonal Wall* does little to resist or complicate the self-evidence of sound. What it resists, instead, are other sets of terms with which it might productively interact. The site is ignored. The piece can be installed nearly anywhere, so long as there is a big enough wall. The audio input, as is so often the case, defaults to the *reductio ad absurdum* of sonic art: the sine wave (or, in this case the square wave). It's fascinating to imagine what might have emerged from this same set-up if the audio input had been something that could acknowledge and put into play its own historical and cultural engagements: Morton Subotnick's *Silver Apples on the Moon*, Richard Nixon's resignation speech, minutes of the most recent MoMA Board of Trustees Meeting, real-time MoMA visitor data, current transmissions from Voyager 1 as it becomes the first human-made object to cross the heliopause and enter interstellar space. What if transcripts of Phil Spector's 2009 murder trial were played by this wall of sound?

But this is not to suggest that a work's primary efficacy lives at the level of input. And I'm intentionally using the work "input" where the word "content" might once have been used. It is precisely the interactions of input with the structure of the work, the situation in which it is experienced, the conventions and expectations of its audience and site, and its relation to precedents and contemporaries that conjure and construct what we take to be a work's content. By thinking about Perich's *Microtonal Wall* in conjunction with another work included in *Soundings*, we get a sense of the subtle calculus at play in these Gordian interactions. Jacob Kirkegaard's *AION* (2006) inputs a very different kind of signal. Kirkegaard gained access to the site of the Chernobyl nuclear power plant in Ukraine, nineteen years after the accident that forced the evacuation of residents within a 30-kilometer radius. *AION* consists of four pieces, each between twelve and thirteen minutes in length and comprising audio and video recorded at one of four sites within the exclusion zone: a swimming pool, a village church, a gymnasium, and a concert hall. Kirkegaard recorded ten minutes of audio in each of these spaces and then subjected that original recording to the same procedure used by Alvin Lucier in his *I Am Sitting In A Room* (1969/70). The recording is played back into the space in which it was recorded and recorded again. That recording is then played back

into the space and recorded. This ping-pong recording process is repeated numerous times. The original recordings capture the abandoned quiet of these spaces. The signal is minimal: air passing through windows and doors, circulating in the interior spaces, an occasional drip of water from a rooftop or a leaky gutter. But as these layers of recording of recording of recording build up, certain frequencies and timbres assert themselves, magnified by the acoustics of their environment. This accretion of signal transforms the nearly silent room tone of each space into a dense billow of sibilant ambience.

Lucier's *I Am Sitting In A Room*, which is explicitly invoked in *AION*'s wall text and in the liner notes for the DVD version of the piece, is a process piece. Lucier reads a text—which is also the ostensible score of the piece, as well as a description of it—into a tape recorder. He then plays it back into the same room and records it again and again. Published recordings of the final piece merely document the unfolding transformation of the audio. We listen to each fully rendered iteration from the first clearly enunciated reading of the text to the last wheezing, metallic, emanation. As listeners we are witnesses to an unfolding operation, conducted not by the artist, per se, but by the interaction of sound and space. The text, that is the operation's input, grants us full access to the work's mechanism. We listen as Lucier listens. More to the point, he listens as we do, extracted from the activity he has initiated, reduced, if that's the right word (and surely it is not), to our level. The text that describes the process is subjected to the process, thus occupying multiple positions in the structure of the work. The text is prerealization instructions for the piece. It is material for the piece. It is a postrealization description of the piece. It is a written, textual component. It is a live, spoken performance. When Lucier says, "I regard this activity not so much as a demonstration of a physical fact, but more as a way to smooth out any irregularities my speech might have," this activity is also a capsule biography of Lucier, whose lifelong stutter similarly becomes both an input, a theme, and a problematic within the work's trajectory.

Lucier has commented that when he originally played the piece for colleagues, they suggested that he edit the results, selecting specific sections to use in a tape-music composition. To his credit (and unlike Eno), Lucier resisted the urge to intervene, allowing the process to elaborate itself in real-time transparency. *AION*, however, functions differently. The recordings start by building up like Lucier's piece. Roughly halfway through, Kirkegaard

intervenes in the process, reversing the accumulation of sonic density so that each piece returns again to its original, nearly vacated level. While Lucier's process reveals itself, Kirkegaard's is opaque. From the evidence of the work alone, it's not clear what we are witnessing. For all intents and purposes, *AION* uses the reference to *I Am Sitting In A Room* as its explanatory text. Whatever transparency it has, it acquires by positioning itself in Lucier's wake. (Of course, this positioning also invites the type of comparison I'm engaging here.) The video components of *AION* are less beholden to Lucier's example. Instead, they are stationary frames of video, depicting the spaces in which the audio was recorded. Kirkegaard has manipulated these shots over the span of each of the four pieces, applying various techniques, such as overexposure, video layering, and feedback. The DVD liner notes explain that these manipulations "can be understood as analogous to [Kirkegaard's] acoustical method."[69] But they are not. The transforming audio testifies to the effects of these evacuated spaces on the accrued mass of their own interior acoustics. But the fading in or out of the video, the obscuration of a recognizable image, the degradation or oversaturation of digitized visual information are not documentation of anything other than the artist's hand and the available technology. What Kirkegaard does with the video is analogous to the postproduction manipulations suggested by Lucier's colleagues.

The handling of the audio of the piece, however, offers a convenient litmus test for the productivity of input as it interacts with the rest of the work. It goes without saying that the power of *AION* is largely a product of its connection to Chernobyl and to the horrifying test of human flesh and judgment initiated by the disaster. Chernobyl occupies a hallowed position in our repository of collective nightmares. The "what-if-scenario" doesn't have to be imagined. We can just wait and watch as the mutations, contaminations, and cancers materialize. The question then, for *AION*, is how it effects the already established historical valence of its source and site. Does the work initiate new ways of thinking about Chernobyl? Does it intensify our responses or rouse somnolent responses from their slumber? Does it fall into the Adorno's black hole of poetry-after-Auschwitz, beautifying or normalizing the unspeakable by giving it form and speaking it? Kirkegaard's *AION* is at least as susceptible to this Adornian gravity as Susan Philipsz's *Study For Strings* (also included in *Soundings*), which explicitly engages holocaust material.

Unlike Perich's *Microtonal Wall*, the disappointment of *AION* is not that it settles for the *reductio ad absurdum* of sonic art. Instead, *AION* stops at the *reductio ad absurdum* of sonic art history, emerging not from its zero degree, but from its zero hour. It is impossible, when considering this work, to sidestep the problem of mapping Lucier's gesture—so insular, so subjective, so entwined with its art historical moment—to the accidental release of radiation hundreds of times greater than that released by the bombing of Hiroshima. Here, we have an audio input seemingly equipped with all the real-world attachment that I earlier imagined for Perich's *Microtonal Wall*, but a similar difficulty still obtains. In both cases, there is a reliance on the uncontestable *is-ness* of ambience; on the certainty that, while all other features of experience are supplemental, inessential, susceptible to manipulation, ambience just *is*. Both pieces also ride an attendant belief that ambience is most at home, most true to itself, most uncontestable when it is sonic.

The material distribution of MoMA's *Soundings* exhibition portrays a dispersed category. Sound art, it suggests, is not just that which emanates from speakers or headphones. Sound art can be images, video, drawings, and installations. It is worth noting this while also recognizing that many sound art exhibitions have already acknowledged this expansion. At the very least, this acknowledgment should loosen sound's connection to its conventional privileges. If sound is not merely what's heard, but also (and sometimes only) what's seen, what's read, what's thought, and experienced more broadly, then surely we can't depend on the old saws and familiar platitudes. The privileging of sound depends on treating sound as either material or medium. But both of these positions have been seriously undermined. The artist and composer, Max Neuhaus, whose work flies easily under the flag of sound art, critiqued the material commonalities of sound art in an essay for a 2000 exhibition at P.S. 1:

> It's as if perfectly capable curators in the visual arts suddenly lose their equilibrium at the mention of the word sound. These same people who would all ridicule a new art form called, say, "Steel Art" which was composed of steel sculpture combined with steel guitar music along with anything else with steel in it, somehow have no trouble at all swallowing "Sound Art."[70]

Meanwhile, Craig Dworkin has pushed the critique of media-specificity to its limit, declaring, in the title of his most recent book, that there is, in fact, *No Media*. Dworkin tests his theory against a set of artworks, films, pieces of music, books, and poems. The harder we push on the idea of a work's medium, the more it eludes identification. Agreeing with Neuhaus, Dworkin rejects the equation of material and medium:

> We are misled when we think of media as objects. Indeed, the closer one looks at the materiality of a work—at the brute force of its physical composition— the more sharply a social context is brought into focus. To begin with, materials can only be legible as media under certain circumstances.[71]

For Dworkin, what we're inclined to call media is not as simple as objects of conveyance. And a medium, inasmuch as we can isolate it—even if only conditionally and temporarily—never functions on its own. Media only become visible as conceptual constructs when they collaborate or contrast with other, adjacent, media. This interaction, says Dworkin, is social.

> No single medium can be apprehended in isolation. . . . Media (always necessarily multiple) only become legible in social contexts because they are not things, but rather activities: commercial, communicative, and, always, interpretive.[72]

Medium, then, is a social category, emerging from the transmission of material: economic, informational, genetic. Medium is also the habitat of the social; where sociality happens. Medium is not a thing, but a process and a set of conditions. When we scratch the surface of even the least questionable of media, like a vinyl record, it accedes to the exigencies of networked interaction: with stylus, cartridge, amplifier, speakers, and ears. Like their users, such media acquire their meaning and utility through their contact with others. Dworkin likens the spectator's recognition of the CD as a material conveyance of digital data (or, in the case of some artists' work, the absence of data) to the CD player's reception and transmission of that data.[73] In order to read the data, the CD player relies on an algorithm that instructs it as to what data to be looking for, parameters for regarding or disregarding that data, and what to do with the data once it has been attained. Dworkin's analogy is strong, maybe stronger than he even intended. As spectators, we too are subject to

algorithmic instruction. A complex set of apparently exterior indicators enable us to detect and identify phenomena; to distinguish that phenomena as art, as beholden to a tradition and a set of precedents; to draw conclusions about the intentions, meanings, attitudes, and antagonisms of artistic phenomena; and to determine how we ought to respond to our encounter with it. This is not a version of media determinism, because, persuaded by Dworkin, I'm inclined to say there is no medium. Media, like everything else, are subject to the convoluted shifts of social relations. Via collusions and camaraderie, conflicts and capitulations, the artificial demarcations between one history and another are inscribed. As Dworkin writes,

> "Media," accordingly, are perhaps better considered as nodes of articulation along a signifying chain: the points at which one type of analysis must stop and another can begin; the thresholds between languages; the limns of perception.[74]

Sound art is best conceived thusly: not as a medium, not as a category founded on common materials, but as a passage between discourses, as unclaimed territory between interpretive domains, as the murmur of meaning produced by unexpected shifts in what is taken for granted. Still, if we insist on delimiting this territory with the modifier "sound," we have to account for the what, when, where, and why of the sonic. This is tricky business. It threatens, at every turn, to collapse back into material definitions and medial classifications. Before long and without much resistance, we can easily find ourselves recounting the audiovisual litany. Our terms, then, must be always already in opposition, contested in their fundamental premises, products of temporal fluctuation, subject to the provisional nature of their site. Any proposals regarding the sonic are accordingly offered as tests; not tests to be applied to artistic phenomena, but conversely, terms to be tested *by* specific instances of sonic art. We must continually ask: Does *this* precept hold when pressured by *that* work? If the collision of a proposal with a work yields no sparks of radical attainment, then it is worthless to us. If a proposal simply concedes to the work at hand, offering no resistance, then it is discarded. The proposals worth retaining are those that pivot in multiple directions when confronted with the force of one work or another. These terms allow entry into diverse orders of conception, depending

on the specifics of a given encounter. They are not closed like vaults, nor inconsequential like Mel Brooks's toll booth in the desert. Nudged this way or that, they open onto distinct readings and effects while still constraining the spectrum of plausible interpretations. The terms themselves have limited reach and shelf life. What's productive here and now may be useless there and then. The available tools are the available tools.

The String and the Mirror, organized by Lawrence Kumpf and Justin Luke at Lisa Cooley Gallery, overlaps in some ways with *Soundings*. Both exhibitions forego sound art fundamentalism in favor of a diffuse array of apparatus. As a trade-off, however, many of the works in both exhibitions comply with established pictorial and sculptural strategies. We see framed canvases hung on walls, objects set on plinths, video projected in darkened rooms. *Soundings*, on the whole, still gathers itself around the kind of affinities that Neuhaus and Dworkin deconstruct, while *The String and the Mirror* resists the magnetism of material and medium. While most of the works at MoMA include audio material, only two of the works at Lisa Cooley actually make sound and only one employs speakers. Perhaps too conscious of this fact, one work, Alan Licht's *How Loud Is This (Gallery)?* (2013), consists of four wall-mounted decibel meters, taking constant measurements of the space's sound levels. It's easier to make sense of this near-absence if we know that the show's title is taken from the first chapter of *Reason and Resonance* (2010), by music historian Veit Erlmann, in which the string is proposed as an alternative to the mirror model of human knowledge based on a subject's ability to reflect on, and see her reflection in, the natural world. In place of the mirror, Erlmann inserts a vibrating conduit, attaching the source of disturbance to its receivers. Nowhere does the exhibition acknowledge or comment on how it relates to its title's source. We are left to decipher whether the exhibition is actively proposing that its included works function as strings *rather than* mirrors, or whether these works are imagined as integrations of strings *and* mirrors. In other words, does the title propose a dialectic or an amalgam?

Like some of the works in *Soundings*, there are works here that rely on zero-degree references to sound's material ontology or to seminal works in the early distribution of sound in art history. But by and large, Kumpf and Luke have gathered works that engage sound from a discursive remove. In fact, it's

difficult to imagine a show that would adhere more literally to the type of non-cochlear sonic practice that I called for in my previous book, *In The Blink Of An Ear*. But *The String and the Mirror* forces me to revisit my prescriptions and to think more carefully about how works interact with the specifics of their situations, with the conventions of their presentation, and with the world that roils outside the insularity of in-references and subtle realignments of practices. The work at Lisa Cooley Gallery compelled me to distinguish between variation and revision, between tweak and transformation, between objection and insurrection.

C. Spencer Yeh's four text pieces, *Bad Ideas For A Sound Mind*, recall the revolutionary Fluxus text scores of the 1960s. These pieces, printed on the wall with vinyl lettering, offer suggestions or instructions for sonic activities or thought experiments. Take, for example, the text of one such piece, entitled, *One Hundred $1 Bills*:

> One hundred $1 bills are buried under a ceramic tile floor. Participants are encouraged to treasure-hunt these with contact mic'd dentist drills, but must wear headphones playing the sound from the drills while doing so.[75]

While Yeh's texts introduce a sour mischief into the text score, they don't reinvigorate the form with anything like the radicality they initially carried. In the 1960s, in the hands of Yoko Ono, George Brecht, Dick Higgins, and countless others, the text score (or word event) undermined the ontological presumptions of both the work of art and the musical composition. Seemingly stable definitions of practices, apparently solid chains of influence and convention, dissolved beneath the understated, yet dogged, pressure exerted by these works. By now, however, works like Yeh's *Bad Ideas* pursue an opposite impulse, displaying obedience to an established art historical precedent. The mistake is to adopt the form of their forebears, rather than siphoning their inflammatory intentions. The energy of radical revision to which Yeh's texts defer, is converted into a retrograde docility.

Considering that each of Yeh's *Bad Ideas for a Sound Mind* satisfies many of the tenets of a non-cochlear sonic art, I find myself in the discomfited position of having to go back to my handiwork to rip out the seams, let out the hems, and restitch along new chalk lines. I knew full well when I published *In The*

Blink Of An Ear that its thesis, like all theses, was subject to change. I wrote, at the time, "Since I do not believe in the concept of 'the final word' on a subject, this book is not one. It is a comment on a blog, a single locution in an ongoing conversation."[76] And I know now, as I baste along the outline of a new pattern, that these alterations are themselves merely fodder for future alterations. This is how we assemble our vestments: piecemeal and provisionally.

As with Yeh's *Bad Ideas*, *The String and the Mirror* also includes multiple instantiations of Christof Migone's *Record Release* (2013). Each consists of circular piles of PVC pellets on the floor. The subtitles of the three works supply information about what these pellets are and how they might be used. The first subtitle is "*(12" black)*"; the second, "*(10" transparent)*"; and the third, "*(7" white)*." The pellets are the raw materials for the production of a 12-, 10-, and 7-inch vinyl record. In this version of the work, Migone initiates a process of imaginative assembly. Viewing the piles of pellets, the spectator mentally constructs the three records referenced in the subtitles. Simultaneously, or perhaps, alternately, the spectator deconstructs the experience of handling and playing vinyl records, reatomizing the fecund platters into the raw, inert materials set upon the gallery floor.

An earlier version of *Record Release*, dated 2012, involves Migone distributing the number of pellets required to make a 12-inch vinyl record. Intermittently, over the course of many months, he personally hands one pellet to a friend or an acquaintance, photographs the pellet in the palm of the recipient's hand, and supplies the recipient with a card certifying ownership of a portion of *Record Release* and bearing the number of the pellet. Migone is now making an iteration of *Record Release*, subtitles *(7-inch)*, which makes the previous versions feel like studies for the final, complete work. In this version, Migone will occupy a particular site for a few days. He suggests sites including, "a museum, a city block, a road, a record plant, a printing press, a refinery, a prison, an archive, a science lab, a hospital, a TV station, an airport."[77] At the site, during the allotted time period, he will distribute the number of pellets required to make a 7-inch record, handing each one, personally, to a visitor, a passerby, a resident, an employee. He will videotape each exchange. The audio from this video will then be assembled into an audio work to be pressed on a limited-edition run of 7-inch records. Migone imagines working at sites that

contain two distinct types of space: public and off-limits, or above and below ground, for example. The audio from each type of space would be presented on alternate sides of the record.

The previous versions of *Record Release* comfortably accommodate non-cochlear precepts. They reference sound without producing it. They function discursively, asking the spectator to produce a narrative or a history that connects the material of the work (the pellets) to a familiar object of cultural conveyance. The 2012 version enacts a social interaction between Migone and pellet recipients. It also implies a subtle critique of market conventions such as collecting and the numbered edition. Yet, these versions stop short of closing the circuits they initiate. The new version of the work provides a return path for the project's charge. Conception and reception are linked in ways that complicate each along the chain of dissemination. The work now generates and distributes productive forces through its nodes. By activating the record as a platform for the reproduction of recorded sound, Migone revives the most vital aspect of the project. The record itself is both the work's substrate and the location of its semantics. To sublimate the record, as in the previous versions, is to muzzle the work. By putting the record back in play, Migone reattaches the material to what's being done with it. As a result, what's being done with it begins to do something itself. The pellets are no longer inert matter, merely suggestive of that active experience of listening to a record. Where, once, they simply signaled "record," they now become the record's signal. At the same time, the "record" is now a record of social exchange, of site, of time, and of the exploded, diagrammatic construct of its potential for signification. As Migone writes of the project, "the act of disseminating the record produces the record."[78] This version of *Record Release* productively engages the nested senses of distribution that ride the literal and figurative surfaces of the vinyl record.

8 Information—Politics—Transcendence

We are now one hundred years clear of the first readymade. In the visual arts, Duchamp's example has been widely embraced and liberally interpreted. Since the 1960s, art has foregrounded the conceptual, concerning itself with questions that the eye alone cannot answer, questions regarding the conditions of art's own possibility. Linguistic conceptualism volunteers art's own corpus, its own ontology, as a test case for the definition of categories. To question the conditions under which art can and should constitute itself is, by association, to question the existential sanctity of all categories and phenomena. To question the identity and use of art is to crack open the egg from which both life and omelettes emerge. As a result, what could once be comfortably called "visual" art now overflows its retaining walls. If a nonretinal visual art is liberated to ask questions that the eye alone cannot answer, then a conceptual, non-cochlear sonic art appeals to concerns that exceed the jurisdiction of the ear.

In my previous book, in countless talks, and in my teaching, I have agitated for the sonic arts to follow the example of linguistic conceptualism. Perhaps prematurely, perhaps complacently, I assumed that, in the visual arts, the debate was settled. But, in the summer of 2013, we suddenly found ourselves returned to a perceptual, ambient mindset. It would be too simple to ascribe blame to the recent embrace of sound in the visual art world. In fact, the acceptance of sound may be as much an effect as a cause. But it's hard for me to believe that sound and the ambient revival are unrelated. The question, finally, is: Why? What combination of factors has delivered us back to this once-rejected mindset, in which tuning out and turning on are considered worthwhile aspirations for artistic experience? To be frank, I don't think I can successfully diagnose this problem. It's too soon. This text is too brief. I probably lack the forensic tools to unearth the exculpatory evidence. And, besides, I am skeptical of simple cause-and-effect equations in the meanderings of cultural inclinations. Nevertheless, provisionally, I propose these suspects in the case of the resuscitated ambient:

Information

My first hunch is that we have succumbed to the much-maligned "information overload." It seems to me that this theory could hold some historical water. At the very least, some archive-rat art historian could assemble a credible set of dots and then connect them with personae, publications, and productions to make a compelling case for a "new anti-informationism." One could, for example, start with the exhibition "Information," organized by Kynaston McShine at MoMA in 1969–70.[79] The show included work from the front lines of what was not yet called "Conceptual Art"; works by Vito Acconci, Robert Barry, John Baldessari, Art & Language, Mel Bochner, Daniel Buren, Dan Graham, Hans Haacke, Christine Kozlov, Joseph Kosuth, Sol LeWitt; the list, believe me, goes on. Next, one could draw a parabolic arc through Marshall McLuhan to the work of Friedrich Kittler, pausing briefly at his phrase, "the bottleneck of the signifier," before easing the cork out of the bottle and allowing the genie of information (or data, as Kittler likes to call it) to infest and invest the so-called real with its semantic agnosticism. On a more popular tip, our forensic historian might touch on James Gleick's 2011 book, *The Information*, which takes the very twenty-first-century view that everything has always boiled down to information, but that we are only now coming to terms with this fact. Via the information technology that sits in everyone's laps and pockets and neoprene messenger bags, we are now, for the first time in "recorded history" (note that this phrase itself is dependent upon and, for all intents and purposes, identical with, a retroactively expanded version of the information age), engaging with our world not as pure phenomena, not as portent of the wishes of the gods, not as a representation of something else nor as something demanding to be represented, but as a data set. And this, according to Gleick, sounding something like Kittler, sounding something like McLuhan-via-McShine, is what the universe is: a vast data set; love it or leave it. Forensic Theory Number One would suggest that leaving is the preferable option. Who wants to live in either the macro-reality of the universe-as-data-set, or in the micro-reality of triple-digit inbox numbers? Wouldn't a bath in an ascending oval of glowing fuchsia be preferable? I'll pause, but briefly, to point out that much of the work I'm corralling under the rubric of ambience, is, in fact, dependent upon and, in many cases, made of, the ones and zeroes of data in its most literal technological materiality.

Politics

Politics is always a suspect. Art has the twofold problem of, first, deciding if it is the place (even *a* place) for politics to be engaged, and second, of formulating a response that is appropriate to the specific politics of its time and place. Every good artist wakes up sweating the Adornian edict about the barbarity of post-Auschwitz poetry. The politics of this particular moment (the 2010s) in this particular place (let's say, specifically, New York, and generally, the United States) present a particularly frustrating construct with which to engage. I am under no illusion that the politics of our moment are any more corrupt than those of previous regimes. The difference, hearkening back to our previous suspect, is the amount of information to which we have access. We know more about the conspiracies, constipations, and contradictions of our present government than previous national subjects have known. While the net effect of this knowledge is ultimately for the greater good (thank you Chelsea Manning, Edward Snowden, Julian Assange), the short-term emotional impact is pretty disheartening. It is better that we know that Monsanto has engineered the entire agricultural system for their own benefit (and at our expense); that we are aware of shadowy private firms contracted by the US government to do its dirty work; that the military employs unmanned aircraft to stealthily cross national borders and kill human beings (US citizens and foreign nationals) with only the skimpiest, clandestine, judicial oversight; that the two major political parties in the United States have transformed their legislative mandate into a game of trivial pursuit focused on the quantity of cheese in their respective wheels. It is better that we know. But knowing sucks. It is depressing. It is sickening. It makes us cynical and skeptical. Knowing whispers in the ears of the oft-invoked angels of our better nature: "Withdraw, angels, no good can come of this." Maybe ambience is a kind of assisted living facility for these angels; a place where all their needs are met and they needn't lift a finger.

Transcendence

As politics has failed us, so too has religion. There are plenty of bureaucratic snafus we could point to. But ultimately, religion was designed to establish, consolidate, and maintain power; to ascribe ignorance and then use that

ignorance against those so described. The more we know, the harder it is to persuade us of the unknown, not to mention, the unknowable. Yet, human beings cling stubbornly, desperately, to the need to feel that there is something that is not subject to our statutes, beyond the reach of physics, outside the law, unrestricted by human moral codes, unbeholden, even, to proofs of logic, reason, test, or testimony. Undoubtedly, this need stems from our own frustrations at our utter beholdenness to all these injunctions and many more besides: social, psychological, civil; the shortcomings of our species and our selves. The ambient is godlike: unknown, unknowing, unknowable. Turrell's light signifies transcendence. Indeed, his whole backstory is a pilgrim's tale. And, as I've suggested, his light is simply a form of documentation, an affidavit testifying to his journey, his piety, and his sacrifice.

This ambient moment is a last gasp, a burst of longing for what we know is lost. I thought we had fought our way clear of such longings. I thought we had reconciled ourselves to our irredeemable immanence. I thought conceptual art was a symptom of our new disease: the death of god, the birth of having to deal with it. Alas, we're not so sick yet.

Notes

1 Sterne, Jonathan, *The Audible Past: Cultural Origins of Sound Reproduction*, Durham, NC and London: Duke University Press, 2003, 15.
2 Kahn, Douglas, "Artistic Interoception: Let Me Hear My Body Talk, My Body Talk," in *Relive: Media Art Histories*, edited by Sean Cubitt and Paul Thomas, Cambridge, MA: MIT Press, November 2013.
3 Cage, John, *Silence*, Middletown, CT: Wesleyan University Press, 1961, 51.
4 Quoted in Kahn, Douglas, "Artistic Interoception: Let Me Hear My Body Talk, My Body Talk," in *Relive: Media Art Histories*, edited by Sean Cubitt and Paul Thomas, Cambridge, MA: MIT Press, November 2013. Kahn's citation: James, Turrell, "Interview by Esa Laaksonen (Blacksburg, VA, 1996)," *Architectural Design*, Vol. 68, No. 7–8 (1997), 76–79. See: http://www.ark.fi/ark5-6_96/turrelle.html (accessed September 29, 2013).
5 Kim-Cohen, Seth, "The Hole Truth," *Artforum*, November 2009, 99–100.

6 http://www.nytimes.com/2013/06/16/magazine/how-james-turrell-knocked-the-art-world-off-its-feet.html?pagewanted=all (accessed September 29, 2013).
7 http://www.nytimes.com/2013/07/26/arts/design/robert-irwins-light-and-space-work-returns-to-the-whitney.html?pagewanted=all (accessed September 29, 2013).
8 Kant, Immanuel, *Critique of Judgment*, translated by John Henry Bernard, New York: Hafner Press, 1951, 41.
9 For example, the Siegelaub-curated "Xerox Book" and "January 5 to 31, 1969" exhibitions. For a trove of information on Siegelaub, see Primary Information's archive of Siegelaub's publications at: http://primaryinformation.org/index.php?/projects/seth-siegelaub-archive/ (accessed October 1, 2013).
10 Krauss, Rosalind, "Sculpture In The Expanded Field," in *The Originality of the Avant-Garde and Other Modernist Myths*, Cambridge, MA: MIT Press, 1986, 289.
11 Kreidler, "Gema-Aktion, Product Placements" (2008), 1: 53 http://www.youtube.com/watch?v=EAptRZlwziA&feature=relmfu (accessed September 29, 2013).
12 http://www.kreidler-net.de/english/works/fremdarbeit.htm (accessed September 29, 2013).
13 Ibid.
14 Ibid.
15 See my *In The Blink Of An Ear: Toward A Non-Cochlear Sonic Art*, New York: Continuum, 2009, *passim*.
16 Sterne, Jonathan, "The Theology of Sound: A Critique of Orality," *Canadian Journal of Communication*, Vol. 36 (2011), 207–25.
17 Ibid., 213.
18 Ibid., 215.
19 Ibid., 220.
20 Ibid., 219.
21 Cox, Christoph, "Beyond Representation and Signification: Toward a Sonic Materialism," *Journal of Visual Culture*, Vol. 10, No. 2 (August 2011), 148.
22 Cox, Christoph, "Sonic Philosophy," *ArtPulse Magazine*, September 2013. http://artpulsemagazine.com/sonic-philosophy (accessed September 10, 2013).
23 Ibid.
24 http://www.nytimes.com/2013/06/21/arts/design/james-turrell-plays-with-color-at-the-guggenheim.html?ref=arts&_r=0 (accessed September 29, 2013).
25 Eno, Brian, liner notes for *Discreet Music*, EG Records, 1975, unpaginated.

26 http://www.tanyabonakdargallery.com/press_release.php?exhibit_id=290 (accessed September 29, 2013).
27 See, for example, the Guggenheim's web page for the Turrell exhibition: http://web.guggenheim.org/exhibitions/turrell/#introduction (accessed September 29, 2013), and the first question in this Eliasson interview in *BOMB* magazine, http://bombsite.com/issues/88/articles/2651 (accessed September 29, 2013).
28 It is included, for instance, in this article by Geeta Dayal on Eno's collaborations with Peter Schmidt: http://rhizome.org/editorial/2009/oct/21/brian-eno-peter-schmidt-and-cybernetics/ (accessed October 1, 2013).
29 Eno, Brian, liner notes for *Discreet Music*, EG Records, 1975, unpaginated.
30 Morton, Timothy, "'Twinkle, Twinkle, Little Star' as an Ambient Poem; a Study of a Dialectical Image; with Some Remarks on Coleridge and Wordsworth," *Romantic Circles Praxis Series*, "Romanticism & Ecology," November 2001, unpaginated. http://www.rc.umd.edu/praxis/ecology/morton/morton.html (accessed September 2, 2013).
31 Morton, Timothy, "'Twinkle, Twinkle, Little Star' as an Ambient Poem; a Study of a Dialectical Image; with Some Remarks on Coleridge and Wordsworth," *Romantic Circles Praxis Series*, "Romanticism & Ecology," November 2001, unpaginated, http://www.rc.umd.edu/praxis/ecology/morton/morton.html (accessed September 2, 2013).
32 http://www.tanyabonakdargallery.com/press_release.php?exhibit_id=290 (accessed September 29, 2013).
33 Morton, Timothy, "'Twinkle, Twinkle, Little Star' as an Ambient Poem; a Study of a Dialectical Image; with Some Remarks on Coleridge and Wordsworth," *Romantic Circles Praxis Series*, "Romanticism & Ecology," November 2001, unpaginated, http://www.rc.umd.edu/praxis/ecology/morton/morton.html (accessed September 2, 2013).
34 Eno, Brian, liner notes for *Discreet Music*, EG Records, 1975, unpaginated.
35 Eno, Brian, liner notes for *Neroli*, All Saints Records, 1993, unpaginated.
36 I say "Deleuzean-derived" here because Deleuze often takes pains to distance himself from such material monism, for example, "The rhizome is reducible neither to the One nor the multiple. It is not the One that becomes Two or even directly three, four, five, etc. It is not a multiple derived from the One, or to which One is added (n + 1)." (Deleuze, Gilles and Guattari, Felix, *A Thousand Plateaus*, translated by Brian Massumi, Minneapolis: University of Minnesota Press, 1987, 21.) Rather than Deleuze, it tends to be Deleuz*eans* who fall into this trap.

37 Morton, Timothy, "Earworms," a talk delivered at Tuned City, Brussels, June 2013. http://ecologywithoutnature.blogspot.com/2013/07/earworms-mp3.html (accessed September 2, 2013).
38 http://www.tanyabonakdargallery.com/press_release.php?exhibit_id=290 (accessed September 29, 2013).
39 Eno, Brian, liner notes for *Discreet Music*, EG Records, 1975, unpaginated.
40 Bochner, Mel, "The Serial Attitude," *Artforum,* December 1967, 28.
41 Reich, Steve, "Music as a Gradual Process," *Writings On Music: 1965—2000*, Oxford: Oxford University Press, 2004, 9.
42 LeWitt, Sol, "Sentences on Conceptual Art," in *Conceptual Art: A Critical Anthology*, ed. Alexander Alberro and Blake Stimson, Cambridge, MA: MIT Press, 1999, 107.
43 Eno, Brian, liner notes for *Discreet Music*, EG Records, 1975, unpaginated.
44 Eno, Brian, "Pro Session: The Studio as Compositional Tool," lecture delivered at New Music New York, the first New Music America Festival sponsored in 1979 by the Kitchen, excerpted by Howard Mandel, *Down Beat* 50, July 1983 (Part 1) and 51, August 1983 (Part 2), unpaginated. http://music.hyperreal.org/artists/brian_eno/interviews/downbeat79.htm (accessed September 7, 2013).
45 Eno, Brian, "Pro Session: The Studio as Compositional Tool," lecture delivered at New Music New York, the first New Music America Festival sponsored in 1979 by the Kitchen, excerpted by Howard Mandel, *Down Beat* 50, July 1983 (Part 1) and 51, August 1983 (Part 2), unpaginated. http://music.hyperreal.org/artists/brian_eno/interviews/downbeat79.htm (accessed September 7, 2013).
46 Eno, Brian, "Pro Session: The Studio as Compositional Tool," lecture delivered at New Music New York, the first New Music America Festival sponsored in 1979 by the Kitchen, excerpted by Howard Mandel, *Down Beat* 50, July 1983 (Part 1) and 51, August 1983 (Part 2), unpaginated. http://music.hyperreal.org/artists/brian_eno/interviews/downbeat79.htm (accessed September 7, 2013).
47 http://www.bloomberg.com/video/artist-james-turrell-new-guggenheim-installation-HVlYYS38SPa~Tn1GwCGeqw.html.
48 http://web.guggenheim.org/exhibitions/turrell/#introduction (accessed September 29, 2013).
49 http://www.tanyabonakdargallery.com/press_release.php?exhibit_id=290 (accessed September 29, 2013).
50 http://www.nytimes.com/2013/06/21/arts/design/james-turrell-plays-with-color-at-the-guggenheim.html?ref=arts&_r=0 (accessed September 29, 2013).

51 Shaw, Lytle, *Fieldworks: From Place to Site in Postwar Poetics,* Tuscaloosa: University of Alabama Press, 2013, 248.
52 Fried, Michael, *Art and Objecthood,* Chicago: University of Chicago Press, 1998, 167. (The essay, "Art and Objecthood," was originally published in 1967.)
53 Eno, Brian, "Pro Session: The Studio as Compositional Tool," lecture delivered at New Music New York, the first New Music America Festival sponsored in 1979 by the Kitchen, excerpted by Howard Mandel, *Down Beat* 50, July 1983 (Part 1) and 51, August 1983 (Part 2), unpaginated. http://music.hyperreal.org/artists/brian_eno/interviews/downbeat79.htm (accessed: September 7, 2013).
54 Morton, Timothy, "'Twinkle, Twinkle, Little Star' as an Ambient Poem; a Study of a Dialectical Image; with Some Remarks on Coleridge and Wordsworth," *Romantic Circles Praxis Series,* "Romanticism & Ecology" (November 2001), unpaginated. http://www.rc.umd.edu/praxis/ecology/morton/morton.html (accessed September 2, 2013.)
55 Morton, Timothy, "Earworms," a talk delivered at Tuned City, Brussels, June 2013. http://ecologywithoutnature.blogspot.com/2013/07/earworms-mp3.html (accessed September 2, 2013).
56 http://www.tanyabonakdargallery.com/press_release.php?exhibit_id=290 (accessed September 29, 2013).
57 Kahn, Douglas, *Noise Water Meat,* Cambridge, MA: MIT Press, 2001, 190.
58 For an exhaustive survey of these effects, see Krauss, Rosalind, "Grids," October, Vol. 9 (Summer, 1979), 50–64.
59 For images of this painting, see: http://www.thing.net/~sg/work.html#CountryScene (accessed September 11, 2013).
60 Veal, Michael, *Dub: Soundscapes and Shattered Songs in Jamaican Reggae,* Middletown, CT: Wesleyan University Press, 2007, 207–08.
61 Ibid., 45.
62 For a bewilderingly naïve version of this kind of denial, see Gary Gutting's post for "The Stone" blog, in the July 15 New York Times. http://opinionator.blogs.nytimes.com/2013/07/14/mozart-vs-the-beatles/?hp (accessed September 26, 2013).
63 For a critique of my positions on the sociality of music, see Kane's, Brian, "Musicophobia, or Sound Art and the Demands of Art Theory." http://nonsite.org/article/musicophobia-or-sound-art-and-the-demands-of-art-theory (accessed September 29, 2013).

64 Kane, Brian, *Sound Unseen: Acousmatic Sound in Theory and Practice*, Oxford: University of Oxford Press, unpaginated manuscript, forthcoming.
65 Ibid.
66 Lyotard, Jean-François, *The Inhuman: Reflections on Time*, translated by Geoffrey Bennington and Rachel Bowlby, Stanford: Stanford University Press, 1991, 28–29.
67 http://www.moma.org/interactives/exhibitions/2013/soundings/exhibition/ (accessed September 17, 2013).
68 Ibid.
69 Kirkegaard, Jacob, *AION*, DVD, Fonik Works 01, 2011.
70 Neuhaus, Max, "Sound Art?" First published as an introduction to the exhibition *Volume: Bed of Sound*, P.S.1 Contemporary Art Center, New York, July 2000. http://www.max-neuhaus.info/bibliography/ (accessed September 23, 2013).
71 Dworkin, Craig, *No Medium*, Cambridge, MA: MIT Press, 2013, 30.
72 Ibid., 28.
73 Ibid., 32.
74 Ibid., 32–33.
75 http://www.lisa-cooley.com/exhibitions/the-string-and-the-mirror-organized-by-lawrence-kumpf-and-justin-luke/images/1461 (accessed September 25, 2013).
76 Kim-Cohen, Seth, *In The Blink Of An Ear: Toward a Non-Cochlear Sonic Art*, New York and London: Continuum Publishing, 2009, xxiii.
77 Migone, Christof, email to the author, dated September 11, 2013.
78 Ibid.
79 http://www.moma.org/learn/resources/archives/EAD/InfoExhibitionRecordsf (accessed September 29, 2013).

Part Two

Shallow Listenings: Sounds, Silences, Scenes, and Sites

1

Nothing That Is Not There And The Nothing That Is: Doug Aitken's *Sonic Pavilion*

In 1979, Brazilian mining magnate, Bernardo Paz, enlisted Alexander Haig as his advisor for a meeting with Deng Xiaoping in Beijing. Chinese officials pulled Paz aside to let him know that he didn't need the services of a "saint" to negotiate trade with the Chinese leader. Haig's apparent canonization stemmed from his role (as Henry Kissinger's military assistant) in facilitating the 1972 Nixon-Mao summit. The Chinese directed Paz to a more pragmatic envoy, an Israeli businessman who split his time between Jerusalem and Beijing. Sainthood, it would seem, only gets you so far in China. Ultimately, worldly connections and ground-level knowledge prove more useful. In recent years, Paz has turned his attention and wealth to art. At Inhotim, his sprawling complex in Brumadinho, Brazil, Paz has combined the most effective aspects of Chinese market pragmatism with artistic saintliness. Paz has assembled a team of curators with real-world know-how and asked them to populate Inhotim's landscaped botanical paradise with otherworldly works by the art world's beatified. The team, led by New York–based Alan Schwartzman, and including Jochen Volz (organizer of the international selection of the 2009 Venice Biennale) and Rodrigo Moura, has responded faithfully to Paz's call. At one end of the property, Chris Burden's *Beam Drop* thornily crowns a barren hilltop. Across the way, Olafur Eliason's *By Means of a Sudden Intuitive Realization*, proposes an on-again/off-again, strobe-lit ecstasy. At the center and on the outskirts of this town-sized fantasia, we find a spatially diffuse constellation of grand projects by Matthew Barney, Hélio Oiticica, Janine Antoni, Janet Cardiff, Dominique Gonzalez-Foerster, Dan Graham, and Rirkrit Tiravanija, to name but a few.

Inhotim, which takes its name from a contraction of "Senhor Tim" (a reference to an Englishman who once owned the land it now occupies), is located two hours from the nearest international airport, 438 kilometers from Rio, 563 kilometers from Sao Paulo. The 1600-acre facility morphs and distorts simple identifications such as museum, sculpture park, or botanical garden, becoming something hitherto unnamed and unimagined. Paz and his park suggest nothing so much as Willy Wonka and his chocolate factory—an analogy that provides a good sense of the scale, ambition, and style of the man and the place. Beyond the coifed inner section of the complex, referred to as "the park," a group of large-scale projects are installed in the adjacent forest and farmland. Among these is Burden's *Beam Drop*, a game of pick-up sticks played with steel I-beams (Moura describes it as "a 3-D Pollock as if made by God"); a pavilion for new work by Cardiff and George Bures Miller; and another that will gather Oiticica's five 1973 *Cosmococa* installations in one space for the first time. Other projects are nearly finished and will formally open to the public in October. These include a new sculptural installation by Barney that echoes themes and forms in his film installation running continuously in the park, and a swimming pool by Jorge Maachi in the form of an open address book: the deck verso, the pool recto, alphabetic tabs forming the stairs leading down into the water.

Perhaps the most ambitious of these ambitious projects is Doug Aitken's *Sonic Pavilion*, a work commissioned by Inhotim and installed on a thickly forested hilltop at the north end of the property. Five years in the making, *Sonic Pavilion* was finally up and running when I visited the third week of August, 2009, with only the *t* and the *i* in "cosmetic" yet to be crossed and dotted. A good portion of the five-year installation was spent creating a hole a mile deep in the earth. As Aitken explained to me, the difficulty stemmed from the necessity of drilling a dry hole approximately 2 feet in diameter, with no groundwater seepage. Using specialized equipment, the hole was painstakingly drilled, emptied, drilled deeper, emptied again, and so on before being lined with concrete. Aitken then lowered a battery of microphones and accelerometers into the hole at varying depths. At the top, the sounds of the earth's rotation and the shifting of seismic plates are transposed into the range of human hearing and amplified by eight loudspeakers arrayed around the

circular interior of the structure. The pavilion itself is accessed by means of a spiraling, ramped walkway that starts outside, following the contour of the hill, before transitioning into a winding concrete corridor. Inside the glass pavilion, the spiral path continues on a raised wooden ramp that doubles as the room's only seating.

Aitken's printed project description speaks of "translating" the earth's movement: "This artwork strives to provide a new relationship to the earth we constantly walk upon and occupy, revealing its mysterious and living dialogue." More than once during my visit, Aitken mentioned his desire to avoid mediation. But he had reconciled himself to the fact that decisions about the depth of the hole, the choice of microphones, the transposition of frequencies, and the sound mix in the pavilion all required unavoidable artistic interventions. Still, he told me, he wanted to create a work with "no beginning and no end," something that was "deep-rooted, pure, and direct." This aspiration for a raw, unadulterated experience often drives artists to work with sound. There is a pervasive sense—not just among visual artists who turn to sound as an alternative, but also among artists who work primarily with sound—that the sonic is truer, more immediate, less susceptible to manipulation than the visual, as if the adjective *sound* (meaning solid, durable, stable) should somehow constitute the noun.

This tendency has a history. In "Primal Sound," an essay written in 1919, the poet Rainer Maria Rilke fantasizes about dropping a phonograph needle into the skull's coronal suture (the line caused by the fusing of bone plates during infancy):

> What would happen? A sound would necessarily result, a series of sounds, music . . . What variety of lines, then, occurring anywhere, could one not put under the needle and try out? Is there any contour that one could not, in a sense, complete in this way and then experience it, as it makes itself felt, thus transformed, in another field of sense?[1]

Rilke's fantasy announces the dream of a unified field of the senses, bridging "the abysses which divide the one order of sense experience from the other," of "completing," to use Rilke's verb, our experience of the world.[2] The implication is that there is a completeness *out there*, and that any feeling we may have

of incompleteness or insufficient understanding, is merely a product of our inadequate perceptual faculties *in here.*

It is hard to imagine the listener for whom the sound of the coronal suture would complete an experience of it. Perhaps, a physiologist's visual inspection could convey information from the palimpsest of the skull: about the brain it once housed, the body of which it was part, the family from whom it descended. But unless physiologists were retrained and medical apparatus redesigned, dropping a phonographic needle into the suture's groove would be meaningless. Like every other medium, sound derives its meaning from context, from intertextuality, from the play of difference in its conceptual and material strata.

Sonic Pavilion houses Rilkean ambitions of an experience that would be immediate, both unmediated and instantaneous. Aitken told me that "*Sonic Pavilion*" presents "a moment that doesn't rely on past or future." This mythical moment, the *augenblick* (the blink of an eye), has been pondered by philosophers from Kierkegaard and Nietzsche to Husserl and Heidegger. In the visual arts, the *augenblick* found purchase with the advent of minimalism in the 1960s. Donald Judd's "specific objects" seemed to demand an all-at-once response that indicated phenomenology as the apposite theoretical rubric for decoding minimalism's apparent objectivity. But in the 1970s, taking their lead from Jacques Derrida's critique of phenomenology, critics began to think that the encounter with a minimalist sculpture requires more than the instantaneous now. Instead, they proposed, minimalism demands an encounter not merely with the object, but also with its context: the exhibition space, the institution, economics, gender, sociality, and politics. By 1990—notably in an essay titled "The Blink of an Eye"—Rosalind Krauss characterizes the concept of the "now" as "myth, spatial or mechanical metaphor, and inherited metaphysical concept."[3] This is a damning indictment of traditional art history's confidence in the "natural sign" of the art object. If the art work's meaning making must necessarily rely on its context, then investment in instantaneous experience is wasted on the empty promise of metaphysical abundance.

I take Aitken at his word when he says that the low, steady rumble of *Sonic Pavilion* is the sound of the earth a mile below its surface. But are we hearing stone moving against stone? Loose material shifting as solid material

beneath it gives way? To pedantically supply this information would reduce the "mysterious and living dialogue" to the didactic monologue of a science exhibit. Instead, *Sonic Pavilion* attempts to open a dialogic space in which the visitor is free to respond to the sonic environment. I couldn't help comparing the sound of the pavilion to other worldly sounds: wind across a microphone, jet engines from inside the jet, the massive transformer outside my bedroom window, and to musical and artistic sounds: the Theater of Eternal Music's *Inside The Dream Syndicate—Day of Niagara* (1965), Peter Ablinger's *Weiss/Weisslich* 6 for 12 cassette recorders (1992), and most uncannily, Nurse With Wound's *Salt Marie Celeste* (2003). It is difficult to see how these analogical comparisons might yield true dialogue. Instead, it is the visitor, rather than science, who supplies the hermeneutic monologue. The sound of the pavilion, though audible, is mute, unresponsive, aloof, and elusive, avoiding the visitor's questions and declining to identify its sonic sources except in the most general way. *Sonic Pavilion* holds out for an immersive, meditative, and ultimately, mystical type of listening experience.

This kind of aural experience has a history too. In 1948, Pierre Schaeffer used the term *acousmatic* to describe the listening required by his newly invented *musique concrete*. Schaeffer, an engineer at the Office de Radiodiffusion Télévision Française, manipulated, first, phonograph records, and, later, edited pieces of magnetic audiotape, isolating what he referred to as the *objet sonore* (the sonic object). *Acousmatic* listening asks that the listener engage sound without consideration of who or what might have made the sound, with what materials, or for what purpose. As legend would have it, the term, *acousmatic*, derives from Pythagoras who lectured from behind a curtain separating his inner circle of disciples from an outer circle, known as the *akousmatikoi*. The disciples situated behind the curtain were privy to more complete and detailed information than the *akousmatikoi*, who could only hear, and not see, Pythagoras as he lectured. Schaeffer's use of the term *acousmatic*, prescribes a listening that similarly denies the listener access to information.[4] This kind of informational inequity has serious ramifications. George Akerlof, the Nobel Laureate economist, has shown that the asymmetric distribution of information rewards deceit at the expense of fairness: "Dishonest dealings tend to drive honest dealings out of the market."[5]

Remembering Bernardo Paz's meeting with Den Xiaoping, we will recognize what Aitken is up to. He uses sound to suggest the saintliness of Alexander Haig, who was there, at the source: the Nixon-Mao summit. The sound of the *Sonic Pavilion* was there, too, at the source: inside the earth. Aitken refuses the utility of facts, dispensing information asymmetrically. He comes to this encounter with the saintly source at his elbow, possessor of both the knowledge and the key that might unlock it. It's no wonder that Paz is drawn to this project.

In 1973, one year after the Nixon-Mao summit organized by Kissinger and Haig, Daniel Ellsberg, former special assistant to the US Assistant Secretary of Defense, testified at Joint Senate Hearings. Ellsberg recounted chastising newly appointed Secretary of State, Henry Kissinger, about the latter's book *Nuclear Weapons and Foreign Policy*, published four years earlier:

> You will feel like a fool for having written all that without having this special information on which to judge. . . . But that feeling will only last for a week or two, because after a week or so of having four star generals bring you in special brief cases, special pouches, books that are available only to you and your boss and a few other people . . . and certainly not to members of the public, you will forget that you were once a fool and remember only that everyone else is a fool who does not have this information.[6]

Implicitly, Aitken is telling us that we, too, are fools. According to Aitken, *Sonic Pavilion* puts us in contact with "something we haven't had access to." He and Rilke (and a host of artists in between) are telling us that we haven't been seeing—or hearing—the whole picture. We are blindered, blinkered, the wool has been pulled over our eyes (or ears). And although neither Rilke nor Aitken claim to be the creator of the secret sensory experience to which he grants access, each announces himself as the gatekeeper of the unsensed, with the power to "complete" our experience.

With the inevitability that emerges only in retrospect, I realize that my trip to Inhotim has been guided by the twin rationales of the saint and the fool. The saint is not simply the one who knows the truth, not simply the one who shares it, but also the one who makes inconceivable efforts, endures unimaginable hardships, to deliver the truth to those who cannot see it. Before

I knew I would be going to Brazil, I had begun reading *Conquest Of The Useless*, Werner Herzog's journals from the period during which he made the film, *Fitzcarraldo*. At Inhotim, I found it increasingly difficult to distinguish the spirit informing the transcendental emptiness of Aitken's hole from the saintly foolishness of Herzog and his crew of thousands of native Peruvians endeavoring to hoist a 320-ton steamship over an Amazonian mountain. More than once, in describing the glorious folly of *Sonic Pavilion*, Aitken himself, unaware of the book in my bag, conjured the name *Fitzcarraldo*, the emblem of saintly perseverance and foolish conviction in the South American jungle. But a distinction must be made between the saintly foolishness of Herzog's *Fitzcarraldo* and that of *Sonic Pavilion*. For Herzog, the only truth that can be shown is the truth of showing. As he has declared in interviews, "cinéma vérité is the accountant's truth."[7] The vérité of *Fitzcarraldo* is not a vérité of things. The film does not simply deliver the real ship or the real mountain or the real Asháninka people. The realism of *Fitzcarraldo* is a realism not of being, but of doing.

Film critic, Paul Arthur, writes that Herzog's production choices, "recapitulated on a material level the dramatic arc of the fictional narrative."[8] And, yes, in one sense, the production follows from the exigencies of the narrative. But, in another sense (one we have to take seriously if we want to talk about a "material level"), the narrative follows the production. The film and the narrative it presents are the *products* of the production. Thinking in this direction, the narrative recapitulates on an allegorical level the arc of everything that went into making the film. In *Conquest of the Useless,* Herzog says that the scene in which the ship is dragged over the mountain is a metaphor for something he cannot name. The truth of the film is not something Herzog knows and will reveal to us. The truth of the film is the truth of the making of the film. What we see on the screen is not itself the truth, but the truthful intimation of a multitude of actions: not the being of things, but of things being done. This is a kind of truth that, although unseeable, is necessary to the realization of what we see.

It is seductive to think that the truth is something *out there* and that knowing is simply a matter of transporting that something *in here*. Herzog warns against this seduction: "Facts do not constitute the truth."[9] Aitken's

Sonic Pavilion equates the facticity of sensory experience with truth, but then dodges the responsibilities of this equation. Instead, the *Pavilion* solicits a blind faith in the fidelity of experience. Like the *akousmatikoi*, forced to take Pythagoras at his word, the listener has no way to judge the veracity or meaning of the sound and no freedom to meaningfully respond. If saintliness includes a requisite foolishness, it is this: insisting that there is something out there in the blankness of the heavens or a hole. Coming to terms, instead, with the burden of knowing there is nothing *out there* that is not also *in here* does not constitute idealism, or a negative ontology, or even nihilism, but an honest act of consciousness, of conscientiousness, of conscience. Even if all we have to work with is nothing, there's still room and reason for preposterous devotion to earthly pursuits. Digging a hole in the ground can not exhume the real. But digging a hole in the ground is, *ex nihilo*, real.

A substantially different and shorter version of this essay appears in the November 2009 issue of Artforum *and was reprinted in* Sound, *edited by Caleb Kelly, part of the Documents of Contemporary Art series published by MIT Press and Whitechapel Gallery.*

Notes

1. Rilke, Rainer Maria, "Primal Sound," as quoted in Kittler, Friedrich, *Gramophone, Film, Typewriter,* translated by Geoffrey Winthrop-Young and Michael Wirtz, Stanford: Stanford University Press, 1999, 41.
2. Ibid., 42.
3. Krauss, Rosalind, "The Blink of an Eye," in *The States of "Theory": History, Art, and Critical* Discourse, ed. David Carroll, Stanford: Stanford University Press, 1990, 176.
4. This legend has been convincingly and finally laid to rest by Brian Kane in his *Sound Unseen: Acousmatic Sound in Theory and Practice*, Oxford: Oxford University Press, 2014.
5. Akerlof, George A, "The Market for 'Lemons': Quality Uncertainty and the Market Mechanism," *The Quarterly Journal of Economics*, Vol. 84, No. 3 (August 1970), 495.

6 Daniel Ellsberg, former special assistant to the US Assistant Secretary of Defense, testifying at the Joint Senate Hearings held on May 17, 1973 by the Committees on the Judiciary and Government Operations, recounting a conversation in December, 1968 with then newly appointed Secretary of State, Henry Kissinger.
7 http://www.focusfeatures.com/article/the_ecstatic_truth_of_werner_herzog.
8 http://www.criterion.com/current/posts/367-burden-of-dreams-in-dreams-begin-responsibilities.
9 http://www.theguardian.com/film/2014/sep/07/werner-herzog-facts-do-not-constitute-truth.

2

I Have Something To Say, But I'm Not Saying It

In anticipation . . .

Art articulates. It is articulated, made of particulate matter. Its particulars matter. Where it starts and when it stops is crucial to its meaning: how it pauses, resumes, divides, combines. In art's skeletal structure, the joints determine where it bends, which way, how far. Meaning's not in the bones, but in the breaks. No one ought to know this better than the musician. Not just the notes, but the rests count (and are counted). Music depends upon the before and after, the in-between, the how long. When John Cage isolates a period of silence and names it by its duration, he is acknowledging (from the obsolete Middle English verb *knowledge*, influenced by the obsolete *acknow* [confess]); he is confessing what the musician knows: that the material of music—sound—is only as good as its articulations, and that these articulations are determined by sound's other: silence.

Articulation is itself articulated. It bends two ways, is double-jointed: *hinged*, as Derrida would say. It is both vertebral and verbal. Derived from the Latin for a *small connecting part*, an articulation is composed of individual articles: short meaningful pieces of a larger enunciation. Both the articulation and the article take and make their meaning from the other. The larger articulation is nothing but the combination, in order, of the smaller articles, while the meaning of each article is constructed and held in place by the sense and thrust of the articulation. Each thing that is gets either a "the" or an "a"—a definite or indefinite article. Every sound is a/the sound. But Cage's famous book is *Silence*—bereft of article—suggesting that this silence is neither articulate nor articulated. Cage means to extract silence from the articulated nature of music.

It is articulation he wishes to escape. He wants to elevate silence above music. He wants a silence that is singular, whole, self-possessing, and self-evident. The realm he has in mind for his silence is not the elevated seat of a still-earthbound power: the throne. Even from the throne, proclamations must be articulated. Cage means to locate his silence in an elsewhere that has no need of articles, articulations, or articulateness.

First articulation

I suspect that when Cage declares "I have nothing to say and I am saying it," in "Lecture on Nothing,"[1] he is tapping into that same unarticulated/inarticulate silence. But, to be fair, one should start by asking if saying nothing is the same as remaining silent. In 1958, the year before the publication of "Lecture on Nothing,"[2] Samuel Beckett published his *Texts for Nothing*. In the eighth of these, he writes, "I should hear, at every little pause, if it's the silence I say when I say that only the words break it."[3] Beckett's silence speaks, or can, at least, be spoken. With *4′ 33″*, Cage announces the impossibility of silence: "Until I die there will be sounds. And they will continue following my death."[4] Yet Cage still pursues silence, hoping that its impossibility is its realization. Like silence, impossibility is unarticulated: it cannot be broken into constituent parts, it cannot be uttered. Silence and impossibility are both absolute. To invoke them in a piece of art, a piece of music, is to invoke the sublime, that unbeautiful category of aesthetic experience that names the unnamable (itself, the name of a Beckett novel from 1953, the year after "Texts for Nothing").

Cage says nothing. Beckett says silence. Each saying is equally impossible. In being impossible, each saying says. What's important is *what* gets said in these unsaid sayings. Cage and Beckett, like every artist, articulate a message while at the same time delivering the instructions for decoding that message. What the artwork says *about* what it says is just as important as what it says it says. Some artworks can even say something they never say. For Giorgio Agamben, Glenn Gould's piano playing always includes, and somehow indicates, Gould's capacity *not* to play.[5] Cage claims to initiate the opposite process: having nothing to say, yet saying it. But of course, his actual aims

are aligned with what Agamben describes. "Lecture on Nothing," is, after all, nothing but words, articulated units of lexical meaning. Cage, apparently, is saying *something*. In *Silence*, "Lecture on Nothing" is seventeen pages of something, for example/that is, "What silence requires is that I go on talking."[6] As Agamben suggests, there's always a little bit of something's absence in its presence. How can we know it's here if we don't know that it needn't be? But surely this can be taken too far. So, Agamben nominates Gould as one who toggles *par excellence* between yes and no, here and not. One wonders if this is a two-way street: Does Gould's not playing the piano include and indicate his capacity to play? When Gould types a letter, do the *Goldberg Variations* haunt the movements of his fingers across the Qwertyan expanse?

What Beckett's "Text for Nothing #8" says it says and what Cage's "Lecture on Nothing" says it says seem similar. The same cannot be said for what each says *about* what it says, about saying silence. Cage means to signify unarticulated silence by articulating it. This articulation comes by way of the piece-by-piece framing of silence via syntagmatic chains of words. One word, another, another. But between each: a space, a gap, a void, a silence. These are composer's tricks. He stretches these silences, from staccato to legato:

"We need not fear these silences."[7]

Cage beats these silences like a drum. They are, after all, his instruments. The words are his capacity *not* to play. As he types the words of "Lecture on Nothing," he plays the silences, the spaces between the typewriter keys. Were it not for the next keystroke, we would not recognize the silence. Beckett says "it's the end gives the meaning to words."[8] Surely, the same is true of silence. Silence and words make each other mean. Until one disappears, each makes meaning.

Jean-François Lyotard insists that "silence is a phrase"[9] and that a phrase will always follow from a prior phrase and demand a subsequent phrase. A phrase is a unit of meaning. It is dictated by its context: what Lyotard calls its "regimen" (e.g., "reasoning, knowing, describing, recounting, questioning, showing, ordering, etc.").[10] It's silence's end that gives it meaning. Silence's end comes in the form of sound, noise, language. Silence, then is always preceded and/or followed by a phrase that is unlikely to be equally silent. "There is no

last phrase."[11] If we have accepted that there will be no final word, we must also realize that there is no such thing as a final silence. If the former is transcendental, so is the latter. If the former is theological, so is the latter. Nor is there an originary silence from which all sound and language emerge. What Jacques Derrida calls *arche-writing*—the always-already potential of writing, of inscription, of marking a surface (the page, the world) with meaning—not only makes meaning possible, but it also makes meaninglessness impossible. This potential writing is meaning's condition of possibility. Unavoidable—yet not originary—this inscription, underwrites reasoning, knowing, describing, recounting, questioning, showing, ordering, etc. But there is no silence that precedes this possibility. The *tabula* was never *rasa*.

Given these twin impossibilities—of an originary or a final silence—we must come to terms with silence's ends, its limits: its beginning limit, its ending limit. It's the ends that give the meaning to silence. In his introductory remarks to "Lecture on Nothing," Cage writes, "And object is *fact*, not symbol,"[12] again omitting the articles. He concludes these remarks, "Not ideas but facts," echoing other mid-twentieth-century declarations of an anti-Platonic facticity, such as William Carlos Williams's "No ideas/but in things,"[13] and Wallace Stevens's "Not Ideas About The Thing, But The Thing Itself."[14] Yet there is an important difference between how Cage sees the world and how Williams and Stevens do. Cage seeks an unarticulated silence-as-fact. Williams and Stevens do not. Their work is the utterance of utterance, the saying of saying. It is a mistake to think that either poet was a closet phenomenologist. Both start from the premise—as must any real poet—that the world is not simply *accessed through* language; it is *constructed by* language. Stevens writes,

> One must have a mind of winter
> To regard the frost and the boughs
> Of the pine-trees crusted with snow.[15]

The mind is not a blank slate upon which the meaningful world inscribes itself. The mind is active in the process of meaning making, inscribing the world with names, uses, messages. These *in*scriptions are not *de*scriptions. They compose the world—that is, the thing we live in, on, and with. Whether there

is a world *out there*, waiting for the mind to discover it, hardly matters. To think the world—to "regard" it, as Stevens says—one must do so in, on, and with language.

Language, in the broadest sense (words being only the most obvious and oft-used example), allows us to make something of the world. If I regard the difference between a bird and a box, or between a blackbird and a bluebird, I must do so in language. If I tell you or write to you about the blackbird—as I'm doing now—I must do so in language. If I make a poem or a painting or a game about the blackbird, I must do so in language. Language is the *about* in the previous sentence. Without language, nothing is *about*—nothing means. Without language, we have what Cage calls "facts." In this ontology, something simply *is*. The nature of such a state of being is inaccessible to us. We cannot know it. We cannot interact with it. We cannot share it. We cannot experience it. Its *isness* is denied us, because we do not partake of the same *is*. "One must have a mind of winter."

Artworks are unique types of *is*. They float in the suspension of the world, without an obligation to stabilize their being or meaning. Artworks are hinged, they bend, they articulate. Meaning's not in the bones, but in the breaks. Since the *is* of an artwork is unstable, how it articulates what it is becomes more important than it would be with a chair or a dog or photosynthesis or a restaurant. As we've already said, what the artwork says about what it says is just as important as what it says it says.

Elsewhere, I've argued that Cage's *4′ 33″* fails to initiate a much-needed self-reflexive, critical, sonic practice.[16] This failure derives not from the work itself, which can, in fact, be read as a critical intervention,[17] but from the narratives about the piece, its creation, and its motivations, that have gained purchase over the past sixty years. Here, I want to propose a similar failure: "Lecture on Nothing," like *4′ 33″*, initiates a practice gravid with critical potential. As perhaps the first explicit lecture-as-performance, "Lecture on Nothing" creates the possibility of a metadiscursive form, capable of saying as much about saying what it says as about what it says. Yet, Cage assiduously declines the opportunity to exercise this latent criticality. Instead, he devotes the majority of the lecture to an internalized commentary on the structure of the lecture itself. This includes more than five numbingly repetitious pages— in the printed text included in *Silence*—reporting that the talk is getting

"nowhere" (presumably, the correlate of the "nothing" of the lecture's title). Cage declares that this getting nowhere "is a pleasure . . . not irritating."[18] He's entitled to his opinion.

As a musician, Cage might have used the performance lecture format to do things that music does not do with ease or simply cannot do. He might have capitalized on the stock-in-trade of language: signification, to undermine the age-old notion of music as a nonsignifying form. He might have made a case for an expanded sense of the space music might occupy, a reconfigured stratagem of how it might constitute itself. And, of course, "Lecture on Nothing" does this in spite of itself, using the articulations of something to designate nothing, using language to intimate silence. But rather than facing down these aporias in a critical manner, confronting the friction between the articulatedness of language and the singularity of silence, Cage proposes the formula I suggested earlier: that silence's impossibility is its realization. In circling silence but never landing on it, in stalking nothing, but never capturing it, Cage constructs a negative theology. His implicit claim is that silence and nothing are transcendental and therefore cannot be located in our experience. This unlocatability serves as evidence of their existence. Theologians of various stripes have made similar arguments for god, contending that we, fallible humans, cannot truly understand god's being. His unknowability (i.e., our ignorance) is the proof of his infallibility, his divinity. This is the fundamental perversity of faith: that it cannot be *known* in any epistemological sense; that knowledge negates belief. It is also the source of religious power, as clergy urge the faithful to obey codes without knowing the source of or reason for those codes.

Second articulation

In a lecture course taught at the Collège de France in 1977–78, Roland Barthes makes a distinction between two types of silence: one, designated by the Latin *silere*, indicates stillness, an empty space of pure contemplation; the other, designated by the Latin, *tacere* (and from which the word "tacet" is derived), indicates a verbal silence, to keep quiet. "In short, *silere* would refer to a sort of timeless virginity of things, before they are born or after they have

disappeared."[19] Barthes compares this vision of silence to the vision of god proposed by the seventeenth-century German mystic, Jacob Boehme:

> goodness, purity, liberty, silence, eternal light, without shadows or oppositions, homogeneous, "calm and voiceless eternity." However, the *silere* of Boehme's God makes him unknowable, since *silere* in short = preparadigmatic condition, without sign.[20]

Barthes's lecture course—published in French as *Le Neutre*, in 2002, and in English as *The Neutral*, in 2005—concerns the elusive element in communication that evades its operative meaning-making structures. To recall Lyotard, Barthes's neutral is that which is alien to the phrase regimen in which it appears. In Barthes's words, it is "that which outplays the paradigm."[21] Barthes's *paradigm* and Lyotard's *phrase regimen* function in essentially the same way within each philosopher's theory of signification. In each case, the term in question designates the network of discursive associations and interests that allows a message to be formulated and transmitted, attaching a signifier to a signified. As Barthes declares, "Where there is meaning there is paradigm and where there is paradigm there is meaning."[22] The neutral, then, is a term within the paradigm that cannot be assimilated. It's interesting to note—in the midst of this philippic on silence—that this is what information theorists call "noise." But for Barthes—concerned primarily with artistic texts: music, novels, films, pictures—this noise is not to be disregarded. Though the neutral may be extraneous to what the text says it says, it is, in a crucial sense, constitutive of what it says *about* what it says. As Stevens wishes to regard the frost, Barthes wishes to regard the noise, to attend to it. To do so, one must have, to paraphrase Stevens, a mind of noise.

Unsurprisingly then, Barthes denies the inarticulateness of silence. How, for instance, can Boehme know that god is unknowable? This knowledge is indicated, it is signified, by the silence that attends god's unknowability. According to Boehme, god's love

> is deeper than any *Thing*, and is as *Nothing* with Respect to All Things, forasmuch as it is not comprehensible by any of them. And because it is *Nothing* respectively, it is therefore free from *All Things*; and is that only Good, which a Man cannot express or utter what it is; there being *Nothing* to which it may be compared, to express it by.[23]

Nothing and silence signify the unsignifiability of that which outplays the paradigm (of god), but in so doing, they signify the unsignifiable. The aporias that Cage dodges in "Lecture on Nothing"—the false dialectic of language and silence, of something and nothing—reassert themselves, and resolve in the recognition that the negative term is always present in the positive, that any effort to indicate the negative as an absence always results in making it present. Silence cannot be silent. As Barthes observes,

> What is produced against signs, outside of signs, what is expressly produced so as not to be a sign, is very quickly recuperated as a sign. That's what happens to silence. . . . Silence itself takes on the form of an image, of a "wise," heroic, or Sibylline, more or less Stoic posture.[24]

Third articulation

It's likely that when Robert Morris adopted the performance lecture as an artistic vehicle, he did so in response to Cage. The relationship between the two artists is well documented.[25] But, as with much of his work in the 1960s and the 1970s, Morris reinvests his artistic sources with additional intent and content. At the Surplus Theater in New York, in February, 1964, Morris presented *21.3*. He stands at a podium. His horn-rimmed glasses and trim suit and tie give the impression of a serious, studious professor. In 1964, this was not too far from the truth. Morris was then a fledgling artist, and the title of the performance lecture, *21.3*, is, in fact, the catalogue number of an art history survey course taught by Morris at Hunter College in New York. The text of *21.3* is excerpted, verbatim, from the first chapter of Erwin Panofsky's *Studies in Iconology*. Originally published in 1939, *Studies in Iconology* "concerns itself with the subject matter or meaning of works of art as opposed to their form."[26] Panofsky identifies three strata of meaning in the work of art. The "primary or natural meaning" is discerned through forms that allow the spectator to see a shape in clay as a human being or a configuration of brush strokes as a bowl of fruit. The "secondary or conventional meaning" connects forms to stories, allowing the spectator to see "that a group of figures seated at a dinner table in a certain arrangement and in certain poses represents the Last Supper."[27]

Panofsky calls this level of meaning the "iconographical." Last, the "intrinsic meaning or content"—the level of meaning central to Panofsky's method—"is apprehended by ascertaining those underlying principles which reveal the basic attitude of a nation, a period, a class, a religious or philosophical persuasion—unconsciously qualified by one personality and condensed into one work."[28] Panofsky's schema is pertinent both to Morris's intentions in the mid-1960s and to mine here.

The only existing documentation of *21.3* consists of a single photograph of Morris's 1964 performance and 16-mm film of a recreation of the piece, made in 1993. The film was directed by Babette Mangolte, with Morris's participation, and also includes three of Morris's other performance works from the mid-1960s.[29] Likewise, there is scant writing on *21.3*. In Maurice Berger's *Labyrinths: Robert Morris, Minimalism, and the 1960s*, Morris is described as delivering Panofsky's text in tandem with a tape recording of the lecture. Berger writes that Morris's speech "moves in and out of synchronization" with the recording.[30] But in *Robert Morris: The Mind/Body Problem*, the catalogue of a 1994 Morris Retrospective at the Guggenheim in New York, Morris is described as lip-synching, albeit in an unsynchronized manner, to his own recording of the lecture.[31] The discrepancy between these two accounts is most satisfyingly settled by the Mangolte film, which features the actor, Michael Stella, reprising Morris's performance of the lecture. The film agrees with the Guggenheim account, featuring Stella lip-synching, out of time, to a recording of Morris reading the lecture. The sound of water being poured from a pitcher into a glass miscoincides—to use a verb in the Guggenheim text—with the image of Stella pouring the water. In addition, various gestures, such as the lecturer fingering his collar, removing his glasses, or lifting the pages of his talk, are carefully scripted. Movements that would normally be spontaneous and unconscious are mechanized and raised to the level of hyper-self-consciousness.

Curiously, in both Berger's *Labyrinths* and the Guggenheim catalogue, the same, short passage is quoted from Panofsky's text:

> When an acquaintance greets me on the street by removing his hat, what I see from a formal point of view is nothing but the change of certain details within a configuration forming part of the general pattern of color,

lines and volumes which constitutes my world of vision. When I identify, as I automatically do, this configuration as an object (gentleman), and the change of detail as an event (hat-removing), I have already overstepped the limits of purely formal perception and entered a first sphere of subject matter or meaning.[32]

Panofsky famously uses the everyday example (in 1939 anyway) of a man doffing his hat, to show that meaning is constructed incrementally from primary formal recognition, to secondary understandings of convention, to the final recognition of the intrinsic attitude of the gesture.

The two texts also agree on Morris's scorn for Panofsky's position. The Guggenheim text argues that "Morris's performance was intended as a subversion of the very notion of [Panofsky's] logic . . . closing off the very distinction between form and content on which Panofsky's demonstration had depended."[33] Berger, for his part, describes *21.3* as a "parody of the art historian."[34] Coming in the very first pages of his study of Morris's 1960s output, Berger situates his analysis of *21.3* as the foundation of his understanding of Morris's work. He argues that Morris's work is "fundamentally theatrical," and that "his theater is one of negation."[35] In *21.3*, according to Berger, this negation is directed at Panofsky's schema:

> In direct contrast to the iconological thinking of Panofsky, Morris's critique of art historical method implies that we must turn not only to the private space of memory and knowledge but to the public space of experience to define our place in the world.[36]

There is no doubt that Morris's performance lecture is intended as critique. But to classify it bluntly as a "subversion," a "parody," or a "negation," is to reduce the complexity of Morris's engagement with art history, with Panofsky's text, and with the nascent form of the performance lecture. To call a work of art "critical" is not to insist that it undertake an all-out attack on its subject matter. *21.3* engages *Studies in Iconology* in order to draw out its innovations, its failings, and, most interestingly and importantly, the contradictions it discovers and invents in the elaboration of its argument. Where Cage seeks (unsuccessfully) to reduce the discursivity of his performance lecture to a murmur meant to indicate silence—Morris courts the metadiscursivity of his

text, allowing it to articulate in multiple directions. What it says about what it says is just as important as what it says it says.

The Guggenheim text identifies a "distinction between form and content" at the heart of Panofsky's argument. But if one engages in a careful reading of Panofsky, as Morris undoubtedly has, one realizes that Panofsky doesn't mean to divide form from content, but in fact to consider both in tandem. In fact, Panofsky's view prefigures, by nearly thirty years, the imbrication of formal components of a work with the social and psychological forces that motivate both their production and reception. When reading Panofsky's description of concerns of time, place, class, and religious disposition "unconsciously qualified by one personality and condensed into one work," it is not difficult to see a tangible connection to Barthes's "death of the author," and, perhaps even more emphatically, to Michel Foucault's account of the "author function."[37] Nor is it much of a stretch to connect Panofsky's views with the debates that would emerge around Minimalism—notably pertaining to Morris's own practice—just a few years after the performance of *21.3*. What, after all, does Michael Fried object to most vehemently in Morris's mirrored cubes but their theatricality? Fried directs his disgust at the cubes' apparent desire to transcend their form, or, more accurately, to fold their form into their function so that the question of content is reduced, pragmatically, to the question of what these forms do and what processes they initiate.

Panofsky's discussion of the gesture of removing one's hat is a similar folding, wherein neither the physical dimensions of the hat, its shape and color, nor the muscular movements of its wearer, are considered in a semantic vacuum. Instead, these facts are woven into the secondary and intrinsic levels of meaning to yield a gestalt experience that is part perception, part knowledge, part affect, and part something else. The pertinence of Panofsky's schema to both Morris's intentions and to mine emerges from this something else. The example of removing one's hat is not offered casually. Panofsky sees the artwork functioning as a similar kind of gesture, related to a historically determined set of actions that both receive and produce meaning in a given situation and for a particular audience. In *21.3*, Morris's scripted gestures—for example, "finger in collar," "step left," "right arm behind back"[38]—are not, as Berger and the Guggenheim text suggest, intended to put a needle to Panofsky's

balloon. It would be a mistake to think that because they are scripted, these gestures become contextless and lose all meaning. Their context may have changed—from the incidental aspects of a scholarly lecture to the intentional choreography of an artistic performance—but still, as always, there is context. And where there is context there is meaning. The idea that these gestures escape context is absurd. The meaning of these gestures in this context accrues both with and against Panofsky's exegesis. Rather than negating Panofsky's position, Morris productively complicates it.

For Panofsky, in order to understand the gesture of the hat or a work of art in its nuances, one must understand the expanded context in which the gesture/work lives. This context is not authored by the artist any more than it is authored by the tipper of the hat. The context is the gesture's *lebenswelt*, its *lifeworld*. Sociologist, Pierre Bourdieu, has developed a theory of artistic production predicated on this something else, this relation of the work to the world from which it emerges and in which it operates. Bordieu names this relation *habitus*:

> durable, transposable dispositions, . . . principles which generate and organize practices and representations that can be objectively adapted to their outcomes without presupposing a conscious aiming at ends or an express mastery of the operations necessary in order to attain them. Objectively "regulated" and "regular" without being in any way the product of obedience to rules, they can be collectively orchestrated without being the product of the organizing action of a conductor.[39]

It is absolutely worth noting, as Randal Johnson does in his Editor's Introduction to Bourdieu's *The Field of Cultural Production*, that "Bourdieu first introduced into his theory the notion of habitus . . . on the occasion of the French edition of Erwin Panofsky's *Architecture gothique et pensée scolastique*."[40] Although Panofsky does not lean as hard on the term as Bourdieu later does, its original sense and usage is Panofsky's.

As noted earlier, Maurice Berger sees *21.3* as a "critique of art historical method [that] implies that we must turn not only to the private space of memory and knowledge but to the public space of experience to define our place in the world."[41] Again, this misreading of Panofsky must be attributed

to the critic and not to Morris's engagement with the text. As should be more than clear, even from the brief gloss I've provided here, Panofsky is willing—more willing than many art historians of his generation—to accommodate the "public space of experience" in his account of artistic meaning making. That Morris's arrival in the art world comes at a moment of high formalism should allow us to see a more sympathetic relationship between Morris and Panofsky than either Berger or the Guggenheim text is willing to countenance.

Fourth articulation

Paul Virilio wants to defend silence. He mourns the loss of that dumbstruck moment, when the spectator stands tongue-tied before the luminosity of the canvas. This experience, he complains, has been overridden by what he calls the "audio-visible," the perennial torrent of media sounds and sights that floods our contemporary perceptual field. Virilio condemns the postmodern condition in society and in the arts for being pathologically uncomfortable with silence. For Virilio, remaining silent is not a form of passivity, assent, or capitulation. Rather, silence indicates a form of attention and a holistic (and, as we shall soon see, implicitly holy) receipt of prelinguistic sensations. In contemporary art, conceptualism's dematerialization has metastasized into what he calls "mutism," an unmitigated negation of the meaningfulness of silent, contemplative perception. "The case instituted against silence, citing the evidence of the works, then ends in out and out condemnation of that profane piety that was still an extension of the piety of bygone sacred art."[42] Despite his cosmopolitan, secular intentions, Virilio, too, draws together silence and spirituality.

Virilio sees this mutism as a political issue. Its implications are apparent in societal mores, in aesthetic agendas, in distributions of power. "The voices of silence have been silenced; what is now regarded as obscene is not so much the image as the sound or, rather, the lack of sound."[43] Virilio's response to the noisiness of the world and its institutions is a resolute, steely, silence of resistance.

> For if certain works SPEAK, those that SHOUT and SCREAM their pain or hate would soon abolish all dialogue and rule out any form of questioning.

The way that pressure from the media audience ensures that crime and pornography never cease dominating AUDIO-VISUAL programmes so much so that our screens have reached saturation point these days, as we all know the bleak dawn of the twentieth century was not only to inaugurate the crisis in figurative representation, but along with it, the crisis in social stability without which representative democracy in turn disappears.[44]

Virilio makes a few specious connections here. First, it is difficult to see how silence might act as, or even foster, dialogue or questioning. To refuse to speak or to participate in objectionable activities may be a form of resistance. It may be a form of critique. But the substance of its response is always singular and blunt: an inarticulate, unarticulated abstention. This hardly constitutes dialogue or questioning in any constructive sense. It is also difficult to understand the equivalence Virilio finds between the positive values of silence and figurative representation. It would be easier to equate silence and abstraction.[45] It is ever more difficult to swallow the too-easy correspondence between artistic representation and representative democracy, to say nothing of their contemporaneous crises.

At the turn of the subsequent century—our own—Virilio detects additional portents of this creeping mutism:

On the eve of the new millennium, the aesthetics of disappearance was completed by the aesthetics of absence. From that moment, whoever says nothing consents to cede their "right to remain silent," their freedom to listen, to a noise-making process that simulates oral expression or conversation.[46]

Cage stalks silence's impossibility, hoping its impossibility is its realization. Despite the fact that "Lecture on Nothing" is constituted of word upon word upon word, Cage means to conjure the same silent, contemplative perception that Virilio wants to defend. Cage's silence, then, is not the silence of the work, but the silence of the spectator. As Douglas Kahn has pointed out, Cage's project does not seek *silence*, the noun, but *silencing*, the verb.[47] And this is the danger of Virilio's position. If we shout down shouting works, we will not have silence, we will only have silenced. As we have learned via the recent controversy surrounding WikiLeaks, the State will always seek to silence voices that threaten its agenda, but it will not accept silence for itself. Equally

disturbing, the 2010 US Supreme Court ruling, Citizens United *v.* Federal Election Commission, finds that corporations have the same free speech rights as individuals. As a result, the corporation is free to bring its sizable wealth to bear on political campaigns, amplifying its singular voice and drowning out the polyphonous voices of the populace.

Morris's elaboration of the possibilities of the performance lecture does not reduce language to a framing device for a latent, ineffable silence. Instead, *21.3* multiplies the meaning-making capacities of Panofsky's text, allowing it to speak its own mind while also performing a series of expansions, revising both singular points and the overall position of the text. Morris presents a work that doesn't SHOUT or SCREAM (to quote Virilio in his all-caps patois). Rather, he allows language to double and triple itself; its volume remaining constant while its implications crescendo. It may seem counterintuitive to place the State and corporations on the same side of this debate as the Zen, mushroom-collecting, Cage. But each wants us to shut up and listen. If Cage's insistence is driven by a Pollyannaish political naiveté, it is no less misguided.

The critical issue here should not be reduced to one of volume or quantity. In "Tympan," the preamble to *Margins of Philosophy*, Derrida plays with the double-jointed meaning of *tympanum*: on the one hand, the ear drum, played by the voices and noises of the world; on the other, *tympaniser*, an archaic French verb, meaning *to criticize*, or in Derrida's understanding, to philosophize.[48] Derrida criticizes the assumptions some are prone to make about the apparent directness of the ear. While it is true that sound waves strike the tympanic membrane of the ear drum, it does not follow that the significant perception of sounds is immediate and unmediated. For Derrida, the identity of any thing is never self-same. The process of meaning can move ever closer to its target, but it can never arrive. The process reaches an impenetrable limit of proximity. Because it is not concrete but merely epistemological (or, as he calls it, after Hegel, onto-theological), Derrida writes of this limit as a nonlimit. The limit of absolute proximity is the process of meaning-in-difference. Sameness is mute and meaningless. Derridean différance is loquacious and loud.

Things can get ever quieter, but there is no absolute quiet; no silence. Cage has admitted as much. So the question, again, is not one of the volume or quantity of signals in the work or the world. Cage's silent listening is a passive

listening. And silent passivity seems more likely than prolix activity "to abolish all dialogue," as Virilio fears, "and rule out any form of questioning."[49]

Fifth articulation

Since the middle of the nineteenth century, people have been assembling at the north-east corner of London's Hyde Park to air their opinions about religion, government, economics, and society. Individuals reputed to have mounted their soapbox at what is known as "Speaker's Corner" include Karl Marx, Vladimir Lenin, George Orwell, Marcus Garvey, Kwame Nkrumah, and William Morris. A great many lesser lights, ranters and ravers, pontificators, and would-be-pontiffs have also offered harangues and homilies at the site. The six-and-a-half-minute video, *Everything You've Heard Is Wrong*, witnesses London-based artist, Carey Young, arriving at Speaker's Corner, ascending a small stepladder, and delivering a lecture on public speaking. Amidst the usual clamor of Sunday orators, Young, dressed in a conservative pantsuit, a stack of index cards in hand, begins,

> Hello, my name is Carey Young and . . . I'd like to teach you about presentation skills.[50]

Young stands just outside the perimeter of a crowd of fifty or more, gathered around a man dressed in white robes and headdress. We can't hear what the man is saying. He is gesticulating broadly and apparently engaging his audience directly. Young offers a banal, business-style tutorial, isolating three things to keep in mind when giving a speech or presentation: "Who is your audience . . ., what is your message, and how do you come across as a speaker."[51] At first, Young fails to attract a crowd. But over the course of her six-minute address, small gatherings assemble and disperse. One man, in a dark coat and sunglasses, attends to the entire performance.

To say that *Everything You've Heard Is Wrong* is *about* public speaking would be to woefully underreport the breadth of its meaning. As with Morris's *21.3*, Young's performance lecture multiplies the significance of its ostensible text. What it says about what it says is just as important as what it says it says.

By *performing* the lecture, rather than simply delivering it, Young extends its boundaries. By presenting it at Speaker's Corner, she implicates the text and her actions in the history of free speech in Britain and in Western democracies. Corporate communication dominates exchanges of contemporary information via telephone, television, internet, inflecting the way we relate to each other not only in the contexts of business, law, and commerce, but also in academia, in the arts, and even at home. In *Everything You've Heard Is Wrong*, these bureaucratized communication strategies are pitted against the anarchic history of Speaker's Corner. The holy man in the background of Young's video is the perfect ballast for her dry, platitudinous, demonstration. Although his message is not audible in the video, he seems to be zealously engaging his audience, aiming to persuade them of the error of their ways, and, no doubt, of the efficacy of his own prescriptions. His investment in his message is bodily, his torso twisting from side to side, his arms always in motion, he leans into the crowd, points at them, beseeches them. Meanwhile, in the foreground, Young is the picture of corporate comportment, natty, contained, prepared, and lacking even a whiff of the evangelist's fervor in her measured disquisition.

The energy of *Everything You've Heard Is Wrong* is generated not by an inherent fundamentalism. That would merely appeal to another manifestation of the absolute proximity deconstructed by Derrida. Young's work engages competing rhetorical modalities, not to champion one over the other but to set them against each other, generating a productive friction. She situates this confrontation in a location renowned for its history as a marketplace of ideas and as a protected zone of free speech. According to Young, Speaker's Corner also projects a communication model beyond its nineteenth-century origins into the twenty-first century. Her website declares, "The site is a model for the sort of free speech supposedly so central to the 'information age.'"[52] *Everything You've Heard Is Wrong* extends its critique of communication beyond the format of the lecture, beyond performance. It asks us to conceive of the temporary communities of interested listeners at Speaker's Corner as a model for decentralized, nodal dissemination of information. Every speaker is a blog, every listener an IP address. The modalities on display at Speaker's Corner and in *Everything You've Heard Is Wrong* offer divergent templates for crowdsourcing, social networking, and tweeting. Young's intervention

into the wild information West of emergent networking represents the bureaucratization of a relatively unregulated arena of communication. Recently, Young's prognosticative projections have come home to roost, as the open source model of the internet faces increasingly vehement challenges from neo-con think tanks such as the Cato Institute, the Goldwater Institute, and the Ayn Rand Institute, and from corporations such as AT&T. The allegory invoked by *Everything You've Heard Is Wrong* is one of net neutrality versus the free market, of the populace versus the powerful.

In this allegory, volume and quantity are red herrings. The critical question facing the dissemination of information—via art, the internet, corporate or governmental communications—is one of access. If the spheres of messaging are open and available, if use, space, and time are distributed equally and without consideration of ability to pay, then the question reverts to one of meaning. Some have suggested that the underlying issue is one of visibility. The information-age illusion of total access, transparency, and the twenty-four-hour news cycle blinds us to the reality that our field of vision is already curtailed by those with the top-secret codes, the demographic statistics, and the market share.[53] In a recent *Artforum* essay, art historian, Pamela M. Lee investigates artworks that engage classified documents, redaction, and "black sites," such as secret prisons and military bases. She writes,

> The secret is itself an ideological contrivance; its withholding—its *visible* withholding—is as critical to its power as whatever content we might imagine it conceals. Thus the secret paradoxically possesses something like an *appearance*—an aesthetics, if you like.[54]

But the significance of information is not visual. When a government apparatchik marks a document "for your eyes only," eyes are not really the main concern. What the official is concerned about is mouths and ears. Withholding information is *not* as powerful as its content. If it were, there would be no point in withholding it. If the content and its withholding were equally powerful, the economic calculus would dictate that it is easier to simply release the information than to exert effort withholding it. Information is *only* withheld when its content is more powerful than withholding it. That is the definition of a secret. (Even when the secret is simply that there is no secret, as

in magic tricks and publicity stunts, it is still withheld due to the power of the information.) Merely seeing the information is not the issue. Hearing it speak is what matters. Withholding information is not a matter of invisibility, but of silence.

In a chapter entitled, "Secrecy and Silence," in her book *The Quest for Voice: Music, Politics, and the Limits of Philosophy*, Lydia Goehr notes the human urge to get "beyond a specific condition, the sense that one can reach for something that presently is not so or does not exist."[55] She goes on to say that philosophy has traditionally divided itself into two camps. One ignores the something that doesn't presently exist, believing it is beyond the ken of philosophy and knowability. The other camp sees the excluded something as the product of a dialectic. "They have allowed that one can acknowledge, account for, or point to the value of that which is excluded through an account of that which is included."[56] The former camp dismisses silence outright. The latter engages it through its others: noise and language. Lyotard, Barthes, and Derrida are clearly members of this camp. Morris and Young are engaged with this position in their performance lectures. Cage's position is less certain. But if we return to the idea that his position is concerned with *silencing*, the verb, and not, in the final analysis, with *silence*, the noun, we realize that he is not attending to a philosophical problem but offering a spiritual prescription. In "Lecture on Nothing," Cage is simply emphasizing a silence of reception, what his Zen brethren might call a quiet mind. This is self-help masquerading as aesthetics. But despite his best efforts, "Lecture on Nothing" says something and says something about what it says. His mysticism notwithstanding, Cage's faith is predicated on the articulations. Art articulates. Where it starts and when it stops is crucial to its meaning: how it pauses, resumes, divides, combines. In art's skeletal structure, the joints determine where it bends, which way, how far. Meaning's not in the bones, but in the breaks. No one ought to know this better than the musician.

. . . Post hoc

Articulation happens. The artist has two choices: to acknowledge and work with it and its prosaic tethers, or to deny it and to both pursue and promise

the unattainable. Goehr suggests that the latter position entails "a conservative commitment to something like an Invisible Hand or Natural Law."[57] In other words, to offload the source of meaning from the work and its world to an elsewhere/elsewhen is to abdicate responsibility for the implications of the work and the world. Goehr asks, "Have we had to put our faith in some kind of spiritual guidance or authority of tradition by taking our own human, rational, experiential, or epistemological limits too seriously?"[58] Morris and Young answer this question not by taking these limits less seriously, but by seriously confronting their contradictions, antagonisms, and frictions; by seeing the complexities of rationality, experience, and knowledge as productive of meaning. One might go so far as to say that these are the only sources of meaning, that they constitute the paradigm.

Goehr calls for a philosophy engaged in "the critical exposure of conflicts and problems in a practice that its authoritative determinations conceal."[59] And there's no reason such a mandate should be applicable only to philosophy. In art and music, in shopping and eating, in socializing and supposing, we must remain critically vigilant. Invisible hands and natural laws are false gods. "True" gods are false gods. There is no singular source, no singular purpose, no singular plan. There is no singularity. Everything is articulated.

Originally published in Tacet Experimental Music Review, *Issue Number 1: "Who Is John Cage?", 2012. Thanks to Matthieu Saladin for the invitation to contribute*

Notes

1 Cage, John, *Silence*, Wesleyan, CT: Wesleyan University Press, 1973, 109.
2 Cage dates the first performance of "Lecture on Nothing" as "about 1949 . . . at the Artists' Club on Eighth Street in New York City." Cage, *Silence*, ix.
3 Beckett, Samuel, *The Complete Short Prose*, New York: Grove, 1995, 131.
4 Cage, *Silence*, 8.
5 Agamben, Giorgio, *The Coming Community*, Minneapolis: University of Minnesota Press, 1993, 36.
6 Cage, *Silence*, 109.
7 Ibid.

8 Samuel, *The Complete Short Prose*, 131.
9 Lyotard, Jean-François, *The Differend: Phrases in Dispute*, Minneapolis: University of Minnesota Press, 1988, xii.
10 Ibid.
11 Ibid.
12 Cage, *Silence*, 108.
13 William Carlos Williams, "A Sort Of A Song," *Selected Poems*, New York: New Directions, 1969, 109.
14 Wallace Stevens, "Not Ideas About The Thing, But The Thing Itself," Collected Poems, New York: Vintage Books, 1982, 534.
15 Wallace Stevens, "The Snow Man," Collected Poems, New York: Vintage Books, 1982, 9.
16 Kim-Cohen, Seth, *In The Blink of an Ear: Toward a Non-Cochlear Sonic Art*, New York and London: Continuum, 2009, 159–67.
17 I attempt such a reading in *In The Blink of an Ear*.
18 Cage, *Silence*, 118–23.
19 Barthes, Roland, *The Neutral*, New York: Columbia University Press, 2005, 21–22.
20 Ibid.
21 Ibid., 6.
22 Ibid., 7.
23 Boehme, Jacob, *The Way to Christ*, http://www.iinet.com/~passtheword/DIALOGS-FROM-THE-PAST/sprsense.htm (accessed May 5, 2011).
24 Barthes, *The Neutral*, 26.
25 See Morris's letters to Cage in *October,* Vol. 81 (Summer, 1997), 70–79.
26 Panofsky, Erwin, *Studies in Iconology*, Boulder, CO: Westview Press, 1972, 3.
27 Ibid., 6.
28 Ibid., 7.
29 Mangolte, Babette, *Four Pieces by Morris,* 1993 (The other pieces are *Site, Arizona,* and *Waterman Switch.*) http://www.babettemangolte.com/film1993.html (accessed May 8, 2011).
30 Berger, Maurice, *Labyrinths: Robert Morris, Minimalism, and the 1960s*, New York: Harper & Row, 1989, 1.
31 *Robert Morris: The Mind/Body Problem*, edited by Anthony Calnek, New York: The Solomon R. Guggenheim Foundation, 1994, 160.
32 Panofsky, *Studies in Iconology*, 3 (Quoted in *Robert Morris: The Mind Body Problem*, 160, fn. 2; and in *Labyrinths*, 1).

33 *Robert Morris: The Mind/Body Problem*, 160.
34 Berger, *Labyrinths: Robert Morris, Minimalism, and the 1960s*, 4.
35 Ibid., 3.
36 Ibid., 3–4.
37 See Barthes, Roland, "Death of the Author," in *Image Music Text*, translated by Stephen Heath London: Fontana Press, 1977, 142–48; and Foucault, Michel, "What is an Author?" in *The Foucault Reader*, edited by Paul Rabinow, translated by Josué V. Harari, New York, Pantheon, 1984, 101–20.
38 Legible in an image of the typewritten script for *21.3* in Berger, *Labyrinths: Robert Morris, Minimalism, and the 1960s*, 3.
39 Bourdieu, Pierre, *The Logic of Practice*, Stanford: Stanford University Press, 1990, 53. (Quoted in Johnson, Randal, "Editor's Introduction" to Bourdieu's, Pierre, *The Field of Cultural Production*, New York: Columbia University Press, 1993, 5).
40 Johnson, "Editor's Introduction", 5.
41 Berger, *Labyrinths: Robert Morris, Minimalism, and the 1960s*, 3–4.
42 Virilio, Paul, "Silence on Trial," *Art and Fear*, London and New York: Continuum, 2003, 93.
43 Ibid., 71.
44 Ibid., 91 (The emphases are Virilio's).
45 In fact, Virilio makes this equation elsewhere in the text. See Virilio, 94.
46 Virilio, "Silence on Trial," 82.
47 Kahn, Douglas, *Noise Water Meat*, Cambridge, MA: MIT Press, 1999 (see, in particular, Chapter 6: "John Cage: Silence and Silencing").
48 Derrida, Jacques, "Tympan," *Margins of Philosophy*, Chicago: University of Chicago Press, 1982, x.
49 Virilio, "Silence on Trial," 91.
50 Young, Carey, *Everything You've Heard is Wrong*, 1999. Single-channel video, color, sound. 6 minutes, 35 seconds, looped.
51 Young, Carey, *Everything You've Heard is Wrong*, 1999. Single-channel video, color, sound. 6 minutes, 35 seconds, looped.
52 Young, Carey, comments on *Everything You've Heard is Wrong*, http://www.careyyoung.com/past/everything.html (accessed May 11, 2011).
53 For one particularly influential instance of this, see Jacque Rancière's thinking on the "distribution of the sensible," in his *Politics of Aesthetics*, London and New York: Continuum 2006; and *The Future of the Image*, London: Verso, 2009.
54 Lee, Pamela M., "Open Secret." *Artforum*, May 2011 (the emphases are Lee's).

55 Goehr, Lydia, *The Quest for Voice: Music, Politics, and the Limits of Philosophy*, Oxford: Oxford University Press, 1998, 27.
56 Ibid., 29.
57 Ibid., 44.
58 Ibid.
59 Ibid., 44–45.

3

That Jabbering Which Thinks It Sees: Robert Morris Sites His Sources

The sense of hearing is a pun. It flip-flops like a fish on a boat's deck—first this way, then that, and elsewhere still. A compass needle riddled by magnets. The *sense* of this phrase is both sensory and sensible. The *hearing* of this phrase is heard and held: accountable, in abeyance, up as an example.

Hearing is a sense: the one accomplished, ostensibly, by our ears. Hearing is a verb: the act of engaging hearing as a sense, but not so actively, one might say, as listening. A hearing is a situation in which evidence is presented. A hearing is not so final as a trial. Kafka did not write a novel called *The Hearing*. Instead, Robert Morris did. But for the fact that it is not a novel, per se, but here words fail me. I have no simple noun for you to hear, or to listen to, as the case may be. Whatever it was, it was presented in New York at Leo Castelli Gallery in 1972.[1]

So as creative writing teachers are wont to advise, let's show, rather than tell. Even, if what creative writing teachers mean when they say to show is, in fact to tell, and, so, we too, shall show by means of telling. For convenience sake, we have reconvened the Investigator, Witness, and Witness's Counsel, whom Morris originally convened. And we join them as the hearing comes to order.

Upon a cruciform platform, a metal table, bed, and chair. One leg each of the table and the bed sits in a trough of wet cell batteries. The chair is hollow and filled with constantly boiling water. Signs warn spectators of the dangers of burning and electrocution.

The set is ambiguous, underdetermined. It suggests: a work room, a prison cell, a therapist's office, a courtroom, a furniture showroom for the purchasing departments of various governments' enhanced interrogation units. When one is looking—at the table, at the bed, at the chair—one is also hearing. And what one is hearing is a three-and-a-half-hour audio recording

of a hearing. Actors play the roles of Investigator, Witness, and Counsel. The words in the mouths of the actors have been put there by Morris. But they are not Morris's own. They were put in his mouth, so to speak, by others. They were removed from their original sites: books, mostly, and essays, by the likes of Foucault, Chomsky, Levi-Strauss, and Wittgenstein and relocated to Morris's site, the site of this hearing. Morris doesn't cite his sources. He merely relocates them, sites them in these actors' mouths, among this perilous furniture.

But here too, their site is ambiguous. For the words are spoken by actors. Their larynxes and throats and mouths and tongues and lips must surely be a site of these words. At the same time, we attribute them to Morris. So he too is their site.

And this set: this bed and table and chair are in our sight, they are what we see. So this set too, must qualify as these words' site.

But there must be more. There always is. Here, today, the words are sited in actor's mouths. It is clear to us that they are reading—sight reading, as musicians call it, but here, today, also cite and site reading—it is clear that these words are not their own. So we demote their mouths as sites. Not that we disavow their sitedness entirely. But we demote it, from site to para-site. Yet, what I've told you about Morris and his actors and the sources of these words should have the same effect, should perform the same demotion upon the sites of the actors' mouths and on Morris-as-site. His recitations, after all, are mere citations. But what if Morris quotes himself? Can he be both site and para-site; both site and cite?

This recitation is a citing, a re-citing, and a re-site-ing of these texts while also citing and reciting Morris's own work: namely his *Card File* from 1962. What is the status of these words and objects; these object-sited words and these word-laden objects? Like the words on the audio tape of *Hearing*, they would seem to occupy three simultaneous statuses:

1. They are the same thing in two different positions;
2. They are two *different* things, each representing a different position;
3. They are actions, events: the source is the *action of invitation*, the citation is the *action of reply*.

The words that Morris cites and re-sites occupy three simultaneous positions: they are the same thing in two different positions; they are two different

things, each representative of a different position; and they are actions, events. Compare this to his *Column* from 1961. A citation: *Cummings, Paul, Oral history interview with Robert Morris, 1968 Mar. 10, Archives of American Art, Smithsonian Institution.*

> The first [plywood piece] was a column that was two feet square and eight feet high. And that's interesting because, while there is no process at all in that object, it was used in the first theatre piece I ever performed at the Living Theatre. It was a group concert I think organized by George Brecht. And everyone had a certain amount of time. I had I think seven minutes. So for three-and-a-half minutes the column was standing and then I pulled it over with a string and for three-and-a-half minutes it was lying on the stage.

Might we see Morris's practice as a postergonal mode of art making; that is, an approach to the image, the object, the event, that acknowledges—from the moment of inception and embedded in the work's very ontology—that the image, the object, the event, is not the beginning or the end of it; that the *it* of it escapes its own delineations, reflecting and echoing and distending in very anti-imagey, un-object-like, nonevental ways.

The site of sound is always plural: sites of sound. There's no there there. Equally, sound is accorded both its meaning and its materiality by its site.

Take, for example, Morris's 1961 *Box With The Sound Of Its Own Making*, which, like *Hearing*, includes a three-and-a-half-hour audio tape, albeit in this case, the nondiscursive sounds of cutting, drilling, and screwing the box in question, which then houses the speaker playing the audio. Everything in the recording of Morris's *Box* is a product of its site of recording: the room in which the box was constructed, but more to the point, the box-as-site-of-construction.

Were it not for the site, the sound of this recording would have no meaning. Morris announces as much in the piece's title. The object constitutes the audio and the audio constitutes the object. But the site of this recording can't be limited to this singular space. The recording too—tape and heads and magnetic particles—is a site. And the playing back of the recording (a site) from within the box (site) instantly constructs second and third sites, or, in Morris's parlance, second and third levels of signifieds. When we listen elsewhere, in a room different than that of the work's recording and construction, a fourth site emerges. And when we talk about listening in a room (site) to this recording

(site) made in a room (site) and played back (site) from within the box (site), our talking constructs yet another site, the site of reconstruction, and of the discourse that both constructs and is constructed by this work.

If the *Box* of 1961 expresses a wish to be its own signified, the *Hearing* of 1972 issues a moratorium on such wishes. Between signified and signifier, between represented and representation, the hearing inserts the act; the act of citing and of re-situating words from their original sources, resetting them in the mouths of actors, recording those mouths, and re-re-situating the words in a carceral/clinical/judicial stage set of injurious furnishings.

The saying is not the same as the said. The former relates to the latter as walking to its route. Which is to say, that saying cannot be represented by the said, nor walking by its route. But the said and the route can themselves be represented, with a transcript, for example, or a map.

Which is not to say that saying is self-identical. The act of hearing—or, as Morris would have it, the act of *a* hearing—maps the saying in a secondary act, that of hearing the said. This represents (without re-presenting) a second level of signified, that maps onto the act of saying, as both mirror and echo. Hearing distorts and delays saying, such that any initial signified is not represented, but *mis-*represented. The game of telephone—saying, hearing, saying, hearing—depends on this; a hearing that subtends and distends both materiality and meaning. And what is Morris playing at but a game of telephone, in which an initial saying is heard as cause for subsequent saying and hearing. And here in this room, we too, hear as cause for subsequent saying. We subject all this saying to hearing and *a* hearing, just as Morris intended.

A talk delivered as part of the panel "Sites of Sound," chaired by Julie Beth Napolin, at the American Comparative Literature Association conference in New York, March 2014.

Note

1 Morris, Robert, *Hearing*, Leo Castelli Gallery, New York, NY, April 18 to May 6, 1972. For the transcript of Morris's piece, see: *Robert Morris: Hearing*, edited by Gregor Stemmrich, Leipzig: Spector Books, 2012.

4

Sound Today (Is No Longer A Function Of The Ear) *or*, Why Do I So Dislike *Glee*?

It is inadequate to write or to say, "I have overcome the problematics of art." It is necessary to have done so. I have done so. Painting today is no longer a function of the eye; it is the function of the one thing we may not possess within ourselves: our LIFE.

—Yves Klein

The Yves Klein Blues

I'd like to open with an old tune, "The Yves Klein Blues." I've taken the liberty of arranging this traditional number to suit my present purposes. These purposes include introducing the notion of non-cochlear sound and the exhibition that sails under its flag. These purposes also include addressing the question: Why do I so dislike *Glee* (Tuesdays, 8 Eastern, on Fox)? I want to create a conceptual synonymy between the notion of the non-cochlear and my dislike of *Glee*.

Although it occupies one time slot, *Glee* is, in fact, two shows. Or, if we must concede the network's privilege in defining the ontological boundaries of a show (based, no doubt, on the subtle epistemological calculus of advertising revenue), then I'll settle for this assertion: *Glee* is Janusian, two-faced; it promulgates a divided worldview. On the one hand, the dramatic (nonmusical) half of the show is a subtle and sarcastic depiction of difference. The setting of the show, the plot lines, and the individual characters, all riff on the tropes of generic TV and movie fare. But, in each case, the particulars are tweaked to unsettle the stereotypes. The dramatic half of the show is a clever subversion of the feel-good, multiculti, mores of middle-of-the-road liberalism. That's not to say that *Glee* is way out there on the branch, overtly pushing a radicalism

hitherto unknown in American culture. But it does undermine some of the smugness of After School Special formulism that helped to rear the political consciousness of the last four decades of American children.

Take, for example, the character, Tina Cohen-Chang: a Jewish-Asian, stuttering, Goth. Her most pronounced and provocative otherness is not established in relation to real American high school students. Her otherness is established relative to TV's representation of American high school otherness. I'm not trying to overstate the self-reflexive, po-mo, lit-crit, value of *Glee* here, but it's worth recounting a poll taken in the 1970s in which real American high school students were asked about the fictional TV series *Room 222*. Overwhelmingly, the students confirmed that the show was a realistic depiction of life in an American high school. When asked if *Room 222* resembled life in *their* American high school, just as overwhelmingly, the students said "no." Fiction forges fact. As it turns out, Tina's been faking her stutter so kids will leave her alone. Get this: she's protective of her otherness; she embellishes it to preserve it. It's not Artaud.

But for prime time, network TV, it's pretty progressive, and pretty smart.

Yet, in the fourth episode of the series, when Tina is given the solo in "Tonight" from *West Side Story*, and Rachel, the Glee Club diva, quits in protest, Tina intentionally misses a crucial high note, so that Rachel will be reinstated as Queen Bee and all will once again be right with the high school hierarchy. Think about it: in the show's dramatic half, Tina cultivates the aspects of her personality that set her off from the conservatism of her milieu. This setting off, is understood—in the hermeneutical play between text and viewer—as a validating reification of otherness. Tina's difference is made manifest as a positive aspect of her character. Yet, in the musical half, a different set of values prevails. First, the fact that Tina intentionally tanks the note implies that she is capable of hitting the note. She's a "good" singer (i.e., she can sing like you're "supposed to"). Second, the established values of the musical half of the show are such that a bum note is grounds for disqualification. Third, it is an assumption of the plot that if Tina drops a clam, Rachel will be reinstated as the lead because she, certainly, is pitch-perfect. In music, apparently, otherness carries no value. There's no room for difference, only self-sameness, fidelity to the melody, submission to the score. Tina's off-ness has no value in the musical half of the show, whereas Rachel's on-ness is triumphant.

Everything that recommends the show's dramatic half—all the subversive snark, all the unstitching of the conventional representations of social fabric—is absent from the musical half. If the musical half of the show had the guts to rise to the challenge of Tina's knowing otherness, *Glee* might be closer to the forensic satire of *Hedwig and the Angry Inch*, John Cameron Mitchell's 2001 masterpiece in which music is acknowledged as being both constituted by, and constitutive of, the world. Instead, *Glee*'s musical half delivers vapid American Idolatry. When the music starts, the irony disappears in a puff of dry ice smoke. The dramatic half's social critique, the deconstruction of stereotypes, the gentle, yet insistent undertow working against prevailing sentiments, all exit stage right as the number begins. Where the dramatic half of the show is willing to unmoor acceptable, established values of teledolescent *dramatis personae*, the musical half is unfailingly deferential to the imperturbability of sincere musical expression. The implication is that, while the real world is shot through with delusions and abuses, music is a safe haven from lived cynicism. Music is separate and unsullied, satisfied with what rock critic, Camden Joy, has called its "stand-alone arrogance."

The two halves of the show are undoubtedly the products of two distinct production teams. The scriptwriters responsible for the drama probably have little to say about the singing and dancing of the production numbers. The arrangers and choreographers doubtless contribute nothing to the overarching plots. The disconnect between the two halves' worldviews is apparent in the musical half's employment of what is ostensibly a corrective prosthesis. This technological curative, known in the recording world as "autotune," is a device that nudges out-of-tune notes back in tune. As soon as one of the *Glee* kids opens his or her mouth to belt out a showstopper or to breathily evince a weepy ballad, someone in the control room flips a switch and autotune guarantees that *Glee* delivers melodic fidelity (if not marital, social, or pecking-order fidelity). For decades, mainstream TV has been applying the psychological equivalent of autotune to its characters—call them "autopaths"—nudging them back into emotional and rational tunes.

What gets my goat is how *Glee* reflects a broadly held cultural attitude in which music (and, by association, sound) is fetishized as sacrosanct and virtuous, as if music has overcome the problematics of being-with-others (and of otherness). *Glee*'s musical world, untainted by the complexity of lived

reality, rejects *Glee*'s dramatic world, in which difference is rightly seen as the generator of meaning. In this musical world, sameness is celebrated: hit the notes as written, do what's expected, be correct. Autotune is this world's insurance policy. Break a leg, wreck the car, come down with bird flu, and like a good neighbor, "autotune" is there. But perhaps it's closer to the truth of how behavior is made, to think of autotune as a societal tool of control, akin to Jacques Rancière's conception of "the police." Deviate and autotune is always already there to modify your behavior. The society of the autotune can't abide deviation. Economic disparity? Autotune it into alignment. Racial inequality? Autotune it into accord. Philosophical disagreement? Autotune it into consensus. All is right with the world. Let us open our hymnals.

Make it Old

The term "non-cochlear" appears in the subtitle of my 2009 book *In The Blink of an Ear: Toward a Non-Cochlear Sonic Art*. Since the book came out, there's been a minor fuss about this phrase. I understand why it's minor (we're talking about sound art after all). But, frankly, I don't understand why there's been any fuss at all. I'm leaning hard on old ideas here. It's been nearly a century since Marcel Duchamp famously called for a nonretinal visual art, an art that would appeal to modes of experience and response that are not primarily about what one sees.

Crudely, the retina is to seeing as the cochlea is to hearing. So, in a transparent attempt to piggyback on Duchamp's brilliance, I coined the term "non-cochlear" to designate the kind of conceptual sonic practice I wanted to promote.

For almost 100 years the visual arts have been reconciling themselves to this idea. But in sound and music, we've witnessed a resistance resembling, if not born of, ignorance. Sound has remained stubbornly attached to the ear. This is true of composers from Igor Stravinsky to John Cage and of artists from, well, Cage to Francisco López. While visual artists have opened the doors of their practice to concerns such as politics, economics, sociality, gender, and power, musicians, artists, and theorists remain self-satisfied: "Hey,

all the arts aspire to the condition of music" (a claim issued by Walter Pater in 1873). These practitioners and theorists believe that sound, being inviolate and separate from worldly (read petty) concerns, can and should go about its rarified business in privileged, unburdened isolation. This is the attitude of the musical half of *Glee*. The other old idea on which I'm leaning hard isn't quite as old, dating from 1967 when Jacques Derrida published both *La Voix et le Phénomène* (Speech and Phenomena) and *De la Grammatologie* (Of Grammatology). Derrida questions the most basic of presumptions: that a thing has its own, internal identity. The pinnacle of this kind of thinking, Descartes's "I think therefore I am," kicks philosophy off from the one thing I can be sure of: that I am. How can I be sure of it? Because I need no outside proof, no confirmation, no translation, or communication of myself to myself. I don't need formulae, language, signs, pictures. I simply know that I am. But Derrida remains unconvinced and, over the course of a few years and a few books in the late 1960s and early 1970s, he unconvinced a lot of other folks too. Derrida responds to Descartes (and, more directly, to Husserl): a thing has no internal identity. Instead, its identity, its meaning, its being, is formed by a differential process. That is to say, I only know what a chair is by ruling out other possibilities, such as seat, stool, couch, recliner, table, lamp, and on and on. (Although, if you've read Derrida, you know that these ruled-out possibilities are never thoroughly ruled out. They stubbornly mark the thing-in-question, infecting the self-sameness of its identity with a radical, constitutive otherness.)

At first glance, this description seems less likely to be true than positing the identity of the chair in the chair. But, if we consider the most basic procedure of semantic identification, looking up a word in the dictionary, we realize there might be something to Derrida's claim. Look up the definition of the word "chair" to say definitively what it is. My dictionary says "A separate seat for one person." So I look up "seat": "A thing made or used for sitting on, such as a chair." Already the circularity is biting us in the ass (I hope you'll pardon the pun). We look up "sitting": "Adopt or be in a position in which one's weight is supported by one's buttocks." We look up "buttocks": "Either of the two round fleshy parts that form the lower rear of the human trunk." I won't drag this out. The point—Derrida's point—is that you can keep looking up words that appear

in the definitions of other words forever and you'll never reach the definition that says "Congratulations! You now understand definitively what 'chair' means." What a chair is derives from a network of relation and differentiation. What's more, as we've seen, this process never ends, but is deferred endlessly in the accumulation and sorting of knowledge. If we try to match Descartes' pith, we have to settle for something like "I am not X(∞), therefore I am I." Not quite as catchy as the cogito.

Nevertheless, if we can swallow Duchamp and Derrida, I don't know why we should have trouble choking down the idea of a non-cochlear sonic art. Indeed, the only indigestible thought is that of sound-in-itself. Sonic conceptualism should be as controversial as a new Thai restaurant.

Out on Parole

One could easily argue that sound art, as a discrete practice, is merely the remainder created by music closing off its borders to the extramusical, to any instance of parole that could not be comfortably expressed in the langue of the Western notational system. Sound art is art that posits meaning or value in registers not accounted for by musical systems. Unlike sculpture, and to a lesser extent, cinema, music failed to recognize itself in its expanded situation. Instead, it judged the territory adopted by expansion as alien and excluded it *tout de suite*. The term "sound art" suggests the route of escape from music, the path of least resistance available to this errant practice. The gallery-art world, having already learned the tricks of expansion and the assimilation of once-excluded modes, proved a more hospitable homeland for the sound practice of the late 1980s, the 1990s, and the 2000s.

I trust I don't need to draw too much attention to the political analogies suggested by this account. Let me simply say that, just as the expanded situation of a given practice includes and is created by social, political, gender, class, and racial exigencies, so too are the responses of institutions, the attitude of a field of cultural activity, and the acceptance by critics, academics, and practitioners of a version of a discipline's history. The expulsion of sound art from music is both analogous to politics and *is* politics. Likewise, the acceptance of sound

art into the spaces and discourse of the gallery arts is politics in theory and in practice. As such, the history to which I am alluding here and the revision I am suggesting have implications beyond the apparently limited scope of which tag we append to a practice, which institutions host it, and which critics have a territorial stake in examining it. As Derrida says, "There is no outside the text," nor is there a safe haven inside it. I'm of the opinion that sound art has always been non-cochlear at heart. But it's difficult to break from convention, from the autotuning of positions. People hear what they want to hear.

I wrote my book *In The Blink of an Ear* in response to such recalcitrance. My strategy was not simply to prescribe the practice of the future, but to redescribe the practice of the past and the present, to highlight the non-cochlearity already there. So, when Michael Schumacher at Diapason Gallery in Brooklyn invited me to put together a show of non-cochlear sound, I saw it as a chance to test my optimism and to let the practice speak for itself. Still, I wasn't sure how many contemporary artists might respond to my term, "non-cochlear sound," or self-identify with the practices I describe in the book. The best way to find out was with an open call for proposals. I would have been happy with thirty or forty submissions—really I would have. As it happens, we got more than 160. Clearly, I wasn't alone in thinking there was something to this non-cochlear thing. If my book was an attempt to expand the field of sonic practice, these examples of practice have expanded that expansion. The artists who submitted proposals (not just those who were accepted) reimagined what non-cochlearity might look like, what it might sound like, how it might behave. So this exhibition was much more than an illustration or an example of a theory. It is precisely the best outcome of writing a book: a dialogue between theory and practice, a call and a response moving in both directions: from thinking to making, from making to thinking.

Originally published as part of the online catalogue—the blogalogue, or catablogue (http://noncochlearsound.com/)—for the 2010 exhibition, Non-Cochlear Sound, *at Diapason Gallery, Brooklyn. (Thanks to Seth Brodsky for drawing my attention to the use of autotune in* Glee.*)*

Part Three

The Conceptual Garage: Rock and Roll, Expanded

5

No Depth: A Call for Shallow Listening

If you Google "Billy Bao," you may read of a Nigerian expatriate who left his native Lagos for Bilbao. You may learn that, after a period as a street musician, this Lagosian assumed the *nom de guerre*, Billy Bao, and joined up with Basque musicians Mattin and Xabier Erkizia to form a band that would share his name. Since 2005, the band, Billy Bao, has released a slew of recordings that combine the visceral politics of early punk and the density of noise with a postproduction cut-and-paste aesthetic. A couple of years ago, the band began making plans for Billy Bao to return to Lagos, to reconnect with the city and to make new music with Nigerian musicians. Last summer, Mattin and Erkizia published an account of their time in Lagos in the *Wire* magazine's "Global Ear" column.

The resulting recordings are due to be released in late 2015. The band refers to them as *The Lagos Sessions*: four tracks, each about fifteen minutes in length, each envisioned as one side of an hour-long, double LP. The music is a departure from their previous work. Within the first minute of side A, we hear bursts of electronic noise, the sounds of street traffic, solo drumming, a capella singing, and snippets of the auto-tuned Naija-pop that dominates contemporary Nigerian radio. Around the two-minute mark, a man, as if issuing the first rallying voice at a political protest, chants, "Here in Lagos the future is ours!" He is followed shortly thereafter by a distorted guitar riff that sounds like a not-quite-copy of the Stooges' "1970." It is not the quick-cut collage work that separates this from previous Billy Bao material, but the intense, saturated appropriation of a set of cultural signifiers: street sounds, political discourse, news broadcasts, and a variety of Lagosian music, popular and traditional, taken from recorded sources, captured in the streets, or recorded in a studio specifically for this project. With this—or against it—Billy Bao sets sections of performed noise-punk. But they also manipulate recordings of the Lagosian

music, layering, editing, and effecting it to create new textures and structures. At times, relatively long passages that could pass for songs are allowed to play. Side B, for instance, begins with four minutes of a Stooges'style rave-up, complete with overdriven vocals in English. The chorus repeats, "We come from Lagos." Eventually, the song is swallowed by electronic noise, which then cedes to almost three uninterrupted minutes of a Nigerian man describing the ethnic, religious, political diversity that feeds the dissensus of Nigerian national politics. Later, against a dissonant soundscape, a woman sings an R&B melody, without rhythmic or harmonic support, about infrastructural problems in Nigerian commerce, transportation, healthcare, and utilities, all the while, "leaders still eating from the massive economic cake."

Everything about this project, from the title to the elaborate back story of Billy Bao's return to Lagos, asks us to listen to these recordings as a kind of site-specific work. But the kind of site-specificity that we are forced to imagine and apply is skewed on a few counts. First, site specificity is a mode most commonly associated with visual art practice. There have been some attempts to theorize the site specificity of sonic works, but most of this literature ignores the vast and frequently revised thinking of site specificity in the visual arts. As a result, theories of sonic site specificity are generally not as sophisticated, thorough, or nuanced as those of their visual counterparts.

Second, site specificity most commonly refers to encountering the work *in situ*, in a particular location and set of circumstances that activate the work. The presumption is that if the work were reconstructed or reconvened in a different location, under different circumstances, it would not function as well. Or, possibly, it would not function at all. Although site-specific works are almost always made on site, that is, in the same location in which they are eventually experienced by an audience, the term site specific is usually more concerned with the spectatorial experience of the work in, and as, its site. Site specificity is not usually overly concerned with the site of production if that site is not also the site of reception. When work is made in the studio, for example, we don't typically think of the work as specific to the site of the studio—if that is not also where it is displayed (although, perhaps, we should).[1]

This brings us to the third skew of site specificity demanded by this project. *The Lagos Sessions* exists solely as an audio recording. The site of production

is not the site of reception. More crucially, Billy Bao cannot control where, when, or under what circumstances, you or I listen to this recording. The site of reception is unstable and unpredictable.

One way to approach *The Lagos Sessions* as a site-specific work would be to abandon the site of reception and reorient attention toward the site of production. This would allow us to think about Lagos as the site of Billy Bao's intervention. But let's not take the easy way out. Stubbornly, yet with purpose, we will retain site specificity's attention to reception. Therefore, in order to engage *The Lagos Sessions*' specificity to its site, we will need to clarify the meaning of the term "site" and we will need to offer an account of the particular site (or sites) engaged by *The Lagos Sessions*.

In her book, *One Place After Another: Site-Specific Art and Locational Identity*, Miwon Kwon has offered what is probably the most influential genealogy of site specificity.[2] Kwon establishes three "paradigms" of site specificity, which emerge in art history in roughly chronological order. The first, what she calls the "phenomenological," responds to the physical realities of the space in which the work is encountered. The second paradigm, the "institutional," goes beyond the parameters of the space itself to consider the agency and history of the gallery or museum. The third, and most recent, discursive site specificity, goes beyond the parameters of the institution, taking "site" as a product of various, intersecting narratives, debates, and practices. These intersections frame the work in a series of overlapping discursive matrices, generated intentionally and coincidentally by the artist, curators, critics, historians, patrons, spectators, commerce, and current events.

Lytle Shaw insists on recognizing that the discursivity that a work claims as its site can complicate the relations generated by the work. In his 2012 book, *Fieldworks: From Place to Site in Postwar Poetics*, Shaw highlights and modifies important implications of Kwon's account of site specificity. A discursive site does not simply reveal a locational site, nor is it merely an environment within which the work exists. Instead, discursivity makes and masks both what the work is *and* what the site is. Relying on observations made by the artist, Robert Smithson, Shaw notes that

> despite various and often insightful engagements with theory, critics of site-specific art (including Miwon Kwon, James Meyer, and Hal Foster)

have persistently avoided the problem of rhetorical mediation—the ways that, as Smithson says, "language 'covers' rather than 'discovers' its sites and situations."[3]

Thus, all three of Kwon's categories fold into one another in complicated, and complicating, ways. The site is always constituted by overlapping matrices of reference, what Roland Barthes so famously called a "fabric of citations." Even at the level of the discursive, we are no longer dealing, simply, with a linguistic text, but always with the (con)text or the *with-text*.

In order to account for the discursive site specificity of Billy Bao—in order to *hear* the discursive site specificity of *The Lagos Sessions*—we need to reattach the music to its often implicit, often ignored, but always present, socio-historic conditions of existence. So, not only do we need to revise our understandings of discursivity and site specificity, but we also need to devise and demonstrate an alternate model of listening. Such a model would locate the sonic work in the dispersed site of what is sometimes called the "extra-musical," that is: additional forces, influences, and relationships that license the motivations, structures, and meanings of the composition. These considerations extend listening to include a broad inventory of concerns and conditions: tradition, expectation, convention, gadgets, subjectivity, institution, and history.

Acting on what was at first a flippant impulse, but now seems increasingly meaningful, I will call this model "shallow listening," in contradistinction to Pauline Oliveros's notion of "deep listening." Deep listening suggests something to be quarried, something at the bottom, a bedrock, an ore, a materiality that contains riches. Oliveros, working along Cagean lines, imagines that sounds-in-themselves are deeply valuable entities, imbued with eternally rewarding sensual and experiential qualities. Imagine the same volume of listening attention. But instead of condensing it within a concentrated, narrow-gauge bandwidth, shallow listening pools at the surface, spreading out to encompass adjacent concerns and influences that the tunnel vision of the deep model would exclude. Billy Bao's *Lagos Sessions* necessitates shallow listening. In fact, other models of listening, whether deep, or conventionally aligned with certain genres, are doomed to mishear this work.

With shallow listening, there is no there there—or there is no ore. Rejecting the material riches of sound-in-itself as an outright impossibility, shallow listening also rejects the transcendent ineffability to which sound often lays

claim. Shallow listening, insists on immanence. Shallow listening insists that we retain the ability to intervene and to effect the sites at play in the sonic work. The discursivity that creates "Lagos" doesn't map to any one geographical site. It is not bounded by the city limits, by the psyche of any individual Lagosian, or by Lagosians in general. The discursive sites of "Lagos" are many, overlapping, never mutually exclusive. One site may have been generated at another. For example, Lagos's relation to its site as a center of the slave trade cannot have been generated entirely within the geographical site of Lagos but is largely generated in Britain and America. Additionally, a site may have been generated locally, exported, modified, and reimported as a new, recombinant site. One might think of Nigerian music traveling to America, only to mutate and return to Lagos as James Brown's funk, before becoming the site of Fela's Afrobeat. In shallow listening, there should be no confusion: What we are hearing is not sound-in-itself, nor the sound-of-Lagos-in-itself, but the sound of an intention to represent the fabric of citations that constitute Lagos. We would not be unjustified were we to create a contraction here, converting Barthes's phrase, "fabric of citations," into "fabrications." This leaves us with "the fabrications that constitute Lagos."

Interestingly, in annulling sound-in-itself, we end up creating a different kind of problem, a problem identified by Hal Foster, in his 1996 book, *The Return of the Real*. As late-twentieth-century art practices see the artist inhabiting and interacting with the site of the other—usually the exploited worker or the postcolonial subject—the artist is transformed into a kind of de facto ethnographer. Vis-à-vis this inhabitation, the artist identifies with the economic and social conditions of the other. The fantasy is that somehow the artist can assume the moral high ground of the oppressed, to absorb her wounds and degradation, thereby healing the other while absolving herself of the guilty conscience of privilege. Foster says the fantasy is based on

> the assumption that the site of political transformation is the site of artistic transformation as well, and that political vanguards *locate* artistic vanguards and, in some cases, substitute for them.[4]

What's worrying about this strategy is that it aspires to a particularly virulent variety of transcendence. When the artist—or the artwork, or the spectator—overidentifies with the other, this identification is based on and located on a

fictitious site, projected as a transcendent idealization of purity and innocence. This is the unattainable space of utopia. And, as Foster points out, it is a utopia forced into the service of the artist, the artwork, and the spectator:

> This site is always *elsewhere*, in the field of the other. . . . This elsewhere, this outside is the Archimedean point from which the dominant culture will be transformed or at least *subverted*.[5]

The site of the other is elsewhere. It resides *beyond*—beyond our influence, beyond our control. The power this site bestows is absolute and inviolate, in a way and to an extent that only a fantasy can be. The innocence of the other indemnifies, inoculates, and absolves the privileged site of those with an investment in the artistic encounter and the culture that licenses it.

One of the fascinating things about *The Lagos Sessions* is that it puts this fantasy at the center of its project. But it neither assumes nor rejects its privileges. Instead, *The Lagos Sessions* compels the listener to engage this problem. In order to do so, we start by marking out some of the operative positions and sites of *The Lagos Sessions*. It seems plain that the cultural-aesthetic other of *The Lagos Sessions* is Lagos itself. But, as we've seen, the plainness of the itself is never so plain. "Lagos itself" nests in quotes, in a fabric of citations, itself a fabrication. We must also remain on our guard about Foster's problematics of ethnographic transposition. What symbolic violence does the *othering* of Lagos (or "Lagos") do to Lagos as a site? And what benefit does it provide for Billy Bao, for *The Lagos Sessions* project, or for me, the receptive listener?

Negotiating these problems depends on what Foster calls "framing" and "critical distance." After appearing to damn a lot of the art that he sees as taking ethnographic approaches, Foster concludes that the truer evils are (1) overidentification with, or (2) disidentification from, the other. These two positions do little more than shore themselves up as finalities, utopian in their communion or isolation. But, Foster suggests, there is a third way. This third way allows for contingency—utterly *topian*, that is to say *sited*—in its multiple, complicated, and contradictory relations with other sites. This way involves framing one's own artistic or ethnographic project, maintaining as much transparency as possible regarding the project's positions and sites. The project must maintain a critical distance without becoming satisfied

that it has successfully outrun the hounds. While fraught with danger and incontrovertibly compromised, this is the only type of engagement with the other that allows differences to remain meaningful.

In order to think more precisely about the framing and critical distance of Billy Bao's project, let's contrast *The Lagos Sessions* with *My Life In The Bush Of Ghosts,* released in 1981 by Brian Eno and David Byrne. Like *The Lagos Sessions, My Life In The Bush Of Ghosts* has a strong Nigerian connection. The title is taken, verbatim, from a 1954 novel by the Nigerian author, Amos Tutuola. Like *The Lagos Sessions*, Eno and Byrne's album is constructed from a combination of live playing and previously recorded sources: looping rhythms, samples of African music, Arabic singing, and Pentecostal preachers. As Byrne confesses in his liner notes for the album's 2006 reissue, he and Eno "fantasized about making a series of recordings based on an imaginary culture. We'd make the record and try to pass it off anonymously as the genuine article."[6] Ultimately, they abandoned this subterfuge, but Byrne admits that "this fantasy continued to guide us in a subconscious way."[7] Byrne goes on to explain how, at the time they made the album, he and Eno were immersed in African culture and music—listening to Fela Kuti, to field recordings on the Ocora label, and reading John Chernoff's *African Rhythm and African Sensibility.*

Byrne's liner notes function as a kind of just-so story of how he and Eno came to make *My Life In The Bush Of Ghosts*, to recount the various ideas and influences that came together to make a recording that is now celebrated for both its experimentalism and its accessibility. At the same time, these notes serve as a kind of framing, in Foster's sense. They establish Eno's and Byrne's *bona fides;* confirming that they are not casual cultural interlopers, that they have done their homework. But the reference to Chernoff's book cuts both ways, opening a can of orientalist worms. As Kofi Agawu points out, the notion of "African rhythm" that Chernoff identifies as central to African sensibility, and that Eno and Byrne rely on so heavily as an exotic and experimental component of their project, is largely a colonialist construct. Rhythm has been essentialized and idealized as *the* prevalent feature of African music. This idea collapses in two directions. First, to generalize an "African music" is to whitewash a continent's-worth, and centuries'-worth of differences. As Agawu notes, "A continent with a population of upward of 400 million distributed

into over forty-two countries and speaking some thousand languages is virtually unrecognizable in the unanimist constructions that some researchers have used in depicting African music."[8] Second, the construction of "African rhythm" is transparently an attempt to other African music as a means of shoring up Western musical values, harmony most prominent among them. In mentioning Chernoff's book, Byrne intends to substantiate his and Eno's deep engagement, not just with African music, but also with its critical analysis. Tellingly, Agawu writes that Chernoff's opposition of African music with what he presumptuously calls "our music," is a problem at precisely the level of "framing." Agawu points out that Chernoff is writing in the late 1970s. Yet, to establish what he means by "our music," Chernoff "invokes the opening four bars of Beethoven's *Sonatina in G Major*."[9] Agawu takes musicologists to task for lazily making such comparisons between what is almost always "our music" and "theirs," without actually doing the comparative legwork. "Instead, one side of the opposition is given short shrift, conveniently silenced, suppressed, ensuring that writers' initial prejudices reemerge as their conclusions."[10] As Agawu points out, a fair accounting of Western music in the late 1970s would have to include—beyond Beethoven—Bartók, Reich, and Stravinsky, to name a few "more or less at random." Considering the Hungarian, Ewe, and Russian folk musics being appropriated by these composers in the Western, high-art tradition,

> a determined researcher could easily show that the sum of isolated experiments in rhythmic organization found in so-called Western music produces a picture of far greater complexity than anything that Africans have produced so far either singly or collectively. One could, in short, quite easily invent "European rhythm."[11]

But, ultimately, to compare *The Lagos Sessions* with *My Life In The Bush Of Ghosts*, one has to abandon any neat correlation (or opposition) of one object to the other. We are, as they say, comparing apples and oranges. Rather than identifying opposing tendencies in *The Lagos Sessions* and *My Life In The Bush Of Ghosts*, our understanding is better expanded by noting the divergent contexts which grant each work its legibility. The comparison then—or at least the one that bears fruit—is the one between a work in the self-critical tradition

of post-1960s art (*The Lagos Sessions*) and a work that, despite all its knowing references to, and incorporations of, avant-garde postures, is part of the culture-industrial complex (*My Life In The Bush of Ghosts*). Despite their art world connections and acceptance, Eno and Byrne, firmly operate in the world of pop and rock music, where framing and critical distance are anathema to both the expectations of the audience and to the functioning of the commercial apparatus. And although Billy Bao releases LPs and CDs, the project frames itself within the critical art-historical tendencies of the last forty-odd years. On *The Lagos Sessions,* Billy Bao is at pains to reveal its positions and contradictions, to avoid easy answers, and to disseminate authorial control of its content. The band's relationship to material on one side, and audience on the other, self-consciously generates the critical distance and framing described by Foster. Billy Bao engineers a nifty maneuver whereby the sites and forces that frame *The Lagos Session* become the semiotic grid within which the album's internal gestures register and make meaning. All works of art engage in this maneuver to greater or lesser degrees: converting situations into semantics, context into text. But *The Lagos Sessions,* as musically sited as it is, proves uncommonly adept at situating itself and its constituent gestures in the expanded context of a particular lineage of political, critical, conceptual art.

There are a lot of musical sites invoked over the full hour of *The Lagos Sessions.* I've mentioned some of these already. But the fabric of citations that constitute Lagos as a musical site is explicit. There is a reason that Lagos figures so prominently in Billy Bao's biography. And there is a reason that this is *The Lagos Sessions,* and not the Bilbao sessions, the Madrid sessions, or the Kinshasa sessions. Lagos is a port city and, in the mid-twentieth century, was a key slave-trading site. Now, the population of metropolitan Lagos is estimated at twenty-one million. Lagos is considered either the fastest or second fastest growing city on the African continent, multiplying and expanding at a rapid rate. As Mattin and Erkizia point out in their article in *The Wire,* resources in Lagos are scarce and most homes receive only a few hours of electricity a day. So the city growls day and night with the sound of gas-powered generators. Still, Lagos occupies a special position in the musical imagination. It is the birthplace of Afrobeat, the melded composite of traditional Nigerian, Yoruban, Beninese, and other West African musics with American funk and Latin

jazz. Fela lived in Lagos, including a seven-year stretch in the 1970s when he declared his home, the Kalakuta Republic, an independent state within the city limits of Lagos. Fela is a controversial figure, a great musical innovator, who studied in London, traveled in America, gradually becoming politicized, and turning his music and his celebrity into vehicles for resistance: first to the lingering effects of colonialism and later to internal Nigerian factionalism, corruption, and oppression under a succession of military regimes.

Billy Bao also uses music as a political tool. On albums such as *May'08*, *Buildings From Bilbao*, and *Urban Disease*, they direct sonic scorn at global capitalism, the co-opting of various cultural forms, and the deactivation of modes of anticonformist living. On their 2008 release, *May'08*, a lengthy section of Fela's celebrated and notorious song "Zombie" is woven into the mix. Billy Bao's Mattin is a prolific thinker and writer, having published widely on art, music, and politics. In 2009, with Anthony Iles, he coedited the volume *Noise & Capitalism*.[12] So it's safe to assume, that by situating *The Lagos Sessions* so specifically in this particular, named, West African city, Billy Bao means to invoke site specificity while also intervening in the conversation that is site specificity. Among the discursive sites that are implicitly invoked and inhabited are the texts I've cited here, most notably and most certainly, Miwon Kwon's *One Place After Another* and Hal Foster's "The Artist As Ethnographer." Additionally, the title of Foster's text echoes Walter Benjamin's "The Artist as Producer" while also borrowing and adapting some of Benjamin's political reasoning. Undoubtedly, as a politically engaged artist and thinker, Mattin is also engaged with Benjamin's text.

And, while it's less likely that Billy Bao is in dialogue with Lytle Shaw's *Fieldworks*, I nevertheless, want to take up a point that Shaw makes, drawing various discursive sites into productive friction. Shaw relates site-specificity—especially the discursive variety—to institutional critique. Discursive site specificity is almost always involved in an archaeology of its sites, pitting texts against each other, teasing out internal contradictions, and in the best cases, excavating the work's own complicity in the relations being exposed and created. As Shaw points out,

> Most of the artists Kwon discusses (including Mark Dion, Andrea Fraser and Renée Green) have been closely associated over the last twenty years with . . . [the Whitney Independent Study] Program.[13]

Shaw doesn't mention that Hal Foster served for a time as Director of Critical and Curatorial Studies at the Whitney ISP. In fact, Foster himself states that *The Return of the Real*, the book in which "The Artist As Ethnographer" appears, was conceived during his tenure there. Suddenly, the site of discursive site specificity and the site of the artist as ethnographer, are revealed as overlapping. The adjacency of institutional critique to site-specificity brings the three sites, the three discourses, into contact with each other. The particular discourse of discursive site specificity starts to mimic the concerns and methods of institutional critique. Shaw's identifies the problem, not in the Whitney program's co-opting of these discourses (although it seems that such co-optation is the problem's mechanism), but in the likelihood that the ISP's concomitant dedication to site-specificity and institutional critique precludes certain varieties of analysis of both sites and institutions. The Whitney's influence on the employment of these discourses—how they are applied to the production and reception of works of art—"forecloses other avenues of analysis,"

> focusing on the ways that museums in effect vaccinate themselves by inviting critical shufflings of their collections by artists, the ISP seems to have taught its artists and critics, including Kwon, to think of the dynamic between critique and containment in spatial rather than temporal terms.[14]

Here's the kicker: Mattin also attended the Whitney Independent Study Program. So, it's no stretch to say that the Whitney program becomes another key site of *The Lagos Sessions*. Mattin's participation in the ISP puts him, so to speak, at the scene of the crime: the discursive site where institutional critique, the artist as ethnographer, and site-specificity are transformed into the three heads of a beastly Cerberus, guarding the entrance to the art historical underworld. I don't invoke the Cerberus as a way of attacking Billy Bao or *The Lagos Sessions*. Instead, I put this three-headed discursive site into play in order to allow us to think about the operative discursive sites of *The Lagos Sessions*. One of the more problematic—and potentially productive—sites is the position staked out by *The Lagos Sessions* relative to Foster's anxieties about the ethical defensiveness of such ethnographic projects. The other engages Shaw's critique of the now common institutional strategy of inviting immanent critique as a way of holding more vicious dogs at bay.

Listening shallowly to *The Lagos Sessions* allows history back into our understanding of the project's site-specificity. Sounds-in-themselves are located entities. The sonic object is a spatial metaphor. The site of *The Lagos Sessions* cannot be merely spatial. The project only makes sense when attached to a sequence of events, a set of conditions, a fabric of histories, that all converge at a discursive (not merely spatial or phenomenological) site we call "Lagos," but could easily call "logos." It would be silly to listen to the sounds of these recordings as discrete phenomena, disconnected from the situation in which they were produced and in which we listen. It is impossible to listen to *The Lagos Sessions* untroubled by the context upon which its meanings depend.

But just as surely, it would be folly to imagine that *The Lagos Sessions* delivers Lagos. The reasons for this, as we have discussed, are twofold: First, there is no "real" Lagos, self-identical and true. Lagos is constituted by its discursive sites, overlapping and constantly shifting, text-tectonically, with and against each other. Second, transposition is a fantasy. Shifting facts or phenomena from one modality or sense to another, does not complete our understanding of the source material. A sound recording cannot reveal the truth of Lagos, or the world, because as Smithson says, that truth is just as much covered as it is discovered by transcription. We must listen shallowly to *The Lagos Sessions*, ever-aware of its relation to its discursive sites. Does *The Lagos Sessions* successfully frame its ethnographic complicity? Can it maintain a critical distance, even while making criticality so intrinsic to what it is? In other words, can it remain self-critical? What do its politics sound like? Can we speak of a "sonic ethics"? Even to focus our listening on the site of Lagos, the city and its history, is not enough. Likewise, listening for a critique of the institutional sites of African politics, global commerce, "political" music, or cross-cultural intervention, is insufficient. We must go shallower. The sites of *The Lagos Sessions* only become meaningful when they are allowed to leak out of their pipes, to seep into the groundwater of adjacent sites. Listening shallowly to *The Lagos Sessions* we must come to terms with the fact that there is no depth to what we are hearing. Meaning is spillage. Sound is spillage. Both spread out, ever shallower, ever more complex; more compromised, like Lagos itself. Whatever that means.

A revised version of a talk delivered at the "Conference on Art, Sound, and Radio," organized by Giorgiana Zachia, in Halmstad, Sweden, May 2015.

Notes

1 See, Buren, Daniel, "The Function of the Studio," Thomas Repensek, trans., *October*, Vol. 10, Cambridge, MA: MIT Press, 1979, 51–58.
2 Kwon, Miwon, *One Place After Another: Site-Specific Art and Locational Identity*, Cambridge, MA: MIT Press, 2002.
3 Shaw, Lytle, *Fieldworks: From Place to Site in Postwar Poetics*, Tuscaloosa: The University of Alabama Press, 2013, 5.
4 Foster, Hal, *The Return of the Real: The Avant-Garde at the End of the Century*, Cambridge, MA: MIT Press, 1996, 173.
5 Ibid.
6 Byrne, David, with Brian Eno, "The Making of *My Life In The Bush Of Ghosts*," liner notes, *My Life In The Bush Of Ghosts* (linear notes), Nonesuch Records, 2006 (originally released, 1981), unpaginated.
7 Byrne, David, with Brian Eno, "The Making of *My Life In The Bush Of Ghosts*," liner notes, *My Life In The Bush Of Ghosts* (linear notes), Nonesuch Records, 2006 (originally released, 1981), unpaginated.
8 Agawu, Kofi, "The Invention of 'African Rhythm,'" *Journal of the American Musicological Society*, Vol. 48, No. 3, Music Anthropologies and Music Histories (Autumn, 1995), 384.
9 Ibid., 386.
10 Ibid., 385–86.
11 Ibid., 386.
12 Howse, Mattin and Anthony, Iles, eds, *Noise and Capitalism: Politics of Noise*, Donostia-S.Sebastiá, Spain: Arteleku Audiolab, 2009.
13 Shaw, *Fieldworks: From Place to Site in Postwar Poetics*, 338, fn. 12.
14 Ibid.

6

Burden Bangs Joy

And . . . in 1977 *Semiotext(e)*, published an issue, double-entendrely titled "Nietzsche's Return." The included essays tie renewed interest in Nietzsche—especially in France—to a post-1968 critique of capitalism and its institutions. Jean-François Lyotard's contribution, "Notes on the Return and Kapital," proposes that Nietzsche's philosophical project offers an alternative to capitalism's bland, bloodless obedience. This alternative, according to Lyotard, goes by the name "intensity."

Elsewhere, the German critic, Diedrich Diederichsen, points out that Lyotard's observations

> repeatedly and explicitly refer to music as the place where the fight between good intensity and bad representation most pointedly plays out—as the fight between the musical note and sound.[1]

It's worth mentioning that Diederichsen's comments appear in the catalogue for the exhibition, *Sympathy for the Devil: Art and Rock and Roll Since 1967*, at the MCA Chicago, in 2007 and 2008. The show focused on connections between rock and roll and the visual arts, emphasizing, almost exclusively, visual parallels between image making in the gallery and image making on record sleeves, music videos, t-shirts, and posters. But the exhibition catalogue includes a couple of essays that delve more deeply into connections in modes other than the visual: common relations to energy, thematics, conceptual concerns, politics, or philosophy. The connection Diederichsen makes is epiphanic. What he describes as the battle between "the musical note and sound" is, of course, the great battle of the last century in experimental music, fought by the likes of Varese, Schaeffer, Cage, Stockhausen, Lachenmann, and Branca. It is also the founding urge of sound art: to escape the mandate to organize sound with structures determined merely by pitch, tempo, duration,

and timbre. Unlike musicians, sound artists engage sound as a phenomenon like clay or metal; as a cultural construct like language or pictures; as a form of energy in waves, like electricity or light.

The epiphany of Diederichsen's observation is that punk rock also engaged this battle. Rejecting the conventions and emphases of Western compositional traditions, punk rock devalued virtuosity and formalized musical knowledge. Case in point: In December 1976, the British fanzine, *Sideburns*, published a now-famous, hand-drawn, fingering schematic for three guitar chords with the accompanying caption: "This is a chord. This is another. This is a third." At the bottom of the page, the 'zine implored: "Now form a band." Nevertheless, this approach still relies on the rudimentary building blocks of musical techniques: a guitar in conventional tuning playing recognized chords formed intentionally with established fingerings. Others struck more fundamentally at the foundation of musical orthodoxy. The bands, Swell Maps, the Pop Group, Public Image Limited, and others now considered part of the "post-punk" expansion of punk's initial revisions, did away with chord progressions altogether. These groups, influenced by the aesthetics of experimental dub remixes by the likes of Lee "Scratch" Perry, King Tubby, and Augustus Pablo, ignored the Western values of development and movement conveyed in pop by verse-chorus-verse structures and anthemic dénouements. Instead, these bands placed their trust in repetition, rhythm, and sonic innovation; in extreme reverb, alternative instrumentation, and subtractive mixing.

Just as importantly, bands subverted the social and economic formulae of musical collectivity, production, and distribution. Embodying McLuhan's decree that the media is the message, Desperate Bicycles closed their first single with the exhortation, "it was easy, it was cheap—go and do it!" They then printed the costs of recording, manufacturing, and distributing their first single on the sleeve of their second. Scritti Politti—named as a homage to the writings of Italian Marxist, Antonio Gramsci—existed as an extended collective. Some members played instruments, some contributed to the band's political, economic, and aesthetic self-analysis. Their "rehearsal" sessions often involved more debating than music making. Like Cornelius Cardew before them, Scritti Politti swung from radical antimusic—self-knowingly referenced as "Messthetics" in the title of an early single—to a later embrace of pop forms to infect wider audiences with their leftist ideology.

Diederichsen notes that, in "Notes on the Return and Kapital," Lyotard opposes intensity both to representation and intentionality. While representation indicates a formal fallacy—that of the signifier being adequate to the signified—intentionality signals a set of problematic institutional values such as planning, restraint, rationality, authority, and conformity. Intensity is the alternative to both problems. Properly experienced, intensity accesses *jouissance*: not a simple pleasure, but a joy teetering on the precipice of dissolution. Such intensity, such joy, cannot produce, or be the product of, intentionality. It cannot be identified in advance. Nor can it be quantified or accurately described in retrospect. Intention is the musical note. Intensity is sound, in the sense, perhaps, of the culmination of Macbeth's famous soliloquy,

> a tale
> Told by an idiot, full of sound and fury,
> Signifying nothing.

And . . . these are at least some of the things suggested by the term intensity: the tale told, the idiocy, the inability to signify—or, in a more productive reading, the ability to signify nothingness. There is also in this a lot of what I mean to suggest with my title, "Burden Bangs Joy": the burden of theorizing, of classifying, of identifying, bangs the joy out of the object of our attentions. Of course, that which can be banged out can also be banged back in. The question is whether the same tool is adequate to both bangings.

Lyotard writes, "Representation is an intrinsic part of philosophical discourse."[2] He says that representation is always accompanied by a weakening of intensities. The effort to theorize compromises that which is theorized. It compresses—to use audio terminology—the dynamics of its source into a manageable, *representable*, bandwidth. In audio recordings, performances or sources comprising wide dynamic swings are smushed into more compact objects. Once compressed, they are easier to handle, easier to reproduce, easier to consume. The loud parts won't do harm to your speakers if you turn up the volume during the soft parts. And the soft parts won't become inaudible if you adjust the volume for the loud parts. The download will finish in the time it takes you to drink that latte.

And . . . rock and roll, in the best instances, is built of little more than intensities, striving to do something very different from representing. And yet rock and roll intensity is itself especially vulnerable to *being* represented. (Witness cultural phenomena from Hot Topic punk stores at the mall, to the latest Rolling Stones tour, to "Jackass" on MTV.) In the same 1977 issue of *Semiotext(e)* in which Lyotard's essay appears, we also find the essay, "Nomad Thought," by Gilles Deleuze. According to Deleuze, Nietzsche wants

> to use all codes, past, present and future, to introduce something which does not and will not let itself be coded.[3]

Deleuze identifies three societal encoding instruments: the law (by which he means sacred law), the contract (meaning the social contract), and the institution (political institutions). I want to fold these three encodings into one master-encoding which, I think, would have to retain the name *institution*, because all three behave identically in relation to those beholden to them and are instituted by the same societal and psychological mechanisms. Lyotard says the institution

> is anything which offers itself as a stable signification (political, legal, cultural . . .), i.e. anything based on set intervals and conducive to representation.[4]

Reading Deleuze and Lyotard, reading Nietzsche, I am tempted (directed?) to imagine the *unstitution*; that which is *unstituted*, something like what Deleuze indicates when he says that Nietzsche introduces "something that isn't encodable, the jamming of all codes." (15) I'm tempted by the idea of the *unstitution* because it performs a microcosmic version of its intentions in its constitution. The *unstitution* is produced in the code of typing—arguably the master code of our technological time—by shifting a finger a few millimeters to the left, from the keyboard's I to its U: a minor physical perturbation (to the *left*, mind you) creates a major semantic disturbance. It is not planned, not targeted, it is a typo, a mistake. It is not intentional. Nor, strictly speaking, does it represent. If institution seeks to regularize everything, even perturbation, then *unstitution* is that which resists set intervals, outruns the paradigm: the

hiccup, the glitch, the joke, the mistake. Deleuze says of such uncodeable phenomena, that they

> must not be translated into representations or fantasies; ... they must not be sifted through codes of ... the institution; ... on the contrary they must be turned into flows which carry us always further, closer to externality, these experiences precisely constitute intensity.⁵

Deleuze credits Nietzsche with inventing a nomadic philosophy that escapes codes and institutions in favor of an uncoded/uncodeable, *unstitutionalized*, experience of intensities. I want to suggest, as a kind of sidebar, that, in a very practical way, the rock group embodies this vision as well as any other figure in contemporary society. Each day, the group's members, trundle into a van, decamping from point A to reassemble temporarily in point B, in another city, in another club. This is a kind of literal nomadism. And while Deleuze is at pains to point out that nomadism needn't be, perhaps *shouldn't* be, literal, the rock group's nomadism also operates in a less literal sense. Their collective voice, their intensity, disperses in the moments when each member is traveling, waiting, milling, and reassembles in moments when, as a group, on a stage, in a studio or a practice space, the individuals coalesce to conjure, to coax, to collect, and to communicate intensities: sonic, somatic, cultural, political, sexual, engendered, and agonized (in both the quotidian sense and in the sense suggested by Chantal Mouffe).

And ... the British critic, Simon Reynolds—who, incidentally, also has an essay in the "Sympathy for the Devil" catalogue—often turns to Deleuzean terminology to make his case for certain musics that Deleuze himself would never have countenanced. For instance, he compares the structure of the music of the German band, CAN, to Deleuze and Guattari's notion of the rhizome, which he says is characterized by "the conjunction 'and ... and ... and.'" The "and ... and ... and ..." of CAN is an exemplary model for how I think intensity is generated. So, as a kind of performative strategy, I've adopted this "and ... and ... and ..." as the structure for this talk. But I'm not sure I want to adopt the model of the rhizome. While the rhizome suggests a kind of liquidity that leaks and seeps in all directions—a kind of ambient flux, intensity is better performed as and by the monotonous, relentless, rhythmic pulse of the and ... and ... and There's nothing

liquid about intensity. It is solid, monotonous, periodic, percussive, dogged, and desperate.

The structure of the "and ... and ... and ..." echoes what I want to propose as one of the immanent features of intensity as a defining quality of a rock-and-roll aesthetic. Rock and roll is insistent. But let me try to clarify what I mean by insistent. In the book *Deleuze and Music*, Jeremy Gilbert identifies "'peak' moments which characterize most improvisatory musics," ascribing these peaks to

> a momentary affect of notes colliding in a space too small to contain them, bursting out onto some new, smoother space with photons bouncing in unimagined directions and in and out of existence altogether.[6]

I want to insist that insistence doesn't depend on peaks. What insistence depends on is simply banging on: banging and banging and banging. It's not about the result of the banging. If we were focused on peaks or results, then the and ... and ... and ... wouldn't matter, or it would have to be converted into and ... and ... AND: which would force us back into the same old patterns of development and instrumentality that Deleuze and Gilbert and intensity and rock and roll want to avoid. Intensity is a matter of pressure, not peaks. Insistence, persistence, and ultimately, resistance, are the forces that intensity brings to bear.

And ... what does Lester Bangs—the great rock critic, dead in 1982 at the age of thirty-three—say about this insistence upon which I'm insisting? Writing of Iggy Pop's forays into long-form self-abuse in the mid-1970s, Bangs says this:

> It's as if someone writhing in torment has made that writhing into a kind of poetry, and we watch in awe of such beautiful writhing, so impressed that we perhaps forget what inspired it in the first place.[7]

Not intention, not representation, but an intensity born in the moment of our witnessing and impossible to aptly recount later. Bangs says of Iggy: "He's crying in every nerve to explode out of [his body] into some unimaginable freedom."[8] This is the funhouse mirror image of Samuel Beckett's "I can't go on, I'll go on." Instead: "I can't go *beyond*, I'll go on." Insistence is knowing the effort is futile, doomed to fail, maybe utterly pointless even at the point of

inception (remember Macbeth's idiot?), yet pursuing it anyway, unflaggingly: aiming against aim for the unimaginable. Like Beckett's "imagination dead imagine," Iggy imagines the unimaginable. He lives in and for that impotent imagination. Banging away. Banging and banging and banging. There's a desperation in Iggy that doesn't exist in Beckett. Beckett is resigned to futility but sees no alternative to simply playing the futility out (or is it the resignation that's played out?). Beckett's mindset may be morose, even apocalyptically numb, but it's not desperate in the sense of clawing at the lid of the coffin from the inside. Iggy, on the other hand, is not resigned to anything. He may know it's pointless—hell, he's internalized that knowledge. It forms the material of his neurons as well as his synaptic voids, it flows in his arteries and puddles in the cavities of his intestines, it crystalizes in the geology of his musculature. But in performance, his sinews rise up against the skeleton that is their architecture, threatening to break free—either fully and finally escaping his body's gravitational pull, or dropping like a soft turd on the pavement. The focus of Iggy's gaze lands on a somewhere else no one else can see. He is not resigned to the material destitution of the here and now. He thrashes against location and time, like a shark in a tight cage. He doesn't go on despite merely fearing he can't. His plight is more terrible than that. He goes on, knowing that the transcendence that sometimes seems so near is, in fact, forbidden. It hardly matters whether it is forbidden by gates, guards, personal limitations, or because its very existence has always been a lie. The desire for it remains. This is what I'm calling intensity: the pressure built between desire and constraint, between the conceivable and the possible.

And . . . Chris Burden's "White Light/White Heat" (1975) starts with a request from Burden to Ronald Feldman Gallery in New York:

> I requested that a large triangular platform be constructed in the southeast corner of the gallery. The platform was ten feet above the floor and two feet below the ceiling; the outer edge measured eighteen feet across. The size and height of the platform were determined by the requirement that I be able to lie flat without being visible from any point in the gallery.[9]

After the request, the piece shuts its mouth. For the twenty-two days of the exhibition, Burden lives on the platform, invisible to visitors. He does not eat, talk, or come down. Burden is better known for more visceral violent works,

such as "Shoot" (1971) and "Transfixed" (1974), and these might seem better examples of intensity and a rock-and-roll aesthetics than "White Light/White Heat." After all, Diederichsen describes intensity as "a devotion to unreserved investment into the potential of grand moments, moments that were also a medium of collectivity."[10] But if Diederichsen is borrowing the term from Lyotard, he should steer clear of claims for anything like a "grand moment." A Lyotardian reading would insist that intensity can occur in the hollows of time, in moments that barely register as moments. While grand moments, like Gilbert's "peak" moments, demand reportage, intensity evades it, coming to visibility or audibility only when its pressure begins to distend the frameworks in which it occurs. Intensity is the result of pressure exerted. It needn't be loud nor frenetic nor shocking nor life-threatening. That's why I'm using words like "insistence" and "persistence" and "resistance," rather than a word like "violence." Intensity in scientific terms is the measurable amount of a given property, such as brightness or force. The more of the given property present, the greater the intensity. In trying to refine the use of the term, I want to say that intensity is a result of great pressure exerted against the limits of a situation or a structure.

"White Light/White Heat" creates more of this kind of intensity than Burden's more overtly violent pieces. It's not just that the title takes its name from the great 1968 album by the Velvet Underground. It's that Burden's piece is about pressure, simultaneously inflating and deflating its situation. The tension created in the gallery space must have been nearly unbearable, pushing beyond the pressure recommended by the manufacturers (i.e., the gallery, art historians, preceding artists). Eyewitnesses claim that though there was nothing to indicate that there was a human being on that platform, they could feel his presence. There's a difference between being in an empty room and being in a room with someone else. The gallery becomes an incubator of "moments that were also a medium of collectivity." We feel the other—the Burden—even if we can't see or touch him. At the same time, Burden's actions (or lack thereof) are a total letdown. The expectations a gallery-goer must have had for a Burden show in 1975 are totally deflated. Nothing "happens." The differential pressures created by "White Light/White Heat" amp up its intensity, like the amplitude of a sound wave, created by the difference in pressure between the surrounding air and the pressure of the wave.

When the Velvet Underground recorded *White Light/White Heat* in 1968, they told producer Tom Wilson to keep the needles constantly in the red. The result, as we all know, is not loudness. The Velvets—for all their persuasiveness—cannot control the volume knobs of our stereos. The result is a pressure exerted on the studio's amplifiers, compressors, mixing desk, and an intensity—known as "saturation"—imparted to the magnetic tape. What we hear in a track like "Sister Ray" is not a peak moment. The song is seventeen-and-a-half minutes long—too long, I would think, to qualify as either a peak or a moment. What we hear is sustained pressure on bodies, on materials, on ears, on our attention, on our tolerance, on the notion of song form, and on every permission granted to a band over the first two decades of rock and roll's existence. Something similar happens with Burden's "White Light/White Heat": saturation, strain, intensity.

And . . . then there's Christof Migone, the rare artist working with or in sound, who actively engages an aesthetics of intensity. For a couple of reasons, I will focus on his CD, *Quieting*.[11] I want to take the opportunity to engage Salomé Voegelin's reading of *Quieting* in her book, *Listening to Noise and Silence*. Since both Salomé and Christof are here, this will be a great opportunity to engage in a kind of applied, collective theorizing focused on a single work.

Quieting consists of thirty-six tracks ranging in duration from sixteen seconds to three minutes and twelve seconds. Seventeen of the tracks are digital silence—no audio has been recorded or encoded. Of the remaining nineteen tracks, most consist of very quiet environmental recordings that read for all intents and purposes as silence. But three of the tracks have more identifiable content:

- Track eighteen is the temporal and thematic centerpiece of *Quieting*. The track is twenty-eight seconds long. At twelve seconds, a cannon is fired. This particular cannon is fired every day at noon in Halifax, Nova Scotia.
- Track twenty-two is sixteen seconds long. It uses audio from the video recording of Burden's iconic *Shoot*. Importantly, the audio Migone uses does not include the gunshot of Burden's title.
- Track thirty-six, the final track, is twenty-eight seconds long and is silent for all but the last six of those seconds. The final six seconds consist of

audio taken from *First Contact*, a film recounting the story of Australian gold diggers entering the interior of New Guinea in the 1930s, using guns to subdue the aboriginal population.

I recount these stats, as if taken from the back of a baseball card, for a reason. The total duration of significant audio on this forty-two-minute CD amounts to thirty-eight seconds. Those thirty-eight seconds all refer, in one way or another, to ballistics. Yet Salomé Voegelin focuses on the thirty-three tracks of silence and near-silence. She writes that *Quieting* "composes silence." She is interested in the "*zipzipzip* of the CD-player," "faint hushes, bubbles, voices and crackles," that may be part of the CD's audio, or may just be sounds in her own listening environment. She compares the firing of the cannon to the "Zen master readying you to fight."[12]

> The fight is the phenomenological focus of listening to the work as a sensory-motor production. The canon [sic] brackets the silence and reveals the intention of the work: to make you listen, to quieten yourself and hear your own process and location of engagement.[13]

The equation here of Zen with phenomenological modes of listening is not an uncommon move in sound art and its discourse. Voegelin seems to want to rescue a kind of primal subjectivity from the clinical methods of phenomenology. But *Quieting* expressly evades such a phenomenological-subjective reading. In the instances of the three tracks mentioned above, the listening experience is expressly directed back to the sources of the audio—not just the guns, but the guns' contexts in the histories of art and colonialism. In hewing fundamentally to her subjectivist phenomenology, Voegelin never acknowledges the ballistic thread running through *Quieting*. Instead she focuses on her own sonic-somatic experience of listening:

> I am bound to the sonic materiality produced in my own listening imagination.[14]
>
> I hear myself in this quiet soundscape, I am the centre of its weightless sounds.[15]
>
> [It] becomes material through my fleshly encounter: hooked inside my body its silence tugs on the surface of my skin to hear it as a whisper all over my body.[16]

Voegelin's experience seems to be self-generated and to exist independently of *Quieting*'s content and means of presentation. At times she claims to have produced or coproduced the work, its effects, meanings, and intentions, in her act of listening:

> My contingent signifying practice of listening to Migone's composition.[17]
>
> Migone composes his silence that enables mine.[18]

This is a claim that runs throughout Voegelin's book: what we might call "authorship-via-listening." And I'm certainly post-Death-Of-The-Author enough to be on board with a bit of listener empowerment. But I also think that listening has an obligation to work with what it's listening to and to attend to its particularities. Otherwise, what need have we of specific works? Indeed, throughout her book, Voegelin derives the same listening experience from a varied set of sonic works, as if listening is what's important and not listening-to.

To the extent that Migone's *Quieting* is "about" anything, it is about gunshots. It is about cannon shots used to defend cities, rifle shots used to pierce flesh and subdue native peoples for economic gain. The silences that weave in and out of these shots on the CD are not Zen-inspired invitations to contemplation or phenomenological objects intended as focal points of heightened perception. These silences are the pressurized befores, in-betweens, and afters of colonialism, of oppression, of conflict, of power, as signified by the cannon shot at the heart of the CD. The 17 silent and quiet tracks before the cannon shot are set-ups, each track persistently pushing forward to the next. Why not one long track of silence? Because these moments tick by with the persistence of a second hand: tick-tick-tick; with the persistence of a ticking bomb: tick-tick-tick. These silences are the methodical set-up before the punch line. They are the ruse that allows the con. They are the complacency that precedes the moment of violation. The 18 tracks of silence after the cannon shot are the ticking emptiness of conscience in the aftermath of trauma. Both the firer and the fired-upon ask questions that cannot be answered: and . . . and . . . and . . ., why . . . why . . . why? The silences after the cannon shot are the never-to-be-answered questions. Tick-tick-tick. The quieting of the work's title is not a Zen quieting of the mind, but the oppressor's quieting of the oppressed. It is also the oppressed's

quieting of herself in a vain effort to go unnoticed, to evade the gaze and grasp of the oppressor. The quieting of the title is the sound of the victim erasing himself in the shadow of mounting threat, an erasure is undertaken because, as horrible as it may be, it is still preferable to what the oppressor, the colonizer, the man with the gun, has in mind. Tick-tick-tick.

And . . . in 2000, the same year he released *Quieting*, Migone published an essay, tellingly titled "Ricochets." The essay presents a series of befores and afters of modern enterprise and its calamitous endgames:

> Past the vessel/shipwrecks, train/derailments, automobile/car crashes, electricity/electrocutions at the end of the corridor we find ethnography/ Perhaps an elliptical silence is the only possible response on the other side of that slash. Perhaps silence is the ultimate catastrophe. We can't be silent anymore. "Silence is complicity."[19]

The intensity of *Quieting* is produced by the pressurized persistence of its silences. But this pressure is motivated, *inflated*, so to speak, by the peak moment of the cannon shot. Without the cannon shot the silences do not produce intensity. Likewise, the silences charge the sonic content: charge them like a current and like a judge. The silences are neither innocent nor bystanders. They are complicit. The tracks of identified audio resist simple decoding. Both include what is apparently language, but neither is easily parsed. These tracks are pressurized by the differential values of the information Migone provides in the liner notes and the frustratingly recalcitrant audio. We are told these tracks contain crucial information regarding peak events. Yet we are unable to extract either the information or the peak.

Overall, the persistence of the silences, track after track: sixteen seconds, nineteen seconds, thirty-two seconds, one minute sixteen, one minute twenty-two . . . the persistence of these silences mounting up in anticipation of the cannon blast generates an intensity of anticipation. The persistence of the silences in the wake of the blast generates a different kind of intensity. The listener is compelled to confront the implications of the aftermath of the blast. The silences after the cannon shot are the silences of history, the silences of moral certitude in which all questions and doubts and explanations dissipate into muteness. These silences are inhabited by the firer and the fired-upon, by

the onlooker, and by those of us who come afterward, mercifully unwounded by the blast itself. As Migone writes in "Ricochet,"

> Silence without agency. Silence as the sound fear makes when at the end of the barrel, the suspension of time after the shot, "the monstrous atrophy of the voice, the incredible mutism."[20]

Quieting is a work of persistence and resistance. By surrounding the cannon blast, the audible imprint of power, with more than forty minutes of "silence without agency," Migone requires the listener to contend with both conscience and consciousness, with both self and other, with the undismemberable entity that *we* and *they* form in the crucible of history. The voicelessness of *Quieting* is the voicelessness of the victim. But it is also the voicelessness of these questions and silence as the only answer we have a right to expect.

And . . . Diedrich Diederichsen's equation of intensity with wastefulness and intention with work—a pairing that is perhaps too tidy—allows us to begin some rudimentary mapping of what's going on in the art world, in general, and with sound art, more specifically. As an illustration, allow me to recount a story. In 2006, I was organizing a sound art event called "Aloud/Allowed." The event was originally planned for the Yale University Art Gallery, and for bureaucratic reasons too dull to get into here, was eventually presented at the Firehouse 12 performance space in New Haven, Connecticut. I invited the sound artist Stephen Vitiello to participate and offered him the space that was originally offered to me for the event by Yale: the Art Gallery stairwell. Stephen got back to me and very politely and apologetically explained that he had to decline because his gallerist had urged him not to take any more commissions in stairwells. Attendees at a sound art gathering will immediately understand the insinuations of Vitiello's gallerist. Sound works are always shunted: into the closet, the courtyard, the entryway, the stairwell, the closet, the bathroom. The gallerist coaches the sound artist: "Don't let the painters and sculptors crowd you out. Demand equal billing." The logic seems self-evident; the call for justice all-too-necessary. But is it? In the visual arts, the critique of the white cube is such old news as to be a requisite credential of the self-aware, critically conscious artist. In patterns that ebb and flow, but never evaporate, visual artists seek refuge from the white cube, fleeing to alternative spaces: smaller, oddly shaped, out-of-the-way. Is this merely a case of the grass always being

greener on the other side of the moveable gallery wall? Not necessarily. The intimacy of the stairwell allows a substantively different experience than the main gallery space. Its status as a thoroughfare implores a different relation to the space, and a different relationship to time spent in that space. As it happens, the stairwell I was offering to Vitiello was a gorgeous Louis Kahn design, a series of flights arranged in a triangular pattern, within a cylindrical tower. It is, in my opinion, a significantly more impressive architectural space than the rather-more-conventional galleries.

This episode was undoubtedly floating on the neurons located figuratively at the back of my mind, when, in 2010, I was organizing the exhibition *Non-Cochlear Sound* at Diapason Gallery in Brooklyn. As I determined locations for the twenty or so pieces in the exhibition, I began thinking about where my own piece would go. I realized I had the opportunity to respond, albeit obliquely, to the edict from Vitiello's gallerist.

Rather than ask one of the other artists to bear the burden of the stairwell, I took it upon myself to think that space as an opportunity and to turn its particular spatial, functional, and hierarchical qualities to the work's advantage. At the time of the exhibition, Diapason was located on the tenth floor of a light industrial building in Sunset Park, Brooklyn. A large fire door at the back of the main space led into the strictly utilitarian gray and white stairwell. Metal banisters fed down the concrete stairs. Large industrial windows composed a grid of panes, allowing abundant light into the stairwell during the day. I asked Michael Schumacher, who runs Diapason, to inquire about the status of the eleventh floor, the floor above the gallery, and was glad to learn it was unoccupied. I realized that the stairs, unlike the gallery space, are a conduit for movement. Folks don't stand still on stairs. They don't linger in stairwells, but use them to move up or down through a building. The gallery space is a discreet and private location devoted to exhibiting sound works. The stairs, by contrast, are communal, part of the building's common spaces. What's more, the gallery space is horizontal, static, existing on one level, whereas the stairwell is vertical, dynamic, and connects multiple levels. Gravity is a more significant issue in the stairwell where a simple stumble can turn into a disastrous plunge. In the gallery, the best (or worst) you can hope for is a pratfall. And, while I like a good pratfall as much as the next guy, what I had in mind for Diapason had a little more oomph.

I began to feel that the urge to move ephemeral sound out of the storage closet, the boiler room, the corridor, was misguided. In the showroom of the gallery—where even the most uncommodified *chazerai* can be transformed into objects of capitalist desire: both accouterments for the well-appointed leisure lifestyle *and* bankable investments—the work was vulnerable. The stairwell granted the work a strength. It could be cacophonous, destructive, wasteful, resistant, and unrecuperable. So, I put the stairwell to use. The piece is called "Critique of Instrumental Reason (by the use of drums)." A drum kit is perched atop the stairs and sacrificed to gravity. At the bottom of the stairs it is collected in a wheelbarrow, escorted through the exhibition space, down a hallway, up an elevator, across the vacant eleventh floor, and to the precipice once again. This cycle is repeated, mostly invisible to gallery goers, for the duration of the exhibition. Every ten minutes or so, visitors' attention is momentarily distracted from the other works in the exhibition, by an insistent, resistant collision of skins, cymbals, and cement.

And . . . with a persistence too impatient to wait out the natural cycles of artistic call and journalistic response, Camden Joy took to the streets of Lower Manhattan in the early 1990s, wheatpasting rock reviews, inchoate wilderness yowls, labors-of-love letters and social-aesthetic manifestoes, to light poles, vacant storefronts, and construction site walls, establishing himself as the first, and maybe still the only, guerilla rock critic. He published a series of pamphlets—in the great tradition of the seventeenth-century harangues of the English Civil War. In this case, however, Joy's target is not Charles I, but Charles' progeny, what Joy calls "the advertocracy." Joy laments the compression of musical intensity into individually wrapped, sealed-for-your-protection, bite-sized portions. Joy ends his greatest-ever pamphlet, the one entitled, "The Greatest Record Album Singer That Ever Was" by recalling a project—possibly apocryphal—from his past.

> I tried to make a living by starting a business with a friend. We wanted (naturally enough) to be advertocrats, big time mercantilist publicity pugs, so we studied up on advertocratic lingo (frankly it all read like nonsense to us).[21]

The text then presents three of these advertocratic projects. The first is a mailer announcing a blowout sale. What is for sale, however, is ambiguous

at best. "Push Your Car Away and Go Home Refreshed," promises the mailer. The second project consists of envelopes to be placed over the heads of parking meters declaring "Meter Is Broken." The third project introduces the practice for which Joy is best known, affixing posters in public spaces. These advertocractic posters read "I will pump your gas for free." The fine print, announced by an asterisk, complicates the deal slightly with the condition, "If you will sleep with me."[22]

Joy's enterprise is purposively purposeless. The services offered are nonsensical, of no help. The advertising is, itself, the only real output, the only real product of this advertising. It is, in Diederichsen's parlance, wasteful.

> Intensity and wastefulness, at least at first glance, obey extra-economic, if not counter-economic, principles. Someone who is wasteful neither saves nor invests. . . . Wastefulness is the opposite of husbandry. Intensity enjoys potential and irresponsibility: whatever happens, we do not put it in the biographical piggybank of subjectivity, heaping up experiences.[23]

Camden Joy's futile advertocratic agency attracted no customers. As Joy puts it, "The windows remained dark within our house of opportunity."[24] Frustrated by their failure, Joy and his friend turn to a different kind of poster messaging, first with a Nietzschean remix of a lost-dog poster which read,

> Lost God
> White, hairy, sees all
> Lost in vicinity of Sunset
> Last seen: mid-19th Century sometime
> Likes to be in charge!
> Will not bite
> (Has had his shots!)
> If seen please contact us "immediately"
> We would just like to know that he is o.k.
> (Without him our lives are nothing)

Later, when he and a friend hung "bomb diagrams," they were visited by the police.

All this advertocratic activity predates the activities for which Joy is best known. Although, truth be told, "best known" is not an appellation that sits well on his scrawny shoulders. He is hardly known at all. Some of his social-

psychological-historical-aesthetic-manifestoes took the form of posters, affixed to available surfaces in lower Manhattan. Others he distributed as handbills, face-to-face to unwitting passersby. Most of these flyers—but not all of them—revolve around or refer to rock and roll. He engages performatively, with rock and roll as a cultural signifier, with rock and roll as a stent in the barely beating heart of slacker culture, with rock and roll as the voice of those who, nestled, in the cracks between the pavement stones of society, can't raise their soft little heads to street level for fear of being treaded upon like the snake on the flag who protested just such an ignominious fate.

Of the 100 manifestoes distributed by Joy during this period, only 22 survive.

One of these was handed to Christmas shoppers at Macy's in late 1995. It takes the form of an open letter to History (capital H), suggesting that History is no longer fit for its occupation and should step aside. For one thing, History is too old. Joy, himself, the signatory, would like to assume its position, replacing the "weary and near-blind" History with "ruddier blood." Among Joy's litany of charges against History and his tenure were

> that communism has gone down as a failure (why not also Love, old bastard? Love too hurts and disappoints why not as well murder it, foolish History? But no—arbitrarily you steal from us communism and leave us Love![25]

Another of the manifestoes, pasted around the World Trade Center in early October 1995, arranges scraps of cut-and-paste text in a circle. Each of eight blurbs crowns a spoke emitting from a central hub labeled "Pleasure thyself." One such epithet reads: "In dimmed rooms of velvety incense dank with unfair death devoutly call on the ones who led us here that they may yet guide us to merry freedom: Mayakefski, Duchamp (he's de champ), Oldenberg, Daniel Johnston." Another, pleads, "Give people the goddamned chance to believe in something, anything."[26]

A third, "attached with hat elastics before Gracie Mansion," must have had a certain poignancy when it was posted in November 1995. But now, given the economic and social crises of this moment, the pressurized politics of the Occupy movement, and the permanent removal of the plea's paramour, this poster takes on a tone that's nearly tragic:

> Joe Strummer Where Are You[27]

And . . . both Bangs and Diederichsen worry about the zone of "merry freedom" designated by the various names we've given it here: intensity, art, rock and roll. Their worry boils down to the concern that

> intensity and experience are at stake in name only, . . . the values have actually been shifted only from one place to another in order not to preserve them but to betray them, to use them as pure decoration.[28]

The betrayal here is that radical experience becomes a style and that style becomes a commodity. We run the risk of experiencing intensity not *as* intensity, but as a representation of intensity—intensity compressed—intensity untensified. Rock and roll is exemplary in this regard. The burden of representation, quantification, even qualification or description, threatens to bang the intensity, the *jouissance*, out of the joyful abandon of not giving a fuck.

As a remedy, Diederichsen cites German advertising agencies in the 1970s and 1980s that endeavored to become factories of nonproduction, employing people to make and sell nothing. These European parallels to Joy's pointless American enterprises represent, not leisure as capital, but capital as leisure. They attempt to do to capital what it does to everything else: to appropriate it in the name of the very things whose existence it denies. Diederichsen sees such enterprise as an exercise in intensity because it disobeys capitalism's demands for instrumentality and productivity, pursuing, instead, a program of wastefulness.

Diederichsen describes how this experiment in what we might call "conceptual capitalism," ultimately devolves. The business model, after all, guarantees the firm's collapse. Because no revenue is generated, there is no future. Either the participants disband and go their separate ways, or the company reverses course, becoming a functioning, profitable business. The wastefulness of the do-nothing corporation exercises a modicum of intensity, existing merely for the uncompressed energy of twisting in the wind. But that intensity increases when that very twisting is seen as a critique of dominant modes of experience and evaluation. The trouble is that to grant the pointlessness a point is to subvert the source of its power. One is tempted to fall back on the Kantian formula, "purposiveness without purpose." Except this is very nearly its mirror image, something like, "purposive purposelessness," which, predictably, leads

to an infinite regress: purposive purposelessness becomes purposeful in being purposeless which is its purpose, etc. ad infinitum. If you're purposively—that is to say, intentionally, instrumentally, disposed—this is the danger of such a formulation. On the other hand, if you are inclined toward wasteful intensity, it is the formulation's saving grace. As Diederichsen puts it,

> Principles of intoxication and wastefulness function only when they are precisely not subject to deflective interpretation, watered down by entrepreneurs, instrumentalized, devalued: when we can believe in them without allowing ourselves to get screwed.[29]

So the tension here is between screwing up and getting screwed. The former desirable, the latter not. And if we can substitute the one for the other and reverse the formulation of our title, we end up with something like: joy bangs burden. Rephrased for the austere nature of this gathering: An aesthetics of intensity subverts the dual instrumentality of the market and the academy.

In the elision between the joy and the bang, between screwing up and getting screwed, something emerges. We become aware of the difference between answers and action. Lester Bangs has a name for this state of actioned intensity. He calls it the Party: all action, no answers. As, Lester Bangs puts it in his hilariously titled essay, "James Taylor Marked for Death,"

> And far from being anti-intellectual, the Party is *a*-intellectual; it doesn't make any promises or ask for any field workers. As an answer to the mysteries of life, it's a Bronx cheer, and not a dada one either but the kind your uncle Louie used to razz the quarterback from behind a Schlitz on Saturday afternoon, but as a *way of life*, it's a humdinger.[30]

The party is workaday. It's football (not chess) and its Schlitz (not Dogfish Head—not even Sam Adams). The action is performative: uncle Louie responding to the quarterback directly, physically, a-linguistically. For Bangs, this is the difference between "answers to the mysteries of life" and—italicized in Bangs's original—"*a way of life*." The Party-as-action-as-answer-as-way-of-life is, in Bangs's words, "a humdinger." For Bangs, the Party is one response to Diederichsen's concerns about getting screwed.

> I believe in the Party as an exhilarating alternative to the boredom and bitter indifference of life.... The Party is one answer to how to manage leisure in a

society cannibalized by it, but it's not bread and circuses either because you can't coopt jive because jive is the true folk music that the liberals can never appropriate or master and only an urban aborigine will understand.[31]

And . . . in Migone's "Ricochets," he recounts a scene from the documentary *First Contact*, the one included on the final track of the *Quieting* CD.

> A screening is arranged for the Papua New Guineans of 1982 to view the Papua New Guineans of 1930. Laughter fills the screening hall. Why this laugh? Does this laugh come from a sense of otherness upon seeing a representation of their sameness? . . . By the time they saw themselves on film, they were no longer themselves. . . . They have been unrealized.[32]

The pressure exerted in this initial confrontation with the represented self negates that very self. Here is the neurosis that plagued Debord, Baudrillard, and even the Abrahamic iconoclasts. The representation extinguishes the represented. Bangs believes that intensity, the Party, Art, and rock and roll are equally and simultaneously serious and a joke, constructive and destructive; they are equally representation and represented, subject and object. If the Party, intensity, rock and roll, laughter, put us in touch with the outer edges of experience, they also connect us—ever so contingently—to the nothing beyond those edges; to that elsewhere that we glimpse in the reflection in Iggy's eyes. In the extinguishing convulsion we are as alive and as removed from life as we'll ever be. Migone, coming to grips with the elision connection at the heart of the Papua New Guineans' laughter, quotes Michael Taussig,

> This is like Bataille's laugh; a sensuous explosion of smooth muscle composing Being in the same instant as it extinguishes it.[33]

This laughter—whether it comes from Nietzsche, Bataille, Bangs, or the Papua New Guineans—is a form of pressure. Breath pushes against the diaphragm. Expectation builds to the unexpected dénouement. The punch line lands, like a shot, a blast, a bang. Reason fails in the ruffle of logos.

In his James Taylor essay, Bangs had already made the connection between laughter and rock and roll, tightening the whole package with a bit of Nietzschean thread. According to Bangs, the problem with James Taylor, and with the whole class of earnest soft-rockers of his ilk and era, is that they don't realize that rock is "a joke, a mistake, and a bunch of foolishness."[34] Bangs

doesn't mean this as a knock against rock. No one before or since has ever been more devoted to rock and roll as an art form than Lester Bangs. Rock and roll's strength, he argues, is that it is (to quote the Minutemen), "serious as a heart attack" while simultaneously refusing the critical advances of listeners, both sympathetic and un-. Bangs declares that rock and roll is

> the strongest, most resilient, most *invincible* Superjoke in history, nothing could possibly destroy it ever, and the reason for that is precisely that it *is* a joke, a mistake, foolishness. The first mistake of Art is to assume that it's serious. I could even be an asshole here and say that "Nothing is true, everything is permitted," which *is* true as a matter of fact, but people get the wrong idea. What's truest is that you cannot enslave a fool. No way to regiment the heebie jeebies or make 'em walk a straight line. And nothing better to do from here on out, now that we got cybernation and all such like, but just go to the Party and STAY THERE.[35]

Bangs's Party is akin to what folks like Bataille, Lefebvre, Bakhtin, and Attali mean by Carnival: a ritualized opportunity to step out of life's routines and beliefs and to reconfigure experience in the absence of direction from church, state, or family. Bangs's Party, then, also overflows from the same wellspring as the various Situationist alternatives to the Spectacle. And, yes, all of this can, in one way or another, lead us back, by that same thread, now untied and removed from the package, to Nietzsche and his prescriptions for escaping the Minotaur of Modernity. Bangs, writing six years before Lyotard's essay was published in English and thirty-nine years before Diederichsen's, prefigures both theorists' adoption of Nietzschean ideas.

And . . . the old saw is to start a speech with a joke, deflate the pressure right off the bat. But if we end with (or as) a joke what becomes of that pressure? It doesn't dissipate. Like energy, it resonates: to the brink of the universe, the margin of time, the bottom of the well, the bowels of the beast. Yes, it returns. The musical note returns as sound. Intention returns as intensity. Representation returns as a joke. Rock and roll returns, again and again, banging and banging and banging and

Legs McNeil: Are you glad you were born?

Richard Hell: I have my doubts Did you ever read Nietzsche?

McNeil: Ha ha ha.

Hell: Legs, listen to me, he said that anything that makes you laugh, anything that's funny indicates an emotion that's died. Every time you laugh that's an emotion, a serious emotion that doesn't exist with you anymore . . . and that's why I think you and everything else is so funny.

McNeil: Yeah I do too, but that's not funny.

Hell: That's 'cause you don't have any emotions [hysterical laughter].[36]

A talk delivered at the Sound Art Theories Symposium organized by Lou Mallozzi at the School of the Art Institute of Chicago, November 2011. Previously included in the online supplement to Leonardo Music Journal, *Vol. 23, December 2013, MIT Press.*

Notes

1. Diederichsen, Diedrich, *Sympathy For The Devil: Art and Rock and Roll since 1967*, edited by D. Molon, Chicago and New Haven: Museum of Contemporary Art and Yale University Press, 2007, 143.
2. Lyotard, Jean-François, *Semiotext(e)*, Vol. III, No. 1 (1977), 44.
3. Deleuze, Gilles, *Semiotext(e)*, Vol. III, No. 1 (1977), 13.
4. Lyotard, Jean-François, *Semiotext(e)*, Vol. III, No. 1, 47 (1977), 47.
5. Deleuze, Gilles, *Semiotext(e)*, Vol. III, No. 1, 18 (1977), 18.
6. Gilbert, John, *Deleuze and Music*, edited by Ian Buchanan and Marcel Swiboda, Edinburgh: Edinburgh University Press, 2004, 126.
7. Bangs, Lester, *Psychotic Reactions and Carburetor Dung*, New York: Vintage, 1988, 207.
8. Bangs, *Psychotic Reactions and Carburetor Dung*, 207.
9. Burden, Chris, Press Release for the exhibition "White Light/White Heat" at Ronald Feldman Fine Arts, New York, 1975. http://www.feldmangallery.com/media/pdfs/exhbur75_press.pdf (accessed January 1, 2013).
10. Diederichsen, Diedrich, "People of Intensity, People of Power: The Nietzsche Economy," *e-Flux Journal*, No. 19 (October 2010), 3.
11. Migone, Christof, *Quieting*, Montreal: Alien8 Recordings, 2000.
12. Voegelin, Salomé, *Listening to Noise and Silence*, London and New York: Continuum, 2010, 88.
13. Ibid.
14. Ibid., 89.

15 Ibid.
16 Ibid., 90.
17 Ibid., 89.
18 Ibid., 90.
19 Migone, Christof, "Ricochets," 2000 http://www.christofmigone.com/html/projects_gallery/ricochets.html (accessed January 1, 2013) (The embedded quote is from Kim Sawchuck.).
20 Migone, Christof, "Ricochets," 2000 http://www.christofmigone.com/html/projects_gallery/ricochets.html (accessed January 1, 2013) (The embedded quote is from Aimé Césaire.).
21 Joy, Camden, *The Greatest Record Album Singer That Ever Was,* Portland, OR: Tract Home Publications, 1996, 39.
22 Joy, *The Greatest Record Album Singer That Ever Was*, 42.
23 Diederichsen, "People of Intensity, People of Power: The Nietzsche Economy," 4.
24 Joy, *The Greatest Record Album Singer That Ever Was*, 42.
25 Joy, Camden, *The Lost Manifestoes of Camden Joy* (no publisher listed, 1995) unpaginated, (Lost Manifesto No. 57).
26 Joy, Camden, *The Lost Manifestoes of Camden Joy*, (no publisher listed, 1995) unpaginated, (Lost Manifesto No. 99).
27 Joy, Camden, *The Lost Manifestoes of Camden Joy*, (no publisher listed, 1995) unpaginated, (Lost Manifesto No. 77).
28 Diederichsen, "People of Intensity, People of Power: The Nietzsche Economy," 5.
29 Ibid., 6.
30 Bangs, *Psychotic Reactions and Carburetor Dung*, 75.
31 Ibid.
32 Migone, Christof, "Ricochets," 2000 http://www.christofmigone.com/html/projects_gallery/ricochets.html (accessed January 1, 2013).
33 Taussig, Michael, *Mimesis and Alterity*, 1993, quoted in Migone, Christof, "Ricochets," 2000 http://www.christofmigone.com/html/projects_gallery/ricochets.html (accessed January 1, 2013).
34 Bangs, *Psychotic Reactions and Carburetor Dung*, 74.
35 Ibid.
36 Ibid., 262.

7

Rock and Roll Lecture No. 1

The original title of this paper was "Power, Desire, Interest." Indeed, whatever power these meditations command may have been earned by a politically interested refusal to push to the limit the founding presuppositions of my desires, as far as they are within my grasp. This vulgar three-stroke formula, applied both to the most resolutely committed and to the most ironic discourse, keeps track of what Althusser so aptly named "philosophies of denegation." I have invoked my positionality in this awkward way so as to accentuate the fact that calling the place of the investigator into question remains a meaningless piety in many recent critiques of the sovereign subject. Thus, although I will attempt to foreground the precariousness of my position throughout, I know such gestures can never suffice.[1]

That's a real dickhead way to start. It's dickhead for a bunch of reasons. First of all, it's lifted verbatim—it is the first paragraph, in its entirety, of Gayatri Chakravorty Spivak's, "Can The Subaltern Speak?"

It's dickhead because I'm a white, male, straight, American, and I'm stealing a statement about power desire and interest from an Indian woman. I'm putting her words in my mouth, as if the mouth doesn't matter. I speak a phrase like "my position" as if it describes my position, when, in fact, the words, as written, were meant to invoke a very different set of positions: female, Indian, postcolonial, queer. It's dickhead because my talk is called "Rock and Roll Lecture No. 1" and so when I mention "power, desire and interest," in the first line, you're likely thinking about totally different kinds of power, desire, and interest than the ones Spivak has in mind. Spivak's essay again, is called "Can The Subaltern Speak?" She's asking what may be the most critical political question of all: Do people who do not register in the official channels of a society have a voice?

When politicians, journalists, and social scientists represent the positions of the subaltern, the politicians, journalists, and social scientists would have us believe that it is the subalterns' voices we hear. They would have us believe that the frameworks into which the subalterns' voices are inserted are irrelevant. The politician, the humble servant, speaking for the subaltern, wants nothing for himself. He's just representing. Ignore the messenger and listen to the message. As if the mouth doesn't matter.

Maybe worst of all, given the sins I've already confessed, this statement at the beginning of an essay that turned out to be a resounding opening shot in the culture wars: a rifle blast, a right jab, the rim shot at the start of "Like A Rolling Stone," this statement is all about the dickheadedness of starting off a statement by calling attention to the position of the speaker. Spivak calls it a "meaningless piety." She's thinking of all the introductions and prefaces that start off pedaling backward, as a way of excusing themselves in the back door of a debate as if their own presence in the debate should go unnoticed and that their statements may seem as if spoken without need of a speaker; as if the mouth doesn't matter.

So what can I do with this? How can I start off with Spivak and say something about rock and roll that doesn't simultaneously slander Spivak and kill rock and roll by talking about it as if I've never heard it? Am I going to claim that rock and roll occupies a subaltern cultural position?

You bet your ass. But not all rock and roll. That would be a specious argument indeed. Van Halen, Phil Collins, Sting, The Eagles. I can't do it. I can't make these rich white dudes sing the blues. Not Nirvana. Not even the Sex Pistols or the Ramones. We have to go deeper. How far down: Black Flag, Rollins-era? What about Minor Threat? Bikini Kill? The friggin' Red Krayola? We have to carve out a narrow slice of the spectrum. We have to start from the premise that only *some* rock and roll is subaltern. But which, who, what, and why? That, in a nutshell, is the bitch of cultural analysis.

Where do we start? The garage, you say? The garage, you say? I can't hear you! Yeah, but here's the bitch of the garage: It's been co-opted, like everything else, by the absolute who-the-fuck-cares, lily-liver glorification of the goddamned entrepreneur.

Look at Steve Jobs's garage on the internet. People go there and take their picture in front of it. Ladies and gentlemen, I am sorry to inform you, but your

dreams are dead. Steve Jobs didn't even invent the computer. He just made a pretty one, the same way Norelco made a pretty razor and Louisville Slugger made a pretty baseball bat. You know what else they made: Louisville Slugger and Norelco and Steve Jobs? They made a pretty penny.

So we lionize Steve Jobs? We take our picture in front of his garage? Steve Jobs didn't even invent the computer. Ladies and gentlemen, I am sorry to inform you, but your dreams are dead. Killed off by the user interface and the veritable hyperinflation of the myth of the entrepreneur, the small businessman, the open-plan office, the ping-pong table in the break room.

It's time to take back the garage. It was rock and roll's to start with, almost as soon as it was the car's. Push that heap out into the driveway, Dad, my friends are coming over to jam.

The best garage band name in the history of rock and roll is The Unheard. Better, even, than the Falling Spikes. If you Google "the unheard garage band" you can see a black and white photograph of them. It's not entirely clear who, of the five young men in the photo, is in the band. Four are standing, one sitting at a three-piece drum kit. One holds an electric guitar. One stands at a Farfisa organ. Three amplifiers are visible, one an iconic Sears Silvertone twin twelve combo, the one where the head tucks inside the cabinet for easy transport or storage. These could be mail-ordered from the Sears catalogue. The band's name is inscribed diagonally across the face of the kick drum. One kid is standing against the back wall next to the drummer. A cable is visible in his left hand. It's unclear if this is attached to a microphone, but maybe. Another leans against the fridge. He may be one of The Unheard. He may just be a friend. Every great garage band has a friend who hangs out while the band practices, forming part of the collective consciousness of receiving and producing and receiving that is the garage band's métier. The band sees themselves through the friend's eyes, hears themselves through his ears. In the extreme foreground, mostly out of frame, a folding metal chair anticipates a break in the proceedings. Sometimes mom brings out some lemonade.

We'll never know what The Unheard sounded like. They're The Unheard. And I salute them. I get down on my knees and I bow before them in all their garage band glory. The Unheard. Like Spivak says, Those without a voice, like thousands of other unheards across this country in garages in Doylestown and Mamaroneck and Madison and Barrow Falls and Ferriday and Stockton and

Waxahachie. But I'm not an idiot. I understand that these are not the people Spivak's talking about. To start with, they're American. Even in America, they're white. They have a garage—or their parents do. There aren't any garages at the bottom of the ladder. Robert Johnson didn't have a garage.

I bow before all the other never-even-named garage bands who stapled egg crates to the garage walls and stuffed pillows in the kick drum, who snuck a Tuborg Gold from their dad's backup fridge and couldn't even finish it. I cry myself to sleep at night mourning the bands they never were, the music they never made, and the antientrepreneurial ambition that stoked the capacious fire in their bellies. Who cares if their only audience is the lawnmower and the folded ping-pong table? Who cares if they have to watch their fingers when they slide up to the fifth fret? How can you justify buying a mic stand when the mic itself has been stolen from the stage of a neighborhood folk festival? A 2 × 2 mounted on a plywood base with a hole drilled in the top works perfectly well. They've got something to say and they're going to need a mic stand to say it. They'll start with somebody else's songs. Sometimes the mouth doesn't matter.

The band with the second-best garage band name, is Them. Just Them. No definite article. Them is Them, just Them. Them were Alan Henderson, Ronnie Millings, Billy Harrison, Eric Wrixon, and a singer named Van Morrison.

They didn't form in the suburbs of Cleveland, but in Belfast, Northern Ireland, in 1964. And that's why Them was not technically a garage band, why they didn't rehearse in a garage at all. Garage bands are American because garages are American. Them rehearsed in a room above Dougie Knight's bicycle shop. Bicycles are European.

Take, for instance, Desperate Bicycles, who were English and, like the Northern Irish Them, not exactly European. But they're not American and therefore can't be a proper garage band and that's what we're trying to establish here. In October 1978, vocalist Danny Wigley expressed the motivation driving the Desperate Bicycles' independent stance: "The biggest hurdle is just *believing* you've still got some control over your life, that you *can* go out and do it."[2] They put out their first single on their own label in 1977. Proudly, the cover states: "45 rpm. Mono." When they put out their second single, "The Medium Is Tedium" backed with "Don't Back The Front," they told the story of the first

record on the second record's sleeve, they gave the total cost of producing it: a measly 153 quid, and impelled other kids to go and make their own bands and records and labels: "It was easy, it was cheap, go and do it!"

That's a garage band, sans garage. I hope Steve Jobs was issued an iPod in the afterlife with the complete discographies of Van Halen, Phil Collins, Sting, and The Eagles on shuffle. The Desperate Bicycles' singles are in a different place, a better place. The garage. And that's where I want to go when I die.

But back to Them above the bicycle shop, banging out what we are going to call garage rock. The song is "Gloria." Hosanna. Heysanna. This is the ecstatic joy of the whirling dervish. But it's also teenage kicks. And some of you are nodding your heads because you know the Undertones are the other great band from Northern Ireland and that was their song. Garage rock. Punk rock. Whatever you want to call it. But it's also product. Even a cursory search turns up six different Decca sleeves for Them's "Gloria" single backed with "Baby Please Don't Go." Except if you'll recall, the first one was "Baby Please Don't Go" backed with "Gloria." Oops.

And the kids above the bicycle shop are oblivious to the market, oblivious until it's impossible to be oblivious, that what they're doing could have anything even remotely to do with the market. And by then it's too late. Van the Man goes solo. "Moondance." And all is lost. By which I mean, of course, that all is gained. If Them was other, alter, possibly even subaltern, well, Van, at least, escaped. He's been given voice. His mouth matters. Them were Northern Irish kids under British occupation. Children of the Troubles. Maybe that would have been a better garage band name: Children of the Troubles. If you're starting a band, feel free to use it. But don't turn around and throw it away and go solo. And try to remember to be oblivious to the market.

When Them and Decca were done with "Gloria," Patti Smith got a hold of it. "Rock and Roll Nigger." Yeah, that was her. A woman in America in the 1970s. A woman in rock in the 1970s. A woman who wasn't a band's hood ornament in rock in America in the 1970s. Few could out-garage Patti. Her guitar player—most of you probably know this, at least the ones who nodded your heads about the Undertones—Lenny Kaye, compiled the *Nuggets* collection which all but invented garage rock, *ex post facto*. Kinda the Alan Lomax of garage. And Patti took "Gloria" and put it in her mouth. She sang, "I make her

mine, make her mine, make her mine, make her mine. make her mine. make her mine. G-L-O-R-I-A." As if the mouth doesn't matter. As if the making it mine does.

What did Dan Graham have in mind when he made *Rock My Religion*? He says rock is the great inheritance of American youth. The Shakers thrashed wildly in the throes of religious euphoria. They shook like epileptics. And why not? They weren't built to last, so why save it? The Shakers believe in equality of the sexes. They were founded by a woman, Ann Lee, and they could see Patti Smith coming. Men and women, they thought, should be equal but separate. Utterly separate. No sex. That's what you call an exit plan. One generation, maybe two, if you count the kids the converts brought along for the lonely ride. And then: peace out. Dan Graham says that kind of ecstasy, that kind of expenditure, is what rock and roll is all about. It's not a new impulse. It's been an American urge since the beginning. But with the 1950s and along with the invention of the teenager, America invents teenage angst, followed by teenage kicks, which, as we all know, are both hard to beat and utterly pointless. James Dean plays chicken at the cliff's edge and the other kid plays the Shaker. Peace out. Dan Graham trains his camera on the other kid, Patti Smith, the Ann Lee of rock.

Subaltern is a shitty thing to be. And I don't want to go all meek-shall-inherit-the-earth, because I don't buy that tripe meant to keep the bottom down. But I will say that there is a certain glory in not giving a fuck about what the market gives a fuck about. There's a nobility in banging out the only three chords you know with all the venom of a dying coral snake locked on the underbelly of a yak. There's honor in throwing every last tear and every last twitch of your sinews into a gig for three kids from Portsmouth, New Hampshire, and nobody else. It ain't pretty and it doesn't smell good and then you have to head back to the basement where the sewage has backed up and clean the crap, literally, out of the quarter-inch inputs of your pedals before you can play again.

Opting out of the values that are infused like rose petals in the glowing screens in our pockets, in our backpacks, on our desks, hung on our walls, in the stores, in front of the stores, above the stores, dotted along the highways, opting out of the messages that they—not Them—the market and the market's

marketers and the marketers' managers, and the super-rich and Monsanto—opting out of all that to bang out those chords and to scream into that mic—even somebody else's songs. There is dignity in abnegation. But there is also a price to pay. All the bands for whom the Unheard carries the flag. All the drummers who played and played their shrinking hearts out but never made a dime and never cut a record and never heard their song on the radio. I mean, once upon a time there wasn't even Soundcloud!

Subaltern? I don't know. I'm a dickhead for even mentioning the word. I really am. Spivak should kick my ass. And maybe she will. (I've a feeling she already has.) But just as we can end up at the bottom because of the color of our skin or the caste into which we're born, we can also end up there because we couldn't swallow what we were supposed to swallow, because for some reason, maybe unbeknownst to us in all but our darkest, most enlightened hours, we were unable or unwilling to make even the simplest little effort toward that little gold hoop that America dangles out over the edge of the carousel. Instead, we hurled ourselves off the ride, landing hard on our heads. We stopped being spun and started spinning, like Shakers, like teenagers.

And sometimes, the baton is passed from the children of the troubles to a woman in rock in America in the 1970s. It was no great shakes when it started: beaten up, dented, chipped, and rusting. But with each hand-off, it gets a little worse. By which I mean it gets a little better. Or maybe it just stays the same. The mouth doesn't matter. The song changes hands. We're surprised that it changes meaning too. From Van the Man to Patti. But suddenly the mouth does matter. When Patti sings Van's words "Gloria" changes. She's not the same girl and it's not the same world and Jesus dies for somebody's sins, but not mine. And then Patti puts words in Tricky's mouth. He's British, not the oppressor anymore. And besides, Black British, doubly cursed by being doubly ignored. When Tricky sings Patti's words, Jesus changes and somebody's sins change. They're not our sins anymore—well not mine, I'm Jewish, but that's a whole 'nother story—they're not the sins Jesus was supposed to have died for. It's just one sin really. And they're all guilty: the Republicans and the Democrats and Silvio Berlusconi and Monsanto and Wal-Mart and Coke and Pepsi and the oil companies and especially the banks, and the Supreme Court and the NSA and Texas and their text books. They're all guilty of the one fundamental sin.

The sin of inventing a single language for all of us to speak. As if the mouth doesn't matter.

Originally presented as the opening act for guitarist, Chris Forsyth at Vox Populi Gallery in Philadelphia, October 2013.

Notes

1 Spivak, Gayatri Chakravorty, "Can the Subaltern Speak?" in *Marxism and the Interpretation of Culture*, ed. Cary Nelson and Lawrence Grossberg, Urbana and Chicago: University of Illinois Press, 1988, 271.
2 Lock, Graham, "Desperate Bicycles," *New Musical Express*, October 14, 1978.

Part Four

Anxious, Dismal, Giddy, Aggressive: Seth Kim-Cohen Interviewed by Mark Peter Wright for *Ear Room*

Ear Room: **We're here primarily to talk about your new book *Against Ambience*, can you briefly outline some of its main themes/topics.**

Seth Kim-Cohen: *Against Ambience* is an example of an endangered species—a book of good, old-fashioned criticism. It starts with an observation: that during the summer of 2013 in New York, there were a lot of exhibitions devoted to sound and light: "Soundings" at MoMA, James Turrell at the Guggenheim, Robert Irwin at the Whitney, Janet Cardiff at the Met, "The String and the Mirror" at Lisa Cooley. One such show, at Tanya Bonakdar Gallery in Chelsea, was called "ambient" (lowercase a). *Against Ambience* considers all these shows in terms of their relationship to what we might call the "post-conceptual condition." What is the relationship of the works in these exhibitions to the questions of conceptualism? Do these exhibitions represent a turn away from the forty-five-year arc of conceptualism in the gallery arts? Is ambience a branch of conceptualism; an example of what Lucy Lippard famously called the "dematerialization" of the work of art? Is ambience nonretinal and/or non-cochlear? Or is ambience a rejection of conceptualism, a move toward unmediated experience without concepts?

ER: **I presume the "against" in the title implies a criticism toward ambience?**

SKC: I see this ambient moment as a dispiriting development. It strikes me as throwing out the baby and keeping the bathwater. Dematerialization is not a materialist issue. It's not about the presence or absence of material. The important move of dematerialization, of conceptualism, is one of emphasis. The best work merely downplays the material aspects of the work,

emphasizing ideas and the relationship of the work to the social, institutional, political, and economic forces that license it. (By the same token, nonretinal art is not about nothing to see and non-cochlear art is not about nothing to hear.) Ambience, however, dematerializes away from ideas and relationships and toward an a-signifying, and a-signifiable, experience that pretends to be inoculated from real-world engagements. The ambient portrays itself as a-social, un-institutional, a-political, unbeholden to economics. If ambience is about bliss, it's surely the bliss of ignorance.

ER: How are you defining ambience?

SKC: Well, I'm careful not to define it. Ambience, in its typical usage, indicates precisely an attempt to evade strict boundaries and definitions. If I want to address ambience rigorously, I feel I have to meet ambience on its own terms and interrogate those terms from squarely within the premises of ambience. Still, ambience almost always implies an undifferentiated experience, something that can't be broken down into constituent parts. Nor can it be adequately represented, because sign systems atomize experience into the elementary particles of their own codes. Such atomization is anathema to the ambient. The ambient is also something like an atmosphere or a mood. It saturates everything in it. Conceived this way, I don't see the ambient as an equalizing or democratizing impulse.

However, in *Against Ambience*, I discuss philosopher Timothy Morton's use of the term, ambient, which is quite different from what I've just described. For Morton, "ambient" describes the intrinsic presence of fissures between being and appearance. All things are subject to this essential gap between what they are and how they appear. All such appearing is a kind of representation, a transposition into codes that are not those of the thing itself. I try to keep the latent (or not so latent) Kantianism of this at arm's length, and take a kind of Derridean position, which goes something like this: The gap between being and appearing is not a gap between the thing itself and any representation of it. The gap emerges from two contradictory realities: first, the pragmatic reality that forces us to proceed as if things are stable and self-consistent, and second, the reality that things establish their meanings and identities by means

of a perennial reliance upon their contexts. I'm drawn to Morton's account of ambience because I think it carries a pragmatic ethics. If we can begin to integrate the contextual reality of things into our practical encounters with them, we may be able to tease out a set of more ethical responses to our world. If this is what ambience means, then I can see a way to read it as a positive horizontalness.

ER: Is the book in anyway a continuation of your last work (*In the Blink of an Ear*): how do the two things connect?

SKC: I believe art is part of the world. A lot of work with sound (including a lot of music) tries to behave as if it's not. Think of the adjectives that attach themselves to sound and music: ephemeral, immersive, transcendent, ineffable. The suggestion is that sound and music operate in a realm beyond the influence of capital and culture and race and gender. And while I can certainly understand the appeal of such a realm, I don't believe it exists. Sound, like everything else, is burdened by being a thing-in-the-world. *In The Blink of an Ear* is an attempt to retell the story of the sonic arts from within the world, rejecting otherworldliness and any notion of a realm beyond. *Against Ambience* is equally committed to worldliness. But instead of focusing on the long, international history of the sonic arts, the new book examines a few months in New York and treats sound as one instantiation of the broader category of ambience.

ER: Although your new book is a critique of ambience, is it perhaps more specific to the relevance/function of ambience during a postcrash society?

SKC: *Against Ambience* closes with what I admit is a speculative naming of suspects: a short list of the cultural, historical conditions that may have given rise to an interest in ambience. I name information, politics, and transcendence, and I think each can be linked to what you call "postcrash society." For example, ambience may be a response to the oft-discussed "information overload." The global economic crash of 2008 was made possible by the massive amounts of information that can now be extracted, stored, and communicated. All the financial exertions that inflated bubbles and animated economic ghosts would

have been impossible in earlier informational eras. It seems just as accurate to call what happened a "data crash" as to call it an "economic crash." In the epoch of binary code, capital is no longer broadly symbolic. It is now merely a series of ons and offs. The masters of global capital are ever closer to controlling each switch. Instead of the haves and the have-nots, we now have the ons and the offs.

ER: It's refreshing to read something that's commenting on exhibitions, which have literally just happened, this year. When did you start thinking of this book and how fast was that process?

SKC: *Against Ambience* is a kind of writing and publishing experiment. It was written in just a few weeks. It is an attempt to respond in nearly real time to the events of the summer of 2013 in New York. I am denying myself the benefits of time and distance and trying to understand a moment from within it. The book will be published by Bloomsbury exclusively as an e-book (at least at first), this being the quickest way to get the book into the hands of readers. The hope is that this book works in and with (and against) the tendencies it observes while those tendencies are still alive and unfolding. It was an exciting way to work. I don't look forward to going back to writing from an outside, long-view perspective. I like the vitality of this kind of project. Of course, I realize it's risky too. The quick turnaround is sure to have engendered some technical and intellectual mistakes. But I don't mind making mistakes. Screw efficiency. With Lou Reed heavy in my thoughts, I consider the process an act of growing up (messily) in public.

ER: In the book you describe the curatorial turn as a movement toward "percepts," that is, a fascination with perceptual objects, sensory phenomena (including sound) and spectacular yet meditative works. As much as the book is against ambience is it more against curatorial ambience rather than artistic ambience?

SKC: I can't see how one makes this distinction between the curatorial and the artistic. If we're talking about work that makes its way to us via both artists and curators, then what we experience is necessarily a curatorial-artistic construct. It's also political, economic, gendered, historical, and art historical. To a great

degree, I see art as a machine for producing responses. And responses, in order to be activated, must be put into circulation. And to be put into circulation, responses must be translated into, or generate, discourse. It's great if I'm moved by a painting, or a film, or a song. But if that feeling never leaves me, never moves anything else in the world, then the work has failed. Or I have. The way feelings leave us is through discourse: talking and writing. This doesn't mean that I devalue art as a practice, or that I think we can or should replace art making with discourse making. I think art catalyzes responses and discourse that wouldn't emerge otherwise. So, I'm devoted to art making.

ER: I think there's some interesting cross over here with your project *Tomorrow Is The Question? Is The Question!* (2012). Could you reflect on that a little.

SKC: I initiated the project *Tomorrow Is The Question? Is The Question!* at Audio Visual Arts in New York. I placed a series of ads in the "Musicians Wanted" section of the New York Craigslist. Each ad describes a music, that to my mind, doesn't exist in the world. One, for instance, read

> Kraut-Soul. What if Marvin Gaye fronted Can? What if Booker T and the MGs played like Neu!? (They kinda did.) What if Kraftwerk was James Brown's band? Let's find out. Instrument, age, gender, ethnicity, virtuosity, unimportant.

When people responded to the ad, we exchanged emails about music, about their backgrounds and interests, and mine. I selected the people I thought could bring something interesting to this imagined music. I then invited a group of selected respondents to the gallery, which had been set up as a rehearsal space, with drums, amps, p.a., and a fridge full of beer. Each group was given two-and-a-half hours in the space. I didn't attend. So this was just like a typical situation in which someone advertises to form a band, except in this case, the person who initiates the project isn't present to organize, make decisions, provide musical direction, or decide who's in and who's out. The group of strangers were left to decide how (or if) to interpret the ad's description, how to coordinate themselves as a band. We recorded each session and I edited

each recording down to a pair of seven-minute pieces to be released on a clear, 10-inch acetate.

 This project is as curatorial as it is artistic. More crucially, it acknowledges the discursive seed and harvest of the process of music making. We start from words about what this music will be, why we're making it, who does what. We organize ourselves, socially and musically, in conversation. The process yields music, yes, but just as importantly, it yields thoughts, discussion, and writing about how the genesis, authorship, history, creation, and interpretation of music interact in complex ways. Ultimately, this project reveals how all these "extra-musical" aspects of music are, in fact, what we're engaged with when we engage with music. And these aspects are the very stuff of being alive, of negotiating the demands of time, other people, history, form, gesture, meaning, and being.

ER: I'm interested in your dissection of the sine wave, particularly the notion of a pure sine wave, which is deployed regularly within the ambient works you comment on. Could you say something about this and perhaps this illusion of purity I think you're hinting at?

SKC: I use sine waves (sometimes called "pure tones") as a kind of synecdoche for sound in general. I suggest that sine waves are prevalent in sound art because they function as a kind of zero degree, a *reductio ad absurdum*, of sound. Sine waves are free of harmonic overtones. So some like to believe they are free of other kinds of overtones too, social, political, historical. Some sound art proposes that if sine waves are pure and are the elementary particles of sound, then sound must be pure too. But sine waves have their own history, their own connotations, their own instruments, and conventions of use. Outside of the technicalities of harmonics, there's nothing pure about sine waves.

ER: Does the book offer a counterpoint to ambience—do you draw upon works to show another possible route?

SKC: I nominate dub as ambient's other. But in true Derridean fashion, dub isn't simply the opposite of ambient. The two are imbricated and codependent. Still, they offer decidedly different ways of thinking about

work. In some of Eno's writing about his process, he mentions dub—Lee "Scratch" Perry, in particular—as a precedent. As musical genres, dub and ambient display some similarities: both use recording and mixing technology as a generative tool; neither documents a live performance; both revel in sonic effects, like reverb and echo, that suggest sound moving in space. But where ambient invites individual listening (think of Eno's creation myth of ambient: lying alone in his sickbed, unable to get up to adjust the volume of the too-quiet music), dub developed as a collective music. Dub plates were acetates produced for sound system parties. Often a mix was custom-made just in time for a particular event. Ambient has its genesis in the English countryside, the singular brainchild of an art college–educated, middle-class, white man. Dub is born in urban Jamaica, developed through the collaborative practices of black musicians and studio engineers working on jerry-rigged equipment.

When ambient is used to mean environment, the environment in question is always a nebulous, otherworldly (or unworldly) space. As Timothy Morton points out, there are other kinds of environments, so there must be other kinds of ambience: urban, anxious, dismal, giddy, aggressive. The environment of Eno's ambient is private and privileged. Art historically, its values are a regurgitation of Cagean values, transferred from the high-art context of the mid-century musical avant-garde, to the mercantile practices of pop and rock. Dub emerges from social exigencies: each sound system needs something unique to draw people to its party. Eno's ambient tries to level foreground and background so that the music interacts, nonhierarchically with its environment. Dub repositions elements that typically play a supporting role (bass and drums), moving them to the foreground. The conventional foreground elements (vocals and guitars) are removed to clear space. Dub is pop music turned inside out, not merely flattened, but reordered to demand a new kind of listening. This listening emphasizes rhythmic elements and cyclicality over melodic lines and thematic development. Michael Veal, in his book on dub, suggests that this revision is a sociopolitical response to the Europeanization of African cultural output. He even goes so far as to say that dub's deletions, its vacated spaces, can be heard as a response to the historical trauma suffered by African people.

ER: **So dub can be read as a form of "engaged ambience?"**

SKC: I propose "dub" as an aesthetic modifier, in the same way that "ambient" is used to describe art practices beyond music. For example, the exhibition "ambient" at Tanya Bonakdar Gallery in Chelsea included six of Sherrie Levine's *Black Mirror* pieces. I find it impossible to think of these pieces as ambient. Understood in the context of Levine's work, they are remixes, they are dub mixes. They start from tracks that have already been laid down: monochromes, the mirrors of the *mise en abyme*, or, as reflective surfaces—*tableaus* waiting to depict something *vivant*. They turn all these references inside out the same way dub inverts song form. In doing so they demand a reshuffling of art historical demands, desires, and values. The only way to think of these pieces as ambient is to pretend you don't know who Sherrie Levine is or what her work is about.

ER: **It seems you are advocating artworks, which through their representation, connect to language, text, reading, and discourse. Does this mean you're only concerned with human-to-human relations? So much of sound art deals with nonhuman species and phenomena—does this mean they (animals, inanimate objects, tools, even sound as a mechanical vibration) are excluded from the debate because they can't speak "our" language?**

SKC: I understand the importance of engaging with nonhuman entities in sound art and in the new materialist philosophies. But I also recognize the limitations of these engagements. As a human being, I inevitably understand such entities through human apparatus. This means that sensory phenomena are necessarily anthropomorphized by my sense organs. The only vibrations I can hear as sound are those between 20 and 20,000 hertz. In order for me to hear them, these vibrations must travel the path of my ear canal. High frequencies and low frequencies activate different locations within my ear. What I hear is literally formed by my anatomy on its way to my cochlea and then further transformed by my nervous system's relays and responses. Additionally, phenomena are anthropomorphized by human conventions and categorizations. I understand why some think this is a problem. But I'm not convinced by their solutions. Deterritorialization and rhizomatics are still human concepts. They are still anthropomorphizations.

The trick, as I see it, is to avoid conflating anthropomorphic with anthropocentric. Just because I am forced to take in the world through my human anatomical and cultural apparatus doesn't mean that I think my receptions and understandings are privileged. I must remain vigilant to whatever biases my anthropomorphisms encourage. I must develop techniques to counteract those biases. And I must be committed to resisting any sense that my understandings are "true" or special.

ER: Going back a little. You have a varied background in fine arts, writing, and curating—I'm curious to know how and when sound became a focus for you?

SKC: In 1989, I was in the MFA program in Creative Writing at Columbia. I paid for books and drinks by working at Artists Space, a nonprofit gallery in Tribeca. Before I finished my degree, I dropped out to start a band. We moved to Madison, Wisconsin. We rented a house sandwiched between a recycling center and an electrical substation where we could play at any hour of the day or night. After nine months, we moved to Chicago. From 1990 until 2002, I played in Chicago-based bands. The best of which was The Fire Show, indebted in equal parts to This Heat, The Birthday Party, Lee Perry, Television, Public Image, Pan Sonic, and Johnny Cash—although many critics at the time thought we managed to transcend those influences.

Toward the end of The Fire Show, I started to chafe against the formal and conventional restrictions of the band format. For example, we organized a show at a venue in Chicago called The Hideout. Each audience member was given a numbered ticket as they entered. A number was announced and the holder of that ticket was escorted from the front barroom into the rear performance space. The lone audience member was seated in front of the stage and we introduced ourselves the way you would if meeting a stranger at a party ("hello, our name is The Fire Show, what's yours?"). Lights were trained on the listener (rather than the band), a photographer took a large-format Polaroid portrait of the listener while we performed a private, one-minute concert. A CD of the performance was burned on the spot and the audience member left with the photograph and the only documentation of the music.

ER: So the form and maintenance of its production ended up taking you in another direction?

SKC: Yeah, it's not the kind of thing that a band can take on the road. The project necessitates a specific spatial configuration. In that sense, it was site specific. Plus, rock venues aren't interested in this kind of project, nor are they equipped to handle its unique requirements, modest though they are. On top of that, a record company wants a band to play their recorded music. And rock audiences too, have different desires for a night at the club. The conventions of the rock production cycle just aren't flexible enough to allow this kind of approach to flourish. It doesn't function in the economic infrastructure of album-tour-album-tour.

So, to answer the original question, I was a musician before I was anything else. And music single-mindedly consumed my energies for more than a decade. But the restrictions of the form became untenable. So I went back to school and did a PhD at the London Consortium, under the tutelage of the great cultural theorist, Steven Connor. I continued to explore music and performance. I did a one-man musical monologue at a rock venue in London. To live-looped guitars, I spun a first-person narrative about a quadriplegic writing songs in his head as he allows himself to die. I suppose the psychoanalytic reading of that piece would suggest that I felt paralyzed by the form and I let it die. That was the end of my rock career.

ER: It seemed like quite an active period for you, I remember your ResonanceFM broadcasts around that time among other things.

SKC: I'm easily bored. So I tend to take on too much. My first foray into the art world was *Symphony 0* at Peer Gallery in Hoxton, a twenty-four-hour piece for solo acoustic guitar, strumming one chord, letting it decay to silence, before strumming it again, for the whole of a calendar day. Around the same time, I developed two radio programs for ResonanceFM in London. The first was "One Reason To Live," in which one guest per episode chose one piece of music to listen to and then talk about for the remainder of an hour. Those conversations were published in book form by Errant Bodies. The second was "Unst: Bespoke Sound," a weekly, hour-long piece of custom-made radio art

for broadcast, that I produced with Drew Morgan, Paul Chauncy, and Rob Mullender. I pursued various works in sound. And I took it for granted that sound art had to be different, in nearly every way, from the music I used to make.

But I've come to realize that I'm still making rock and roll. In fact, I'm making the kind of rock and roll I wanted to make when I quit The Fire Show. In order to make this kind of rock and roll, I had to give up on conventions like a band, venues, touring, albums. Those are the limiting factors. All along, without ever planning or even realizing it, I was groping toward a conceptual rock practice, a practice that treats rock as a source of cultural energy, as a discrete historical phenomenon, and as an aesthetic problem.

ER: I enjoy the way your writing is always critical, always disruptive—is this something you consciously strive for? I'm guessing it is, but perhaps you could talk a little about your writing practice; how ideas and thoughts are articulated through writing; how that process begins and if there's any notable reference point for you?

SKC: Thanks. My work is always trying to poke holes in the barricades that divide practices and histories and disciplines. So, similarly, I try to write between and across registers. There are times when philosophical terminology is required to address specific histories or problematics. Other times, a belly laugh or a punch in the gut might be more effective. Lester Bangs is the greatest critic I've ever read. His writings about rock and roll are a form of rock and roll. His essays don't sit outside of their concerns, passing judgment from a remove, they wrestle with the same issues the music is wrestling with and they wrestle with the difficulties of wrestling with something that's already wrestling with something else and with the commensurate bankruptcy of objectivity and subjectivity. It's a sloppy kind of wrestling: mud wrestling. Bangs is funny as hell. And sad as hell. He can't abide the superficiality of rock and roll and, at the same time, he imagines it's deeper than the Mariana Trench. When Bangs was writing for rock magazines, rock wasn't yet taken seriously as a cultural form. His writing acknowledges this while also agitating to change it, simply by finding in great rock and roll the same concerns and problems one finds in all great art. I try to write like Lester Bangs would have if he thought his

readers were also reading Derrida and Borges and Wallace Stevens and Beckett and Robbe-Grillet.

ER: And finally as always *Ear Room* asks, What does the term sound art mean to you?

SKC: What it means to me doesn't matter. Time will decide. Probably, it will fade away like "video art" and those who utter the phrase will seem quaintly out of touch, like a grandpa with a flower in his lapel.

Originally published at https://earroom.wordpress.com/2013/12/04/seth-kim-cohen.

Index

Ablinger, Peter 89
"absolute music" 18–19
Acconci, Vito 41, 74
acousmatic listening 49, 89
African music 137–8
African Rhythm and African Sensibility (Chernoff) 137
Afrobeat 135
After School Special formulism 122
Agamben, Giorgio 95–6
Agawu, Kofi 137–8
AION (Kirkegaard) 63–6
Aitken, Doug 12–13, 86–8, 90–1
Akerlof, George 89
akousmatikoi 89, 92
"Aloud/Allowed" 156
Ambient 1: Music For Airports (Eno) 28, 34
ambient conceptualism 10, 51
ambient exhibition 4, 21, 28, 32, 36, 37, 51, 54, 184
ambient moment 29
ambient music 36, 47–8, 183
ambient poetics 28, 30
"Ambient Poetics: an Introduction" 37
ambient presentness 44–6
"and ... and ... and ..." 148–9
and/nor-ness, of sound 31–2, 49, 60–1
anecdotal sounds 56
Antoni, Janine 85
arche-writing 97
Architecture gothique et pensée scolastique (Panofsky) 105
"Art and Objecthood" 44
Art and Technology project 9
Artforum 37, 111
Arthur, Paul 91
articulation 94–113
"The Artist As Ethnographer" 140
"The Artist as Producer" 140
Artists Space 185

Art & Language 74
Asher, Michael 41
Assange, Julian 75
Aten Reign 27, 38–9, 41–2, 45
The Audible Past: Cultural Origins of Sound Reproduction 6
Audio Visual Arts 181
audiovisual litany 6, 60
augenblick (the blink of an eye) 88
"authorship-via-listening" 154
"autonomous art" 18
"autopaths" 123
"autotune" 123, 124
Ayn Rand Institute 111

"Baby Please Don't Go" 171
Bad Ideas For A Sound Mind (Yeh) 70–1
Badiou, Alain 24
Baldessari, John 74
Bangs, Lester 149, 187
"baring the device" 52
Barney, Matthew 85
Barrett, G. Douglas 8
Barry, Robert 74
Barthes, Roland 99–100, 112, 134
Beam Drop (Burden) 85, 86
Beckett, Samuel 95–6, 149–50
Being and Time (Heidegger) 55
Benjamin, Walter 140
Berger, Maurice 102–5
Berlusconi, Silvio 173
Bildungsroman 40
Billy Bao 131–4, 136–7, 139–41
The Birthday Party 185
Bishop, Claire 44
"Black Mirrors" 51, 184
Black Sabbath 34
"The Blink of an Eye" 88
Bochner, Mel 33, 74
Boehme, Jacob 100
Bourdieu, Pierre 105

Box With The Sound Of Its Own Making (Morris) 119–20
Brassier, Ray 24
Brecht, George 70
Broodthaers, Marcel 41
Brooks, Mel 69
Brown, James 135
Buildings From Bilbao (album) 140
Burden, Chris 41, 85, 86, 150
Buren, Daniel 74
Burroughs, William 10
By Means of a Sudden Intuitive Realization (Eliason) 85

Cage, John 9–10, 28, 34, 50, 94–9, 101, 103, 107–8, 112, 124, 134, 144, 183
CAN (German band) 148
"Can The Subaltern Speak?" 167
Cardew, Cornelius 145
Card File (Morris) 118
Cardiff, Janet 3, 37, 85, 177
Caro, Anthony 44
Cash, Johnny 185
Cato Institute 111
Çerkez, Mutlu 8
Charlie Rose (talk show) 37
Chauncy, Paul 187
Chernoff, John 137–8
Children of the Troubles 171
Chion, Michel 56
Citizens United v. Federal Election Commission 108
Cloisters 3
Collins, Phil 168, 171
The Complete On The Corner Sessions 49
con-artists 11
concepts/conceptualism 9, 13–20
Conceptual Art 4, 15–16, 74
conceptual turn 4
Conquest Of The Useless (Herzog) 91
correlationism 23
Cosmococa installations 86
Country Scene 52
Cox, Christoph 24–6, 58
"Critique of Instrumental Reason (by the use of drums)" 158
curatorial-artistic construct 180

dasein (being-there) 57
Davis, Miles 48
Day Is Done 3
Dean, James 172
Decca 171
deep listening 134
De Landa, Manuel 24
DeLaurenti, Christopher 8
Deleuze, Gilles 24, 147
Deleuze and Music (Gilbert) 149
dematerialization, of art 10, 15, 177
Deng Xiaoping 85, 90
Derrida, Jacques 21, 31, 61, 88, 94, 97, 108, 110, 112, 125–7, 188
Deschenes, Liz 37, 51
Desperate Bicycles 145, 170, 171
deterritorialization 184
Diapason Gallery 127, 157
Diederichsen, Diedrich 144–6, 151, 156, 159, 161–2, 164
differance 59
digital recall system 29
Discreet Music 28–9, 33
discursive site specificity 42–3, 133–5, 140–2
"Don't Back The Front" 170
Doppler effect 62
dramatis personae 123
Dream House 5
dub music 47–8, 52, 182–4
Duchamp, Marcel 73, 124, 126, 160
Dworkin, Craig 67–8

The Eagles 168, 171
Eliasson, Olafur 5, 28–9, 36–7, 51, 85
Ellsberg, Daniel 90
Eno, Brian 3, 28–36, 42, 47–52, 64, 137–9, 183
"Eno Discreet Music" 29
Enoesque ambience 51
Ensemble Mosaik 18–19
Erkizia, Xabier 131
Erlmann, Veit 6, 69
Everything You've Heard Is Wrong 109–11
extra-musical model 134

"fabric of citations" 134
Falling Spikes 169

Farfisa organ 169
Fela 135, 140
Ferrari, Luc 56
The Field of Cultural Production (Bourdieu) 105
Fieldworks: From Place to Site in Postwar Poetics (Shaw) 43, 133, 140
The Fire Show 185
First Contact 153
Fitzcarraldo (movie) 91
Fluxus text scores 70
Forensic Theory Number One 74
The Forty Part Motet 3
Foster, Hal 133, 135
Foucault, Michel 104
4′ 33″ 50, 95, 98
Fremdarbeit (Outsourcing) 17–20
Fresh (album) 35
Fried, Michael 44–5, 104
Furniture music 50

garage bands 169–71
Garage rock 171
Garvey, Marcus 109
Gilbert, Jeremy 149
Glee (TV series) 121–5
Gleick, James 74
"Global Ear" column 131
"Gloria" 171
Goehr, Lydia 112–13
Goldman, Susan 52–4
Goldwater Institute 111
Gonzalez-Foerster, Dominique 85
Gould, Glenn 95–6
Graham, Dan 74, 85, 172
De la Grammatologie (Derrida) 125
Gramsci, Antonio 145
"The Greatest Record Album Singer That Ever Was" 158
Greenbergian formalism 16, 41
Griffin, Tim 28, 30, 34, 37, 48, 50–2, 54
Guggenheim 3, 20, 27, 28, 36, 38, 42, 102–4, 106, 177

Haacke, Hans 74
Haig, Alexander 85, 90
Harman, Graham 23

Harrison, Billy 170
Hayes, Sharon 8
hearing, sense of 117–18
The Hearing (Morris) 117–20
Hedwig and the Angry Inch (movie) 123
Heidegger, Martin 55, 57
Henderson, Alan 170
hermeneutic monologue 89
Herzog, Werner 91
The Hideout 185
Higgins, Dick 70
Hoff, James 8, 29
House, Ron 60
How Loud Is This (Gallery)? (Licht) 69
Hudson, Keith 47

I Am Sitting In A Room (Lucier) 63–5
Iggy Pop 149–50
Ikeda, Ryoji 5
Iles, Anthony 140
immaterialization 10
immersive installation 5
infinitesimal degree 50
information age 110
"Information" exhibition 74
The Information (Gleick) 74
information overload 179
Inhotim 86
Inside The Dream Syndicate—Day of Niagara 89
insistence 149
institutional site specificity 133
intensity 146, 147, 149
In The Blink Of An Ear: Toward A Non-Cochlear Sonic Art (Seth) 4, 12, 70–1, 124, 127, 179
Irwin, Robert 3, 5, 9–10, 12–13, 16, 28–9, 51, 54, 177

Jakobson, Roman 31
Johnson, Randal 105
jouissance 146
Joy, Camden 123
Judd, Donald 44, 88

Kahn, Douglas 9–10, 50, 107
Kahn, Louis 157

Kalakuta Republic 140
Kane, Brian 56
Kantian-Greenbergian questions 4
Kantianism 178
Katchadourian, Nina 8
Kaye, Lenny 171
Kelly, Mary 41
Kirkegaard, Jacob 63–5
Kissinger, Henry 90
the Kitchen 34, 37
Kittler, Friedrich 30, 74
Klein, Yves 121
Kosuth, Joseph 74
Kozlov, Christine 74
Krauss, Rosalind 16, 42–3, 88
Kreidler, Johannes 8, 17–20
"Kreidler composition" 20
Kubick, Chris 8
Kubisch, Christina 12
Kumpf, Lawrence 6, 69
Kwon, Miwon 42–3, 133

Labyrinths: Robert Morris, Minimalism, and the 1960s (Berger) 102
LACMA. *See* Los Angeles County Museum of Art (LACMA)
Lagosian music 131–2
The Lagos Sessions 131–42
language 98
Laruelle, François 24
Latour, Bruno 24
"Lecture on Nothing" 95–9, 101, 107, 112
Lee, Ann 172
Lee, Pamela M. 111
Le Neutre 100
Lenin, Vladimir 109
Leo Castelli Gallery 117
"Let Me Hear My Body Talk, My Body Talk" 9
Levine, Sherrie 37, 51, 184
LeWitt, Sol 33, 53, 74
Licht, Alan 69
linguistic conceptualism 10, 15, 73
linguistic turn 4
Lippard, Lucy 15, 177
Lisa Cooley Gallery 3, 28, 69, 70, 177
listening 49, 56, 89, 134–5

Listening to Noise and Silence (Voegelin) 152
liveness, of sound 45–6
Lomax, Alan 171
López, Francisco 12–13, 124
Los Angeles County Museum of Art (LACMA) 9
Loy, Herman Chin 47
Lucier, Alvin 63–6
Luening, Otto 49
Luke, Justin 6, 69
Lyotard, Jean-François 96, 144

Maachi, Jorge 86
Macero, Teo 49
Mangolte, Babette 102
Manning, Chelsea 75
Margins of Philosophy 108
Martin, Agnes 53
Marx, Karl 109
material ontology 69
Mattin 131, 140
May'08 (album) 140
McLuhan, Marshall 6, 21–3, 74
McShine, Kynaston 74
meditative-spectacular experience 38–9
medium 67
"The Medium Is Tedium" 170
Meillassoux, Quentin 23–4
Meireles, Cildo 41
"Messthetics" 145
the Met 28, 37, 177
the metaphysics of presence 21
Metropolitan Museum of Art 3
Meyer, James 133
Microtonal Wall (Perich) 62–3, 66
Migone, Christof 8, 71–2, 152
Miller, Cardiff 86
Miller, George Bures 86
Millings, Ronnie 170
Minimalism 44–5, 104
"mirror strip" works 37
mise en abyme 51, 184
Mitchell, John Cameron 123
mitsein (being-with) 57, 58
Modernist work 44–5

MoMA. *See* Museum of Modern Art (MoMA)
"Moondance" 171
Morgan, Drew 187
Morris, Robert 44, 101–6, 108, 117–20
Morris, William 109, 112
Morrison, Van 170
Morton, Timothy 24, 28, 30–2, 48–9, 61, 178–9, 183
Moura, Rodrigo 85
Mullender, Rob 187
Murraybay, R. 18, 20
Museum of Modern Art (MoMA) 3, 5, 27, 28, 62–3, 66, 69, 74
musique concrete 56, 89
mutism 106
My Life In The Bush Of Ghosts (Eno and Byrne) 137–8

Nauman, Bruce 41
neue musik 18–19
Neuhaus, Max 66, 67, 69
The Neutral 100
New Music, New York 34
New York Times 13, 27, 38, 41
Niblock, Phil 8
"Nietzsche's Return" 144
Nigerian music 131, 135
Nixon, Richard 63
Nixon-Mao summit (1972) 85, 90
Nkrumah, Kwame 109
"No ideas/but in things" 97
noise 100
Noise & Capitalism (Mattin and Iles) 140
Noise Water Meat (Kahn) 50
Noland, Kenneth 44
"Nomad Thought" 147
nom de guerre 131
No Media (Dworkin) 67
non-cochlear sonic/sound art 70, 73, 121, 124–7, 157, 177, 178
Non-Cochlear Sound 157
nonretinal visual art 124
"Notes on the Return and Kapital" 144, 146
"Not Ideas About The Thing, But The Thing Itself" 97

Nuclear Weapons and Foreign Policy (Kissinger) 90
Nurse With Wound 89

Object-Oriented Ontology 24, 37
objet sonore (sonic object) 57, 89
October (semi-journal) 42
Office de Radiodiffusion Télévision Française 89
O'Hara, Frank 3
Oiticica, Hélio 85
Olitski, Jules 44
Oliveros, Pauline 134
One Place After Another: Site-Specific Art and Locational Identity (Kwon) 42, 133, 140
"One Reason To Live" 186
Ong, Walter 6, 21–3
On The Corner (album) 48–9, 52
op-art 5, 7
Operative Ambience 49
Orwell, George 109
otherness 122

Pablo, Augustus 145
Panofsky, Erwin 101–6
Pan Sonic 185
Park Avenue Armory 5
Pater, Walter 125
Paz, Bernardo 85, 86, 90
pellets 71–2
percepts 9–13
Perich, Tristan 51, 62–3, 66
Perry, Lee "Scratch" 47, 53, 145, 183, 185
phenomenological site specificity 42, 133
Philipsz, Susan 3, 37, 65
"philosophies of denegation" 167
photograms 37, 51
phrase regimen function 100
ping-pong recording process 64
Pink Floyd 29
"political" music 142
politics 22–3, 75
Pop Group 145
post-conceptual condition 177
postcrash society 179
postindustrial paradigm 28, 32

precepts 9, 20–7
"pre-Christian" civilizations 22
Price, Seth 51
"Primal Sound" 87
Product Placements 17
Public Enemy 29
Public Image Limited 145, 185
punk rock 145, 171
pure tones. *See* sine waves
"Push Your Car Away and Go Home Refreshed" 159
Pussy Riot 8
Pythagoras 89, 92

The Quest for Voice: Music, Politics, and the Limits of Philosophy (Goehr) 112
Quieting 152–6

Rain Room 5, 37
Rancière, Jacques 124
Random International 5
Ranièrism 4
R&B melody 132
Reason and Resonance: A History Of Modern Aurality (Erlmann) 6, 69
recording technology 29–30
Record Release (Migone) 71–2
reduced listening *(écouter réduite)* 56
reductio ad absurdum 63, 66, 182
Reed, Lou 180
reflective judgment 14
Reich, Steve 33
relational aesthetics 4, 43
representation 146
ResonanceFM 186
The Responsive Eye 5
The Return of the Real (Foster) 135
Reynolds, Simon 148
rhizome/rhizomatics 148, 184
"Ricochets" 155, 156
Rilke, Rainer Maria 87
Robert Morris: The Mind/Body Problem 102
rock and roll 147, 149, 167–74, 187
"Rock and Roll Nigger" 171
Rock My Religion? 172
Ronald Feldman Gallery 150
Room 222 (TV series) 122

Rosenberg, Michelle 8
Rosenfeld, Marina 8
Rosler, Martha 41
Ruddock, Osbourne (King Tubby) 47, 53, 145

Salt Marie Celeste 89
saturation 152
saying, act of 120
Schaeffer, Pierre 56, 89
Schneemann, Carolee 41
Schumacher, Michael 127, 157
Schwartzman, Alan 85
Scrim veil—Black rectangle—Natural light 3
Scritti Politti 145
"Sculpture In The Expanded Field" 16
"Secrecy and Silence" 112
"seeing yourself seeing" 28–9, 32, 36
sein (being) 57–8, 60
Sein und Zeit (Heidegger) 55
semantic agnosticism 74
Semiotext(e) 144, 147
The Shakers 172, 173
shallow listening 134–5
Shaw, Lytle 43, 133, 140
Shklovsky, Viktor 52
"Shoot" (1971) 151, 152
Side B 132
Sideburns 145
Siegelaub, Seth 3–4, 13–14
Sierra, Santiago 19
sight 38–41
signs, sounds as 56, 59–60
silence 94–113
Silence (Cage) 94, 96, 98
Silver Apples on the Moon (Subotnick) 63
Silvertone 169
"simply is" of sound 21–3
sine waves 55–6, 63, 182
"Sister Ray" 152
sites of sound 119–20
site specificity 41–4, 132
Sly and The Family Stone 35
Smith, David 44
Smith, Patti 171, 172
Smith, Roberta 27, 38, 41
Smith, Tony 44

Smithson, Robert 41, 133
Snowden, Edward 75
social/institutional site-specificity 42
Sonatina in G Major 138
sonic arts 25, 54, 57, 63, 66, 68, 70, 73, 179
"sonic ethics" 142
Sonic Pavilion 12, 86–92
sonic practice 98
sound art 5, 27, 55–6, 60, 63, 66, 68, 126–7, 144, 153, 156, 182
Soundings exhibition 27, 28, 37, 62, 63, 65, 66, 69, 177
sound-in-itself 135
sound ranges 26
sound studies 60
Sound Unseen: Acousmatic Sound in Theory and Practice (Kane) 56
"Speaker's Corner" 109–10
Spector, Phil 63
Speculative Realism 23–4, 37
Spivak, Gayatri Chakravorty 167, 168
"stand-alone arrogance" 123
Steinbach, Haim 51
Stella, Michael 102
Sterne, Jonathan 6, 21–3, 60
Stevens, Wallace 97, 100, 188
Sting 168, 171
Stooges 131, 132
Stravinsky, Igor 124
The String and the Mirror exhibition 3, 6, 8, 28, 69–70, 177
Studies in Iconology (Panofsky) 101, 103
"The Studio As Compositional Tool" 34
Study For Strings (Philipsz) 65
Subotnick, Morton 63
Surplus Theater 101
Swell Maps 145
Sympathy for the Devil: Art and Rock and Roll Since 1967 144
"Sympathy for the Devil" catalogue 148
Symphony 0 186

tableau vivant 51
Tan Lin 37
Tanya Bonakdar Gallery 3, 28, 36, 37, 177, 184
tape machines 30

Tate Modern's Turbine Hall 5
Television 185
Theater of Eternal Music 89
Them (music band) 170, 171
"The Theology of Sound: A Critique of Orality" 21
This Heat 185
Thomas Jefferson Slave Apartments 60
Thompson, Errol 47
Tiravanija, Rirkrit 85
Tomorrow Is The Question? Is The Question! 181
transcendence 75–6
transcendent ineffability 134
The Transfinite 5
"Transfixed" (1974) 151
"transmission loss" 35
Turrell, James 3–5, 9–13, 16, 20–1, 27–9, 36–41, 45, 51, 54, 177
21.3 (performance lecture) 101–4, 109
tympaniser 108
tympanum 108

Ultra Red 8
the Undertones 171
The Unheard 169, 173
"Unst: Bespoke Sound" 186
unstitution 147–8
Untitled (Charlotte Posenesnke) 51
"The Upsetter." *See* Perry, Lee "Scratch"
Urban Disease (album) 140
US Assistant Secretary of Defense 90

Van Halen 168, 171
Van the Man 171
Veal, Michael 53
Velvet Underground 151, 152
Venereology (Merzbow) 34
Virilio, Paul 106–9
visual arts 73
Vitiello, Stephen 156
Voegelin, Salomé 152–4
La Voix et le Phénomè ne (Derrida) 125
Volz, Jochen 85

Walsh, Anne 8
Waterman, Alex 51

The Weather Project 5
Weiss/Weisslich (Ablinger) 89
Western avant-garde 18
West Side Story 122
White House tapes 34
"White Light/White Heat" 150–2
Whitney 3, 28, 177
Wigley, Danny 170
Williams, William Carlos 97
Wilson, Tom 152
The Wire magazine 131, 139
Wrixon, Eric 170

X. Xiang 18

Yale University Art Gallery 156
Yeh, C. Spencer 70–1
Yoko Ono 70
Young, Carey 8, 109–12
Young, La Monte 5, 57
The Yves Klein Blues 121–4

Zazeela, Marian 5
Zeit 44–6
"Zombie" 140

www.ingramcontent.com/pod-product-compliance
Lightning Source LLC
Chambersburg PA
CBHW071423170526
45165CB00001B/369